ADVANCED >>> DIGITAL BLACK & WHITE PHOTOGRAPHY

JOHN BEARDSWORTH

LARK BOOKS
A Division of Sterling Publishing Co., Inc.
New York

Advanced Digital Black & White Photography

Library of Congress Cataloging-in-Publication Data

Beardsworth, John David.
 Advanced digital black & white photography / John David
Beardsworth. –
1st ed.
 p. cm.
 Includes index.
 ISBN-13: 978-1-60059-210-2 (pb-with flaps : alk. paper)
 ISBN-10: 1-60059-210-4 (pb-with flaps : alk. paper)
1. Photography–Digital techniques. 2. Black-and-white
photography. I.
Title. II. Title: Advanced digital black and white photography.
 TR267.B435 2007
 778.3–dc22
 2007015986

10 9 8 7 6 5 4 3 2 1
First Edition

Published by Lark Books, A Division of
Sterling Publishing Co., Inc.
387 Park Avenue South, New York, N.Y. 10016

© The Ilex Press Limited 2007

This book was conceived, designed, and produced by:
ILEX, Lewes, England

Distributed in Canada by Sterling Publishing,
c/o Canadian Manda Group, 165 Dufferin Street
Toronto, Ontario, Canada M6K 3H6

If you have questions or comments about this book, please contact:
Lark Books
67 Broadway
Asheville, NC 28801
(828) 253-0467

Manufactured in China

ISBN 13: 978-1-60059-210-2
ISBN 10: 1-60059-210-4

To download example files from
Advanced Digital Black & White Photography, go to:
www.web-linked.com/adbwus

For information about custom editions, special sales, premium
and corporate purchases, please contact Sterling Special Sales
Department at 800-805-5489 or specialsales@sterlingpub.com.

CONTENTS

WITHDRAWN

INTRODUCTION

When my father heard I was about to begin a second book on black-and-white photography, he thought back a few years to his surprise at seeing the first one. After all, he had asked, doesn't everyone want color nowadays?

Just as the moving picture, even with the addition of sound, never succeeded in killing off still photography, decades of color haven't proved fatal to black and white. If anything, they made it seem more distinctive as an artform, crucially separated from the world of color. Artforms are not necessarily swept away by technological progress, but accumulate and happily coexist. In fact, the arrival of digital imaging seems to have given yet another burst of life to black-and-white photography.

But things do move on, thoughts develop, needs change. Over a period of just a few years, digital capture of images has become less the exception and more the norm, and the need is no longer for help in making one's way from the wet to the digital darkroom. We are in a period of reflection, and of maturing and establishing our digital photography skills.

This book's purpose is to offer an up-to-date approach to black-and-white digital photography while staying firmly within its rich tradition. It is aimed at the serious photographer, whether you're earning a living from your work or are an enthusiast who thinks carefully about your results. All you'll need is a basic familiarity with Photoshop and the desire to move forward.

The book's first section is about the picture-taking process and emphasizes shooting in color, not using your camera's built-in black-and-white settings. As well as keeping open the option to produce both color and mono versions of the same scene, the best starting point for a top-quality digital black-and-white picture is the well-composed, well-exposed RAW image file, with all its color information intact. To paraphrase Ansel Adams, the digital color file is the score, and the black-and-white image is its performance.

The second part looks at converting those color files to black and white. There are too many alternative techniques to list here, and some are mentioned more so you may recognize them as old and obsolete when you see them advocated in web forums, in recycled magazine articles, or by the camera-club bore. Placing those methods in their historical context means you can then appreciate the advantage of newer techniques that fully exploit the color image's data to produce the best possible black-and-white rendition.

The section's key objective is to show where you can exercise creative control during the black-and-white conversion. Once you start exploiting the color image's channel data, the specific choice of conversion method becomes a secondary matter. This step is less about overall image contrast, which can be resolved later, and much more about how a certain combination of channel values changes the picture's grayscale tones—and what that tells the viewer about its subject.

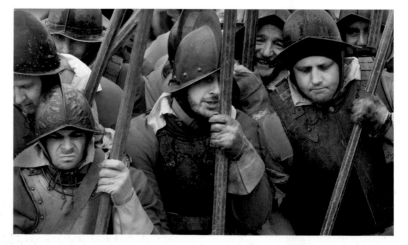

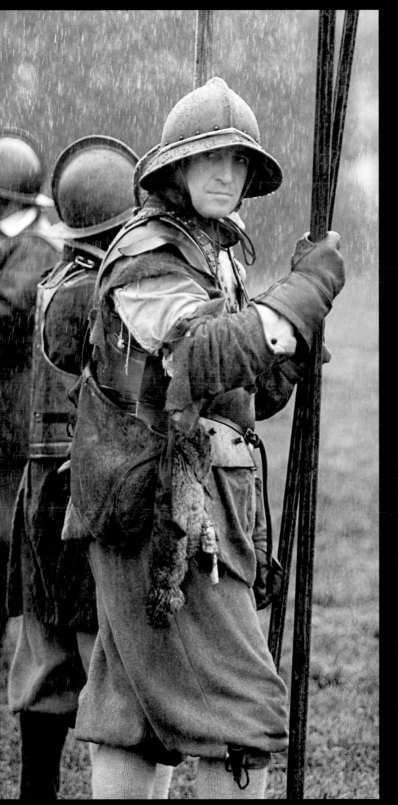

Left and Opposite: The choice of black and white can sometimes be rationalized, but it is often ethereal and subjective. I chose it for a project on 17th century historical re-enactment because I wanted the pictures to echo the World War II and Vietnam-era war photography that I'd grown up with. That meant observing Capa's dictum of "if it's not good enough, you're not close enough," but I also went for the sort of harsh monochrome seen in the work of McCullin or Baltermans. But thinking more about it, my vision of the period had always been in black and white. All my college books used contemporary lithographs and woodcuts to depict major events, real life, and ordinary people, and even Van Dyck's rich paintings of the aristocracy were reproduced in black and white. The medium suited the subject matter for a mix of cultural and aesthetic reasons, and a subsequent project on 19th century military re-enactors has been realized in purplish and sepia mono tones that alluded to that era's photographic heritage.

INTRODUCTION

The conversion step is all about tonal separation, distribution of grayscale tones, and image balance. Contrast is a separate step, and is discussed in the third section. As well as controlling overall image contrast, you may want to lighten or darken, or "dodge and burn" selected areas, and apply sharpening. But, as at the conversion stage, it is all very well to know the modern, versatile equivalents of the wet darkroom's dodging and burning. Once you know what is achievable, then it is much easier to understand why you might deploy those techniques. The fourth part of the book shows a number of more creative effects. Nowadays it is hard to draw any

Right and Below: *A great color capture is the best starting point for a great black-and-white image.*

line on digital manipulation, but here the limit is broadly the canon of traditional darkroom work. Toning lies firmly within that scope, as does simulating lith prints, solarization, or pinhole camera effects. But one or two other techniques are also included, such as simulating infrared film photography and line art—nothing too weird or offbeat, however.

The final part of the book is about presentation and output. A black-and-white image can be damaged by highlights lying close the picture's edge, so this section covers borders and techniques such as edge burning. Sharpening, for print or web, is covered, as are specialized black-and-white inks and CMYK conversion. The section also addresses solutions for outputting entire shoots as black and white—

Aperture and Lightroom are now viable alternatives to Photoshop for high-volume work.

Some photographers only work in black and white, others only with color, but digital photography allows the rest of us to have the best of both worlds. If this book achieves even its smallest objective, it will convince you there's a lot of life in black and white. Why limit yourself to color?

Above: *The "best" black-and-white conversion is not just an objective measure of the range of tonal values, but a subjective one. What should the black and white say about its subject?*

TIP

To download example versions of the images in this book as layered PSD files, check the URL on page 4.

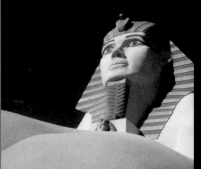
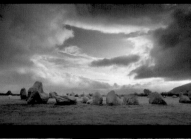
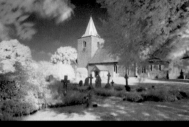

CAMERA WORK
CAPTURING THE BLACK AND WHITE IMAGE

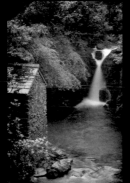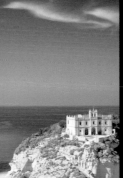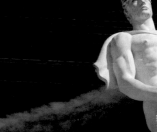

BLACK AND WHITE MODES

There's a very obvious way to make black-and-white pictures with your digital camera: choose its black-and-white mode. Not all digital cameras have such a feature but the number is increasing all the time, and it's now unusual to see a new camera model that ships without monochrome settings. More sophisticated options, like filter and toning presets, are also being added and these provide the photographer with another level of creative control.

While such options are nice to have, they shouldn't be the decisive factor in your choice of a new camera if you want to concentrate on black and white. More important are core picture-taking features like the ability to override automatic exposure settings, the range of ISO sensitivity, and even a small, on-camera flash. They are however useful if you need to deliver black-and-white versions quickly, and the results can be very good.

THE SACRIFICE OF CONVENIENCE

You can manage perfectly well without these built-in black-and-white modes, and there are some pretty good reasons why, at least most of the time, you might choose to avoid them.

One relates to file format. If you set your camera to a black-and-white mode and save your pictures in JPEG format, you are losing forever a lot of valuable image information. Most enthusiast and all professional-level cameras can save pictures to the memory card as either RAW format files or as JPEGs. RAW is the camera manufacturer's proprietary file format and contains every bit of raw data captured by the sensor, while JPEG is a "lossy" format that is designed to minimize file size. While it can be read with no special software, and is ready to print straight from the memory card, JPEG's small file size comes at the price of losing "unnecessary" image data.

So when you choose the JPEG-only option and set a monochrome mode, your camera processes the raw data and outputs a black-and-white JPEG, discarding all the megabytes of color information. You can never make a color print from a black-and-white JPEG. While some may be willing to accept this loss of

versatility, that discarded color information is actually even more valuable than you might at first think. With it, you would almost certainly have been able to produce a better black-and-white image later on your computer. For the black-and-white photographer, that's a heavy price indeed.

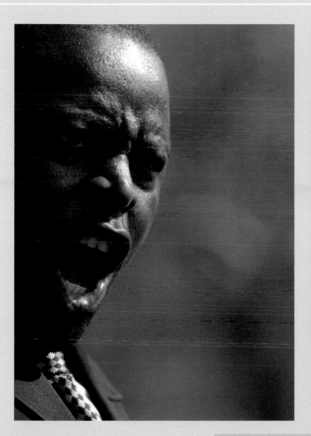
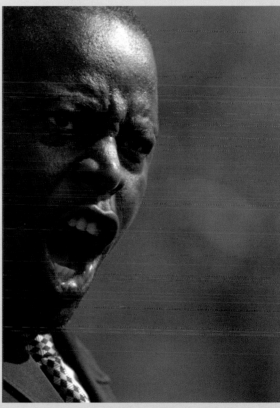

Above: *Setting your camera to shoot in black and white is great when you are need to send JPEGs to clients or friends quickly. But even though the JPEG+RAW option doubles the number of files you have to manage, retaining the RAW file's color data means you will always be able to produce color and black-and-white versions.*

Mode Options	
JPEG	Records a standard 8-bit image from your camera, default on many compacts
Black and White JPEG	Processes the image in the camera to Black and white, discarding all color information. It is likely to be a simple conversion.
RAW	Saves a 16-bit color image with all possible image information and additional camera setting details
Raw + JPEG	Saves both a processed JPEG for speed and a Raw file with all the data described above.
Black and White Raw	Saves all the data of an ordinary Raw, including color, but displays a simple black and white conversion as a preview. It is still allows all the fine tuning possible from a standard Raw.

SHOOT RAW AND IN COLOR

For all the convenience of digital cameras' black-and-white modes, the best choice for today's black-and-white enthusiast is to shoot in color. The principle is simple: color images—and especially RAW files—contain the maximum amount of information, so why limit yourself to any less? Never throw away in camera what you might need later.

Even if you rarely make color prints, there's an obvious advantage to keeping your options open so you can make color or mono versions when you please. If you set your camera to a black-and-white JPEG-only mode, that chance is gone forever because no color information is saved. The camera will process the image virtually instantly and save only a grayscale image to the card.

THE BENEFITS OF RAW

If you like your camera's black-and-white mode, try setting it to the RAW option. A RAW file contains all the raw data captured by the sensor and is consequently much larger than a JPEG. You will still see a black-and-white image on your camera's screen or when you transfer the pictures to your computer, but this is only a preview thumbnail that the camera adds to the RAW file, along with one or more larger previews. All the raw data remains in the file so you can process in mono or color.

Quality is every bit as important as flexibility, and the way to produce the highest quality black-and-white print is to shoot in color, using RAW mode, and then convert the picture in the digital darkroom.

We are not talking Photoshop or computer wizardry here. It is vital to keep emphasizing that there is so

Caption: *Using the RAW option in your camera's black-and-white mode gives you a standard grayscale preview image, concealing the color information.*

much more to the art of black and white than turning down the color saturation and making a grayscale image. The same color photograph can have many black-and-white interpretations, all resulting from creative choices made when you see the picture on your computer screen and exercise control over how it is converted from color to mono. You might decide to apply certain conversion settings because you like how they heighten the contrast, or moderate it; or how they darken the sky, lighten a skin tone, or change where the shadows and lighter midtones are situated in the frame. Some choices are deliberate, while others may be accidental—at first—and happen to work out well. Not surprisingly, a large part of this book is devoted to showing exactly how that can be done.

By shooting in color, or saving in RAW format, it is you and not the camera's designer who can control exactly how your color images look when converted to black and white.

Below: *Using RAW means bigger files and more post processing work, but a single adjustment layer in Photoshop can almost always produce a better monochrome result than your camera's black-and-white setting.*

WHAT WORKS IN BLACK AND WHITE

Even the most experienced and dedicated black-and-white photographers often question themselves about what works best in black and white. After all, does the black-and-white enthusiast really think differently when he or she looks through the viewfinder and presses the shutter release? Is it possible to see in black and white at that point? It's a highly contentious question, and—if you'll forgive the obvious pun—it's one to which there are no black and white answers.

At the extremes, some pictures are inherently monochrome while others are all about color. A colorless, wintry scene is inevitably black and white, while a sunset's glory is all about the sheer beauty of warm colors. But the vast majority of scenes and almost all subject matter lie between those points. Would Cartier Bresson's pictures have been any less arresting if they had been in color? Or Mapplethorpe's nudes any less striking? Perhaps, but the point is certainly arguable. Indeed, thinking of the latter, near the end of his life Mapplethorpe produced beautiful studies of flowers, some in color and some in mono, and deciding between them is a very tough call. And thinking back to that imaginary wintry landscape, might its strength not lie more in its composition than in its absence of color? In short, a well-composed picture, with interesting subject matter, will be great in black and white, if that's what you prefer.

Taking the point further, think of Ansel Adams's *Clearing Winter Storm*. It is a glorious black-and-white image, with a complete range of tones, and superbly printed to emphasize the storm and reveal interesting detail throughout the frame. It's perhaps the black-and-white icon. But you can now park your car close to Adams's viewpoint, and many photographers have produced fine color versions of exactly the same scene.

Alternatively, consider Steve McCurry's equally memorable color photograph—a picture so iconic one barely needs to say it's the one of the Afghan girl from the *National Geographic* cover. The picture works partly because of the wonderful green of the girl's eyes, the complementary reds of her shawl, and the greens showing through its holes and in the background. But those eyes look no less haunting, and nor is the photograph any less perfect, in black and white.

Below: *Clearing Winter Storm by Ansel Adams*

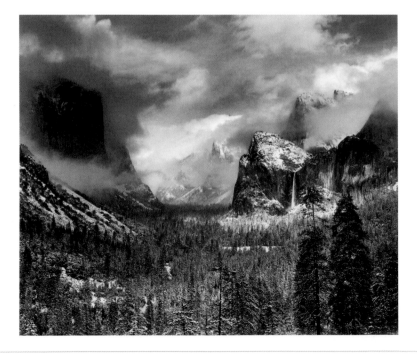

COLOR OR BLACK AND WHITE?

For today's digital black-and-white photographer, shooting in color means you are no longer restricted by the type of film that happened to be in your camera when you raised it to your eye. You can consider the picture at leisure on your monitor and—by quickly cycling through the color channels—present yourself with three often widely differing grayscale interpretations to help you decide if your picture works in black and white.

It's not an avoidance of responsibility to doubt that there's any real answer to what work works best in black and white, nor to question whether one can really "see" in mono. It's actually more liberating for those whose preference happens to be black and white. As I have already said, a well-composed picture, with interesting subject matter, is perfect for black and white. Just go out, shoot those color images, and set aside philosophical niceties.

Right: *A well-composed picture will work equally well in color or black and white.*

Above: *A classic gritty subject for black and white.*

TONE AND CONTRAST

For more than a century, black and white was how we depicted our world and recorded events. First through photography, and then reinforced by film and television, we have learned to accept black and white as being realistic. Of course, it isn't—reality is color, at least it was the last time I looked. Once you shake off any idea that the black-and-white image needs to be faithful to the scene your eyes observed, it's not a big jump to treating it as simply a composition in grayscale tones.

Shades of gray are all that is available in black and white, so much of the skill lies in managing the grayscale composition and positioning blocks of similar tone around the frame. Film users do this before pressing the shutter, placing colored "contrast control filters" over the lens. One filter may darken the sky, perhaps too much, while another may balance the sky and key landscape detail. In the digital era, those manipulations of tonal or brightness values now happen on the computer, but you are guided by the same principles.

With only grayscale tones at your disposal, contrast plays a greater role than in color photography. Overall image contrast is obviously something that confronts you the first time you see your color picture in black and white, either working on it on your computer or, if you used the camera's black-and-white setting, when you review the capture on its LCD screen. The last thing you want to see is a mass of indistinguishable shades of gray, while high contrast can be so harsh and unflattering that the result is more like a graphic special effect than a photograph. Acceptable contrast usually contains true

blacks and whites and a range of tones in between.

Tonal contrast in key areas of the picture is every bit as important as the image's overall appearance. This local tonal contrast requires special attention and an eye for detail. Two neighboring image areas may have had very different colors in reality, but may look identical in black and white. That may be desirable, for example if you wish to show fewer skin tones,

or it may diminish the information the picture conveys about its subject. Shooting in color means you can fine-tune the black-and-white conversion, and exploit the color differences so the image areas are represented in distinct grayscale tones. Tonal separation, both overall and local, is just one of the ways in which the black-and-white conversion becomes less a routine, and more a key part of your creative process.

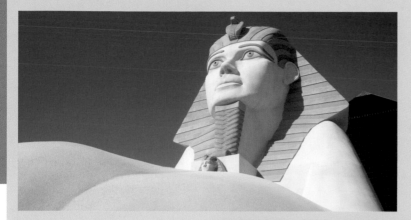

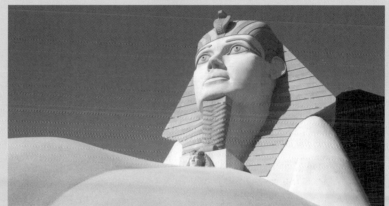

Below: *Image contrast needs to be considered in overall and in local area terms. This version's overall contrast may be acceptable, but look at the sphinx's headdress. Its yellow and blue stripes are identical grayscale tones.*

Above: *The color image is partly about composition, tone and form, but is also about color. Here a deep blue sky is a key part of this image.*

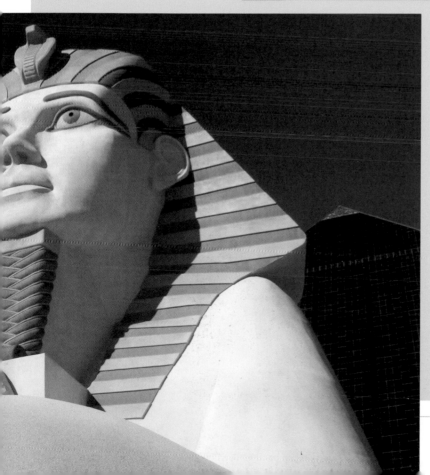

Left: *There are many ways to make a picture black and white. This version has a lot of punch, and the viewer now understands that the headdress contains different-colored stripes.*

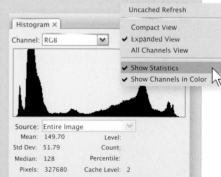

Above: *Photoshop's histogram shows statistics about the image's brightness and contrast. Here, standard deviation shows how widely brightness values are dispersed—in other words, indicates contrast—and can be used as an indication when you are preparing a set of images.*

DIGITAL BLACK AND WHITE EXPOSURE

How do you determine the correct exposure for digital black and white photography? Black-and-white film users often speak of "exposing for the shadows," which ensures that printable detail is recorded in the negative's lightest areas. Film usually has sufficient dynamic range to capture highlight detail, too. Digital exposure, for color or for black and white, is the other way round, more akin to shooting color slide film where you make sure you expose the highlights correctly, leaving the shadows to resolve themselves. Known as "exposing to the right," from the shape of the image's histogram, this ensures that detail is recorded in the most valuable part of the tonal range.

One can only rely so much on modern metering systems and cameras' auto settings. But digital capture brings the ability to check your exposure in the field. There are times when checking the LCD screen makes you miss the action, but on the whole it is an enormous advantage for the photographer. As well as confirming that you pressed the shutter at the right moment and got the shot, it also lets you check that you set the right exposure. Just as Polaroid instant film was used to assess and correct exposure, so you can review the digital capture on site, make adjustments, and reshoot. This instant feedback can also speed up the learning process, so the next time you are in tricky lighting situations you get the exposure right first time.

HIGHLIGHT CLIPPING WARNING

Most digital cameras' LCD screens have two main tools that help you set the correct exposure. The highlights alert is usually an optional setting that makes burnt-out image areas flash on screen. While it is a great quick way to see where large areas of the picture are so overexposed that no usable image data has been captured, it doesn't give you an accurate idea of how much to reduce the exposure. But that quick indication is valuable enough that many experienced photographers keep this setting activated all the time.

Opposite: There are plenty of exceptions where the shot is not harmed by blown highlights. Sometimes it's more important to capture the action.

Below: Digital cameras often have optional highlights alerts that flash to warn you when image areas may be overexposed.

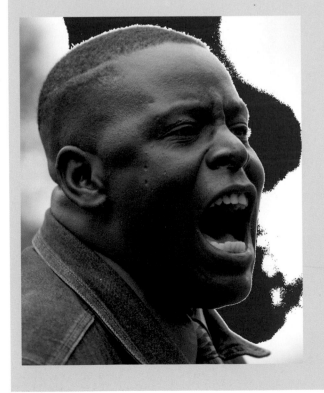

HISTOGRAM

Right: *A single thin spike on the far right of the histogram indicates lots of pure white pixels and areas that lack any detail. It's not necessarily damaging, but is a valuable warning of potential problems.*

Above: *Where they appear deliberate, large expanses of white need be no more distracting than the paper on which the picture is printed. Studio shots may well benefit from a completely overexposed background.*

The second tool, the histogram, is found not just on the camera's LCD screen but also in Photoshop, and at many other points in the digital workflow. It shows the distribution of brightness values in the picture—black (or 0) is at the left, and white (or 255) is at the right. "Exposing to the right" means that the histogram's far-right extreme will just touch the chart's far right. In other words, only the very brightest pixels in the image are pure white, which means the sensor has recorded plenty of detail throughout the highlight areas. In general, you are aiming to avoid spikes at either end of the scale. A spike at the left would indicate lots of pure black pixels and underexposure, while one at the right would mean that the capture contains large areas of featureless white and may be overexposed. It doesn't necessarily tell you precisely how much you may want to adjust the exposure, but you can easily see whether you might need just a small amount or something much more significant like a couple of stops.

EXPOSING TO THE RIGHT

Black-and-white photography has always involved what we now call "shooting for post processing." The color film or slide enthusiast usually tried to get it right in-camera, and may well have objected to subsequent manipulation. However it has always been fundamental to the craft of black and white that the picture will be fully realized in the darkroom and that your first straight prints are not expected to be the finished article. This means the black-and-white photographer often exposes pictures not for how they appear straight from the camera, but in anticipation of what can be done in the darkroom. This principle now applies to digital color too, especially to RAW, so you set the exposure to capture as much important image data as possible, thinking ahead to how you will be able to use it later on the computer. In this sense, not much has changed since Ansel Adams wrote of the negative being the composition, and the print being the performance.

Nowhere is this truer than with the highlight tones and the concept of "exposing to the right." This is a well-regarded way of judging your exposure by using the histogram on the camera's LCD screen. So you take a shot, check the camera's alerts and the histogram, and adjust the exposure. The aim is to get the histogram as close as possible to the right side but without making the highlights indicator flash or causing a spike at the 255 brightness value. This maximizes the number of brightness values recorded by the sensor, means more light readings are being used to record shadow detail, and so keeps digital noise to a minimum.

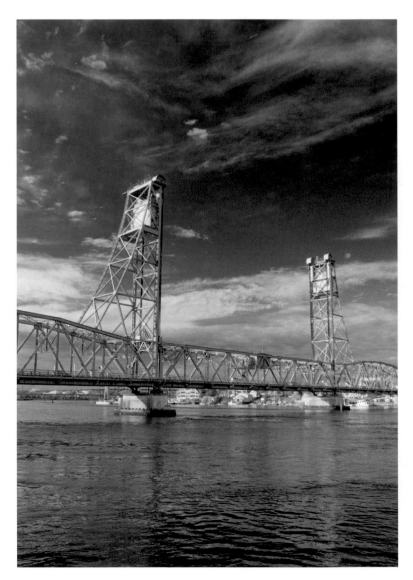

Right: *The properly exposed final image provides the viewer with visible detail in the shadows and the highlights.*

The key to this technique is to capture all the highlight detail. Sometimes this means you need to increase the exposure and so make the overall picture look too bright on the LCD. While this is easy to correct when you examine the pictures on computer, it does mean more post processing work, a burden which you may or may not want to shoulder. Overexposing also means keeping a close eye on the shutter speed—the slower shutter speed increases the risk of camera shake or might blur the motion of moving objects.

When the highlights alert flashes on the LCD screen, or the histogram's right edge is a spike, it is an indication that you may want to underexpose to protect your highlights. Again, this will mean the picture's overall appearance looks wrong, in this case too dark and with shadows dense and blocked up. It also means committing more time to post processing. Levels and Curves adjustments can stretch out the shadows, and working in 16-bit mode may help deal with any posterization (uneven gradations in areas of smooth tone). There is also a greater risk of digital noise. The benefits, though, are that underexposure means a faster shutter speed—and most of all, you retain all that valuable highlight detail.

 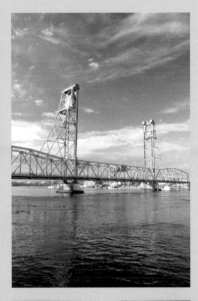

Top and above: *A spike on the left of the camera's histogram indicates underexposure and potential loss of interesting detail in the image's shadow areas.*

Top right and above: *A spike on the histogram's right indicates that the brighter areas of the image are overexposed. The clouds behind the bridge are areas of pure white and contain no visible detail.*

Above: *"Exposing to the right" means the histogram just touches the right side.*

THE SHADOWS

Ideally, an exposure should capture detail in the brightest highlights and in the deepest shadows, and give the viewer a full range of tones. But digital sensors do not yet match the dynamic range of film, let alone of black-and-white film, and scenes frequently exceed the range of brightness that sensors can capture. When it's a choice between retaining highlight detail and sacrificing the shadows, there's only one loser—you do what it takes to keep the highlights from burning out.

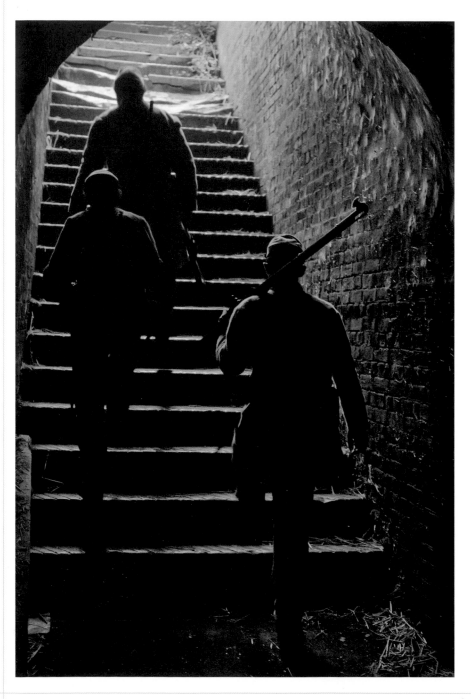

Left: *Until recently, war photography was mainly black and white, and harsh and grainy, too. Here, a purplish tone echoes 19th century print colors.*

DIGITAL NOISE

When preserving highlight detail means you have to underexpose, other problems can creep in. The more you underexpose, the worse the signal-to-noise ratio becomes and the more likely it is that random noise will become visible, particularly in the shadows. Like grain with faster film, noise is the price you pay for taking the shot in poor light.

That's not to say there is nothing you can do. Some cameras have an optional noise reduction setting which applies special processing before writing the image to the flash card; this can be most useful with long, tripod-mounted exposures.

Once the picture is on your computer, RAW converters like Adobe Camera Raw have noise reduction options—Luminosity sliders are most likely to make the biggest difference— and there are specialist programs and plug-ins like NoiseNinja and NoiseAware that can target noise in the shadows and ignore it in other tonal ranges.

Sometimes you may simply decide to let the clip the blacks a little more aggressively than usual in Photoshop. In the end, shadows can obscure all sorts of sins.

Right: *There is an immediate loss of impact when a picture has no true blacks.*

Below: *Shot deep inside a 19th century fortress, a test shot showed I would need to underexpose by a stop to hold any detail in the highlights.*

Right: *If you do a lot of low-light photography, consider getting a specialist noise reduction program such as NoiseWare, which offer more sophisticated features than Photoshop's filters.*

DRAWN TO THE BRIGHT LIGHTS

Highlights play a huge role in black-and-white photography. This isn't just due to technical concerns about absence of detail in image areas, it is a result of behavioral factors in the viewer. It's all about how we typically examine the black-and-white image.

While blacks and shadow tones "anchor" the image and give it "body," they are often overlooked. It is only the trained eye that tries to distinguish their subtleties and any detail they may hide. Usually, and particularly in black and white, the eye lands on the picture's shadows, but is then drawn straight to its brighter tones, as this is where one expects to find what is interesting about the photograph.

Failure to record the highlights in the original capture, or losing them in the digital darkroom, is usually very obvious. Blown highlights are featureless white holes in the picture, attracting the eye and immediately telling the viewer that something is missing from the original scene. It often causes a lasting loss of confidence in the picture's veracity.

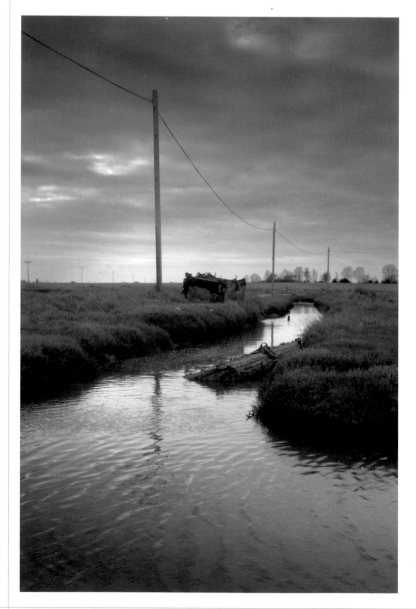

Left: *The final image makes use of its bright areas without being overpowering. Additionally an image border, and judicious cloning has removed the harmful distraction of burnt-out highlights.*

GETTING HIGHLIGHTS RIGHT

From the moment you release the shutter, to the time you send the picture to the printer, you need to remain sensitive to potential problems. Getting it right in-camera—"exposing to the right"—is a great way to start and encourages good habits such as checking your camera's histogram. You also need to take care throughout the post processing work. Try to develop routine working practices such as checking for any clipping in the Levels and Curves adjustments by holding down the Alt/⌥ key when you drag the white-point triangles.

Well-rendered highlights also have powerful compositional value in black and white, leading the viewer around the frame. In the picture shown here, the eye tends to move along a zigzag shaped path, starting from the foreground and then following the stream into the distance and to the horizon, before noticing the brighter areas of the sky. Sometimes this introduction of movement is subconscious, simply how you happen to observe the scene, but it is also something that can be exploited as part of the composition.

There is another reason why the positioning of highlights around the frame is particularly important in black and white. A highlight will be especially noticeable and potentially harmful if it lies close to the picture's edge. Paper is also white, and such bright areas can easily blend into the surrounding paper, making the picture look as though notches have been chopped out of its rectangular shape. The eye may follow such highlights and be led out of the frame, so one solution is to add a black border or mount the print in a black matte. You can also clone away or burn in these damaging patches of brightness, or crop the picture more tightly. Most of all, do a final review of the image before sending it to the printer.

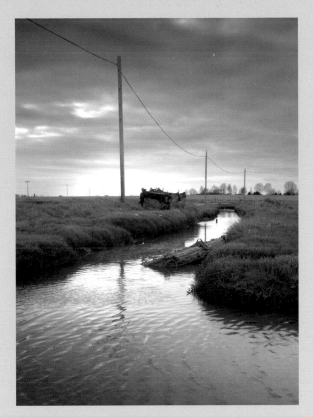

Above: *The eye is immediately attracted to blown out highlights, and interprets the image accordingly. This scene is no longer about a grim marshland landscape, but confuses the viewer—there may be an explosion on the horizon, or a strangely positioned sunrise.*

Left: *Even very small areas of blown highlights may damage the image when they are positioned close to the edges. Here, a bright area of sky is like a notch chopped out on the picture's left side.*

Above: *Highlights guide the eye around the frame.*

INCREASING DYNAMIC RANGE

Where a scene contains a very great range of brightness, sacrificing the shadows may be one option, but it isn't the only one. If the camera is mounted on a tripod, another approach is to take a matching pair of images and marry them later in Photoshop.

EXPOSING TO THE RIGHT

"Exposing to the right" can easily capture an image that, for all its wonderful highlight detail, is unusable because of the problems in the shadows. Once on your computer screen, the blacks may well be indistinguishable from the darkest midtones. You might try boosting the shadow contrast with Curves or Levels, or Photoshop's Shadow/Highlights adjustment, but there would always be a danger of posterization problems. Even if you work in 16-bit mode, you could end up doing all sorts of laborious masking and other work to rescue shadow detail.

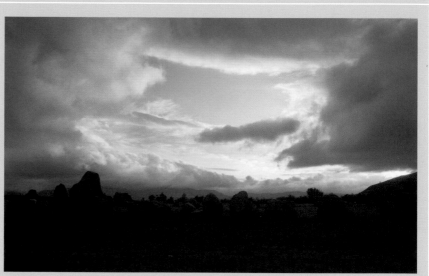

Above: *This frame was "exposed to the right." Its highlight detail is great, but the standing stones are in deepest shadow.*

REGROUPING

Another post processing workaround is to make two differing conversions of the RAW file, and sandwich them together. Alternatively, Adobe Camera Raw and other RAW converters now have sliders for "fill light" which can detect shadow areas and lift their brightness and contrast. So instead of sandwiching two conversions, more can be achieved in the RAW converter itself at a single pass. But you are still working with limited image data about the shadows.

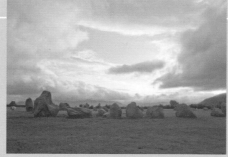

Left: *It is often not an option to lift the brightness of shadows in an image that was underexposed to protect highlights—the digital noise can be horrendous.*

Left: *A second frame is exposed to record shadow detail. This received an additional three stops.*

BRACKETING

While black and white often lets you get away with blocked shadows, a great solution is to blend bracketed exposures. With the camera on a tripod, meter as usual and shoot a pair of shots of the scene, changing only the exposure between frames. One frame is "exposed to the right," with the highlights fully captured and the shadows left to look after themselves. The other is usually exposed according to the camera meter, blowing out the highlights. The two can easily be matched up in Photoshop by holding down the Shift key as one image is dragged onto the other (or using the Photomerge tool). The final image contains the highlight elements from one, and the shadows from the other. The dynamic range is at least as great as film, and nor does it challenge too many scruples about manipulation.

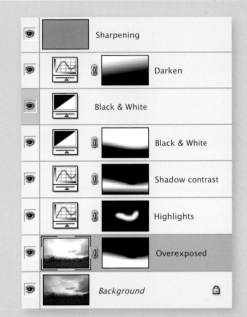

Left: *The key to the finished image is in the bottom two layers. The sky was masked out of the overexposed frame, allowing the correctly exposed sky to show through.*

Below: *Sandwiching exposures increases your camera's dynamic range, and provides the viewer with interesting detail throughout the frame.*

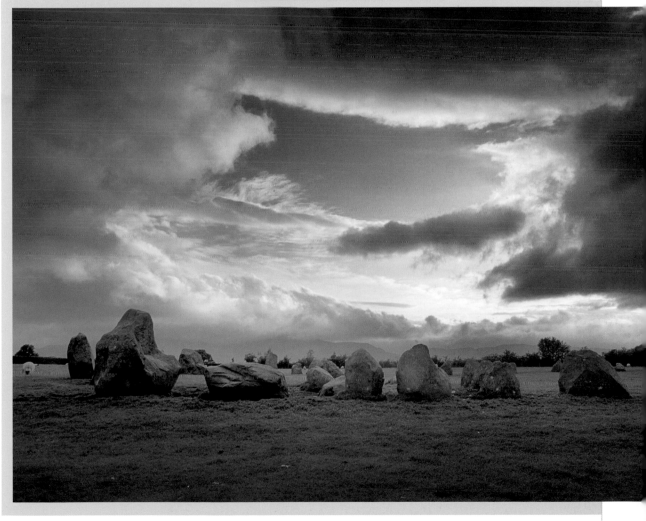

COLORED FILTERS: NOT FORGOTTEN

We are only a decade or so into the digital era, and one misconception is that colored lens filters might still be useful to shoot black and white with a digital camera. This is a mistake. For one thing, we've already seen that you have a lot more creative choice if you convert the color image to black and white on computer. Even if you shoot in RAW format, a filter will give you an image with a strong color cast that is very likely to restrict what you can do at the black-and-white conversion stage, and will certainly prevent you from making straight color prints from the same frame. And if you are shooting JPEG-only, then there's no chance at all of making a color version since the camera will only save the black-and-white image. Even if you never actually make color prints, why throw away the versatility that color capture provides?

LENS FILTERS: COLOR CASTS

Newcomers to black-and-white photography are often surprised to learn how integral colored lens filters have been to the art. Made of optical glass or resin, the filter allows light of the same color to pass through the lens, while interrupting other colors. This principle gives the film photographer lots of control. For instance, a red filter blocks green and blue, and so it might be your choice if you wanted to darken how a blue sky appears in black and white. Alternatively you might screw a green filter onto the lens if your intention was to brighten foliage and make more tones apparent in a landscape.

Experienced black-and-white film photographers would typically carry a selection of various filters—reds, oranges, yellow, blues, and so on—and entire books have been written on the subject.

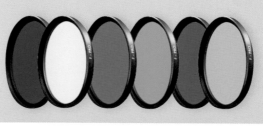

Left: *A huge variety of colored filters is available for contrast control with black-and-white film.*

Left: *An orange filter would darken skies and make clouds stand out on black-and-white film, but in the digital age it removes color, leaving this much information to work with.*

Right: *A color image can be easily converted to appear as if shot on black and white with an orange filter.*

FILTERS: RAW ALTERNATIVES

Another reason why colored filters are not suitable for digital photography relates to how digital cameras capture images. The sensor consists of a grid of light-sensitive cells. These are usually laid out in patterns of four, two of which record green brightness values, and one each for red and blue. In the camera if you are shooting JPEG, or later on computer for RAW files, this capture data is "demosaiced" to a grid where each cell or pixel has red, green, and blue values. Broadly speaking, a colored lens filter would block light from some of the light-sensitive cells, so a red or blue filter would mean that only three-quarters of the cells were being used, while a green filter would cut that to half. This is often enough to degrade the image quality and at worst can cause bitty artifacts in smooth-toned areas.

But most of all, it is simply not necessary for digital. The underlying principles of light filtration are unchanged and still relevant. It's just that they apply not when the light enters the lens, as with black-and-white film, but later when you convert the picture to black and white and manipulate the red, green, and blue channel values. If you are shooting JPEG-only, this occurs as the camera processes the capture data and creates the JPEG, but if you are shooting in RAW format, the conversion step occurs later in the digital darkroom. Colored lens filters are no longer needed for shooting black and white with a digital camera, but if you can find a copy of Ansel Adams's classic *The Negative*, take a look at the use of colored lens filters—the underlying artistic principles remain relevant and translate directly into the language of the digital darkroom.

Above: *In Photoshop, make the pictures black and white and zoom right in. The orange-filtered image is much noisier than the raw color version.*

Above: *Digital sensors consist of a grid of photocells, each sensitive to one color channel.*

Edge burning

Black & White

Black & White

Sharpening

Background

Above: *Shooting in RAW and in color allows much more creative flexibility. For the final image, two channel filtrations were used to make the picture black and white, like using yellow and red lens filters for different parts of the frame.*

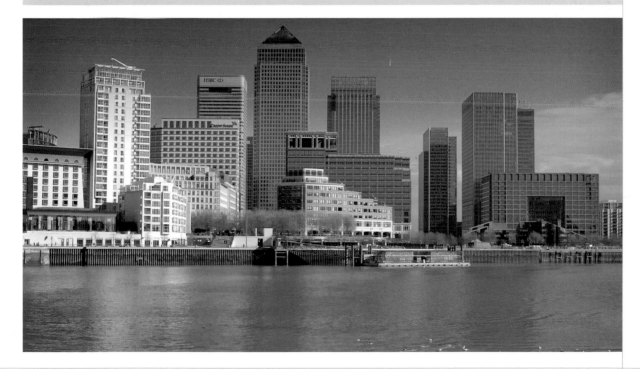

FILTERS FOR DIGITAL BLACK AND WHITE

A filter is optical-quality material, usually glass or plastic, which is placed over the lens and affects how light reaches the film or sensor. Glass filters tend to be more expensive and screw directly onto the lens, meaning their thread or diameter has to match. Resin or plastic filters slot into standard-size holders which are then attached to the lens using adapters for each thread size, so this is much more flexible if you have a few lenses. Some lenses, like ultra wide-angles, only take gelatin filters which slide into slots at the rear of the lens. There is a wide variety of filters to choose from.

As we've seen on pages 30–31, colored lens filters belong to the film era, so that's a whole lot fewer lens filters to weigh down your camera bag. But what filters remain valuable for the digital black-and-white shooter?

FILTERS: GRADUATED

"Neutral grads" are filters that are graduated from gray to clear. The gray half darkens that part of the subject by 1–3 stops without altering its colors. This is useful when the sky is bright in relation to the landscape and it lets you render detail in all areas without over-exposing or "washing out" the sky. It is perhaps worth having a neutral graduated filter just in case, but if you are using a tripod, it may be as easy to bracket a couple of shots and match them up later in Photoshop.

FILTERS: NEUTRAL DENSITY

Neutral density filters simply cut down all light entering the lens, "neutral" signifying that they affect all wavelengths uniformly. Since less light is reaching the sensor, you need to keep the shutter open longer to achieve a correct exposure, so their biggest use is a creative one. They allow you to use a much slower shutter speed than you would otherwise.

While the neutral density filter remains useful, there's a limit to the amount you can carry and the polarizing filter can be a fine substitute in many circumstances. It is effectively a 2–2.5-stop neutral density filter. To use it, set the lowest ISO value, stop the lens down to $f22$, and attach the filter—this can often be enough to produce motion blurring or water and other moving objects.

Below: *Use a neutral density filter and a small aperture to blur water—this exposure lasted 2 seconds at $f22$.*

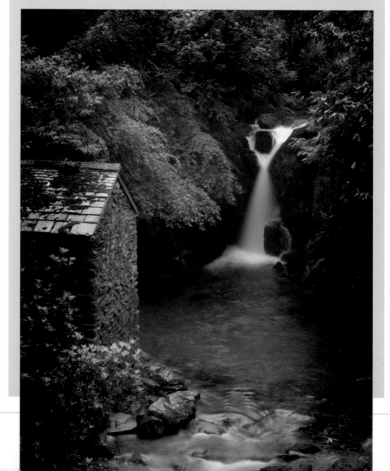

FILTERS: POLARIZING

There's little dispute that, for film or digital, polarizers are by far the most useful filters and it's worth spending a little more for good quality.

The polarizing filter is actually a pair of filters that prevent unpolarized light from passing through the lens. Reflected light is unpolarized, so the filter means the camera captures fewer reflections off surfaces such as water, glass, polished wood, and leaves. As a result, these objects' colors are richer and more saturated. Sunlight also reflects off particles like mist and haze, so the polarizing filter makes skies bluer and makes clouds stand out.

The strength of polarization changes as you rotate the filter's top layer. It is also affected by the type of light and by its direction, being strongest when the filter is at 90 degrees to the sun. Sometimes the color saturation effect is overpowering, or the filter can cut out attractive reflections, so you need to decide for each shot whether it should be used and to what degree.

The loss of reflections can be particularly important for black and white. Without them, colors may be more saturated but that doesn't necessarily improve the picture's appearance and isn't relevant for mono. There's always a danger that a polarized image will appear dull and lifeless.

Polarization can make the sky look uneven and the make parts of it too dark. This is something to watch out for, especially with wide angle lenses.

Also remember that because the polarizing filter reduces the light reaching the sensor, your exposure needs to be longer. While the camera's metering system will handle this for you, generally you lose 2–2.5 stops and for some shots this will mean you may have to use a tripod. It is effectively a neutral density filter too.

But these are disadvantages are minor by comparison with the polarizing filter's huge value. Many photographers gladly carry one polarizer for each lens thread size.

Left: *The polarizing filter eliminates reflected light. Clouds stand out more in blue skies, and here different shades have been brought out in the sea.*

Above: *The polarizing filter remains as useful in digital as it is in film photography.*

Right: *The polarizing filter captures richer colors and usually makes it easier to render more detail in the black-and-white image.*

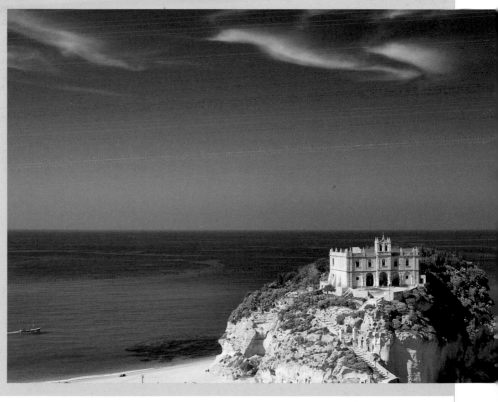

DIGITAL INFRARED CAPTURE

Infrared photography has long been an interesting creative niche in the black-and-white medium. It should not be confused with night vision or thermal imaging, where heat emissions are captured. Instead, the infrared photographer usually works in daylight and uses a lens filter to eliminate the visible wavelengths of light, so the sensor only records light from the infrared part of the spectrum. One of the great things about it is that after the warm early morning light has disappeared, you can switch to shooting infrared and make the most of sun that is directly overhead.

Another important distinction is that here we are talking about capturing infrared light directly with a digital camera, not simulating the effect in Photoshop. A simulation, like the one demonstrated on pages 128-131, starts with a visible-light picture and makes it look like it is infrared—turning the sky near-black, brightening foliage, and so on. Infrared photography, on the other hand, captures light that we cannot see, and so it often records things that would not have been in a regular photograph of the same scene. For instance, infrared light isn't reflected off water in the atmosphere, so mist is simply not recorded in the infrared capture, which consequently reveals cloud patterns and distant objects that would not have been in the visible-light photograph.

Shooting infrared with film meant loading and unloading the rolls in complete darkness, often with your hands inside a changing bag. By contrast, digital infrared is so easy you can shoot one frame conventionally and the next in infrared. There are essentially two choices: having your digital SLR modified so it captures infrared, or seeing if you can use your existing camera with an infrared lens filter. The first approach permits shutter speeds high enough to hand-hold the camera, but it's costly and means dedicating the camera body to infrared. The second approach usually means much longer exposure times and forces you to use a tripod. This isn't a bad thing—it opens up fascinating creative opportunities to blur moving objects like clouds and produce a distinctive digital infrared style very different from film-based infrared photography. Whichever approach you take, it's faster and much more satisfying to achieve the infrared look in-camera than to fake it in Photoshop.

Below: *Infrared captures are fundamentally different from visible-light photographs. Here the infrared exposure was so long it blurred the water and the boats. It also shows the power station over the estuary that wasn't in the visible-light picture (below left) shot at the same time.*

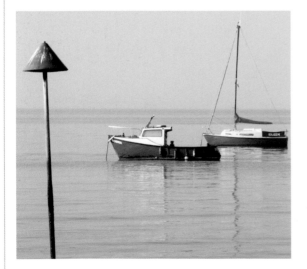

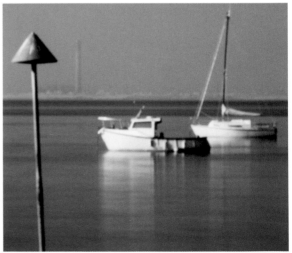

INFRARED: DIGITAL CAPTURE

Infrared filter

Filter holder

1 Digital cameras are not all equally good at capturing infrared light. Infrared (IR) degrades the quality of the regular image, so camera makers have good reasons to add anti-IR filters to the digital sensor. Their effectiveness varies, not just between camera makes but between models. For example, Nikon used to have less effective IR filters than Canon, and so were generally better for infrared photography, but more recent models have been trumpeted as having reduced IR sensitivity. One person's feature is another's disappointment.

While your camera manual may specify your camera's infrared capability, it's easy to work it out for yourself. Set your camera's exposure mode to Manual and use the Bulb shutter speed so you can hold the shutter open for a few seconds. Then, in darkness, release the shutter and fire an infrared remote control—like the one for your TV— into the lens. Check the LCD and see if the sensor has captured an image.

2 Once you know your camera can capture infrared, you need an infrared filter over the lens. These are made of glass or gel and block light from the visible spectrum so that only infrared wavelengths reach the sensor. Many brands are available, and they vary in strength and the wavelength above which they begin to permit light. Infrared light's wavelength is over 700 nanometers, and the higher this value, the purer the infrared capture and the less visible light will be recorded.

This infrared filter fits into a filter holder while others are available which screw directly onto the lens.

3 The infrared filter usually gives photographs a weird red or purple color. You can eliminate this in Photoshop or you may save post-processing time by setting your camera to shoot black and white.

If your camera has no black-and-white mode, try setting a custom white balance. How you do so varies, so check your camera manual, but usually it's a case of shooting a mid-gray subject through the filter. Once you've set up the preset, the camera will capture a black-and-white picture, though a slight color cast often remains.

Left: *The infrared image will often show a red or purple color cast before image processing.*

INFRARED: DIGITAL CAPTURE CONTINUED

4 Unless your camera body has been converted for infrared, IR photography usually means using a tripod. This is because most digital cameras need such long exposure times for infrared, often many seconds, and you can't hold the camera still for that long. Equally important is the fact that the infrared filter is so opaque that you can't see to compose the picture, even if your camera has an electronic viewfinder. So mount the camera on a tripod, frame the shot and focus, and then attach the lens filter.

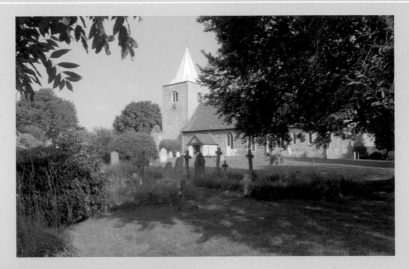

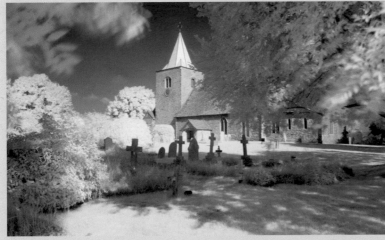

050817 018335 Great Wakering.dng

Metadata	Keywords
▷ File Properties	
▷ IPTC (IIM,legacy)	
▷ IPTC Core	
▽ Camera Data (Exif)	
Exposure	: 18.0s at f/22
Exposure Bias Value	: +1
Exposure Program	: Aperture priority
ISO Speed Ratings	: 200

5 It's also a good idea to stop down the aperture. This is because infrared light focuses at a slightly different point to visible light and a smaller aperture's greater depth of field will counteract this difference. A second aspect is that there are good creative reasons for setting a slower shutter speed and having greater depth of field. At f16 or f22, digital infrared exposures may last 30 seconds or longer, so you can blur water and moving objects and this creates a digital infrared effect very distinct from film infrared. Here the exposure was a minute, giving the clouds time to move across the sky. Notice too how well a Lith effect works with infrared.

6 If you use an SLR, there is a danger that visible light can reach the sensor through the eyepiece, and this can easily overwhelm the infrared light. Some cameras have a switch to close the viewfinder, or add an eyepiece cover. You won't have this problem if your camera doesn't have an optical viewfinder and you use the LCD to compose the picture.

7 Digital infrared exposure is slightly tricky but it's easy to follow a "plan-do-review" cycle. For your first infrared captures, use the camera's automatic setting to determine the exposure, and then review the captures carefully on the LCD—the histogram can quickly tell you how much you need to adjust the exposure. You will probably need to make a few tests before you can decide how it responds to infrared.

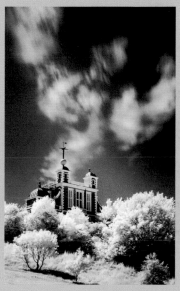

8 Most of the work is done by the time you press the shutter. If you have set a custom white balance, you may just need to desaturate the image in Photoshop and remove any remaining color casts. Also hot pixels may be visible because of the long exposure, but these can be fixed easily with Photoshop's Spot Healing Brush tool or by using Adobe Camera Raw 4's spot healing feature.

Here, Adobe Camera Raw picked up my custom white balance but this infrared capture still has a slight color cast. I can drag the Saturation slider to -100% and quickly make it pure black and white.

Digital infrared is so easy you can take one conventional image, adjust the exposure, add the filter, and shoot the next frame in infrared. You can then stack the two images in Photoshop and apply the Color blending mode to the color image. It's a technique I like to call the "infrared sandwich."

Below: *Classic infrared subjects include various shades of foliage, and interesting skies with broken clouds. Notice that the digital infrared picture doesn't have the glow or graininess typical of infrared film photography.*

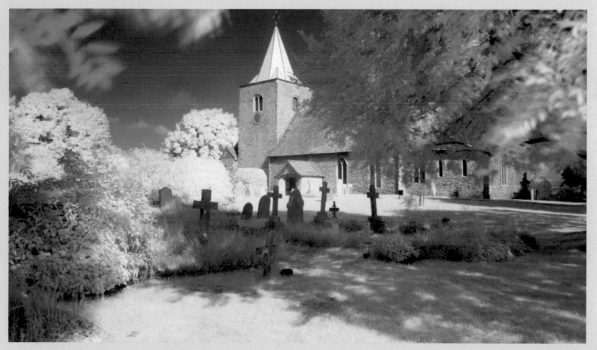

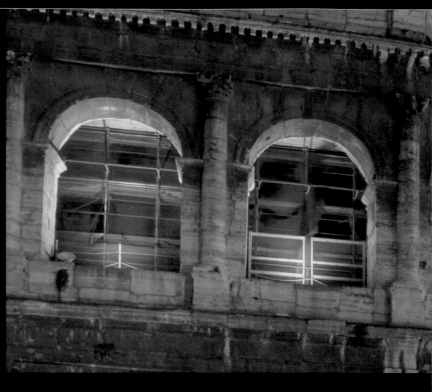
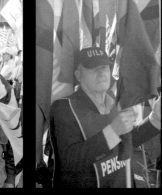

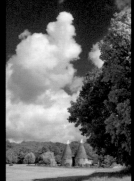
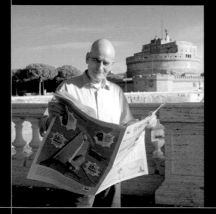
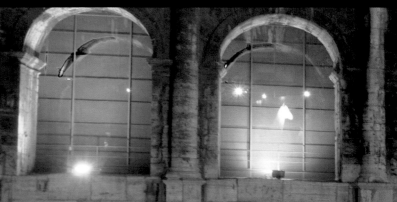

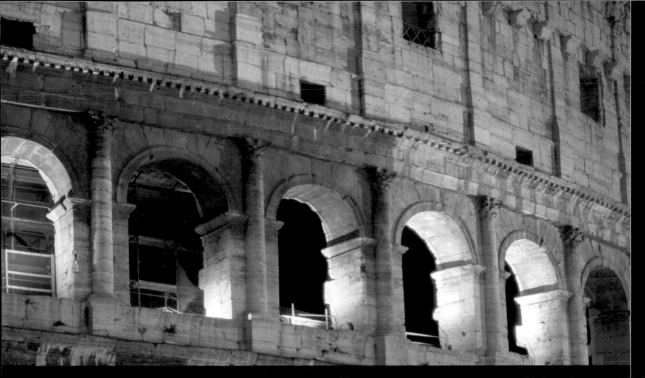

THE DIGITAL DARKROOM 1
CONVERTING TO BLACK AND WHITE

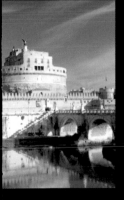

DESTRUCTIVE TECHNIQUES

Photoshop's black and white functionality has "history." Every year or two, a new version of the program provides tools that make better techniques possible or practical. Layers of tutorials accumulate over time. An outdated method might be recycled in a new-looking web site, or a convincing commentator in an online forum might not mention he uses an old version, or may even be so stuck in an earlier era that he sees no need for today's best practice. You can spend forever working out what belongs in which era of development, what's old and best forgotten, and what's the best way for you to work.

In the following pages we are going to try to make sense of this accumulated knowledge and examine some of the many techniques for rendering a color image as black and white. The older ways still produce quality results and won't be ignored, but they also have disadvantages in terms of flexibility and creative expression. We will then examine how more modern methods exploit the information in the image's color channels, using adjustment layer and masks, so the final image is the best black-and-white treatment you can achieve.

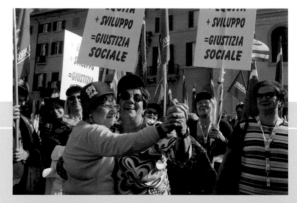

Left: *Italian protest rallies often seem motivated more by fun than politics.*

GRAYSCALE

There are some very simple ways to make an image black and white, and none is simpler than *Image > Mode > Grayscale*. This changes all pixel values in the file to grayscale values. Photoshop examines each pixel and takes 59% of its Green channel value, 30% of its Red and 11% of the Blue, so a dark bluish pixel which has an RGB value of 35:35:82 will becomes 58. This ratio comes from an assessment of the average color responsiveness of the human eye, so the results are pretty average too.

It is quick, and the resulting file will take up less disk space since all the color information is discarded. On the other hand, once you save and close the file, the image's color values are gone forever, so you can never adjust the black-and-white conversion. In other words, this method isn't very flexible and gives you no creative control over the black-and-white conversion.

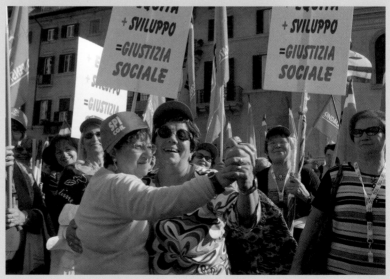

DESATURATE

Another easy method is to use *Image > Adjustments > Desaturate* or Ctrl/⌘+ Shift+U, which simply discards the image's saturation value. You can produce the same results by adding a Hue/Saturation adjustment layer and dragging the Saturation slider all the way to the left.

Like the Grayscale method, it's a "one size fits all" approach, but it also ignores how the eye responds to colors. Again, the absence of creative input means this is one to avoid.

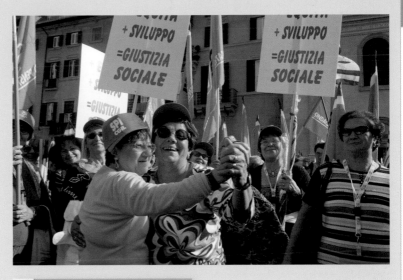

GRADIENT MAP

The Gradient Map method maps a monochrome gradient to the image's luminosity values. First reset Photoshop's colors (D) and then add a Gradient Map adjustment layer. Adjusting the Smoothness slider controls how the gradient relates to image luminosity, while other sliders change the gradient's brightness range. In effect, the Gradient Map method lets the user adjust image contrast while also making the image black and white, and perhaps that is behind its cult status on the forums that is otherwise hard to explain. While you can get decent results, you're also ignoring the color channels and losing their creative potential.

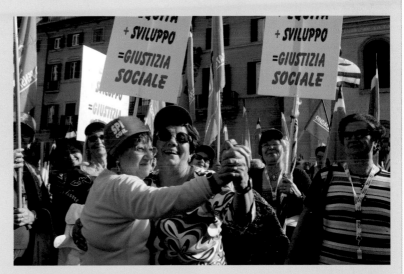

Above. *The destructive methods can all produce good results but their "one size fits all" approach means there is no scope for creativity. They are best avoided.*

DESTRUCTIVE TECHNIQUES

MATCH COLOR

Although this tool is really designed for matching colors, like skin tones, acrosss a number of images, it can be repurposed for an unusual destructive monchrome conversion. There are two ways the tool can be taken advantage of, depending on the outcome you're looknig for. The simplest, for example, is to use it only in reference to the image you're

working on, and dial down the color intensity. That might sound idental to desaturation, but instead of removing all the color a duotone-like effect is created, using the image's predominant color to create the tone. The result is dependant on the image you start with, but it can be quite pleasing.

The second way of worknig with Match Color, at least for our purposes,

is to take advantage of its ability to work from other source images. If, for example, you've found an image with color tones that you like, then simply select it and perform the same reduction of the Color Intensity setting. This trick can be applied to more than one image, giving them matching duotone-style conversions.

Left: *The original image, which has a high concentration of red.*

1 Select *Image > Adjustment > Match Color.* A dialog will appear with two distinct sections, Image Options at the top and Image Statistics at the bottom. To use the existing color from the image, simply slide the Color Intensity slider to the lowest possible value and click OK.

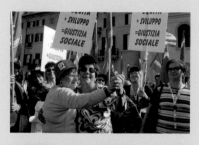

Left: *The resulting image from the simple Color Intensity reduction method.*

Left: *An alternative treatment, using the color tones from the lake image.*

2 Alternatively, if you're interested in using the color from another image, then before you click OK choose it from the Source drop-down. It's also possible to save your favorite statistics

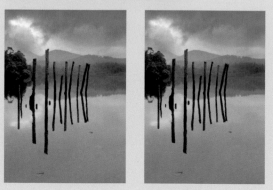

Left: *The lake image has a more subtle blue/green feel, but that still has an effect if converted using the one-step method.*

LIGHTNESS

The Lightness method involves switching the image's color mode from RGB to Lab, which records the brightness and the color values separately. The color information is then thrown away, leaving just black and white. Like the other basic methods, Lightness is a destructive technique, changing pixel values permanently. The color information remains in the History palette, but is lost when you close the file. If you want to fine-tune the conversion, you have to go back to your original photograph. Lightness also applies to the file as a whole, and offers no opportunities to use the individual color channel values to control how individual tones and areas are converted.

1 Select *Image > Mode > Lab Color*.

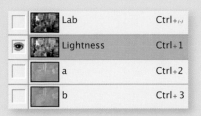

2 Activate the Channels palette, delete either the a or the b channel, and you're done. Alternatively, select the Lightness channel and then choose *Image > Mode > Grayscale*.

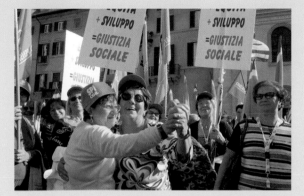

Right: *But of the basic methods, Lightness is probably the best. The resulting black-and-white picture is usually the most natural or neutral rendition of the original scene's brightness. If that is what you want, don't rule out the Lightness method.*

COLOR BLEND

Another quick conversion technique involves adding a Color Fill adjustment layer and selecting a shade of white through to black. Then change the layer's blending mode to Color. This means its only effect is to render the image black and white. It doesn't have any real virtue and I include it only for completeness.

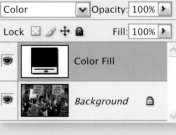

CALCULATIONS

Under Photoshop's Image menu lurks the mysterious Calculations command. Its main role is in retouching and compositing, where it is used to make sophisticated selection masks, so Calculations is not something most photographers would ever need to use. Nonetheless Calculations can merge the values from up to two color channels and output a new, black-and-white Photoshop document.

Because you can control the mixing of color channel values, Calculations permits more creative control than other basic methods over how tones are rendered in black and white. Historically, it also made the most of limited computing power and disk space, and predates Photoshop layers.

Such limitations are now behind us, and Calculations is neither as convenient nor versatile as modern layer-based techniques. The new black-and-white document the command creates contains no color information, so changing your mind about the color-to-mono rendition means starting all over again. Since such fine-tuning is so much easier now using other techniques, it isn't immediately appealing. Calculations can produce great results, but its awkwardness can limit your creative experimentation.

So why is it covered here? First, Calculations is still touted often enough that it needs to be put in its historical context. The second reason is more important, and that is to introduce the role of channels and creative black-and-white conversion.

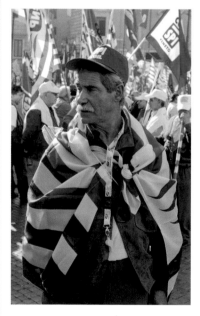

Above: *When you are experimenting with mono conversion techniques, select images with a variety of colors, such as the strong greens and reds in this rally.*

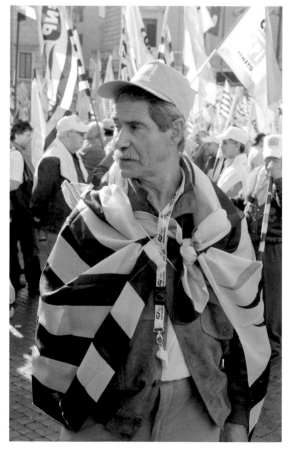

Left: *Although it can be awkward to use, Calculations does offer a degree creative control. Using the blue channel darkens the skin tones on this man's face, so the photographer can convey that he is a heavily tanned man. It also tones down the background and changes the emphasis of the composition.*

CALCULATIONS METHOD

1 Choose *Image > Calculations* and go directly to the Result section at the bottom of the dialog box. You need to set this to New Document, because while Calculations may be previewed in the working image, it can only make selections of channels there. Also, the Layer drop-down boxes should in general be set to Merged, so any retouching layers are included in the process. Use the Background Layer if there are no other layers.

The most important controls are two Channel drop-down boxes which enable you to choose the channels that Calculations merges into its black-and-white output document. For instance, pick Red in one drop-down box, and Calculations' output will show lighter skin tones, because the red channel values of skin are quite high. Choose Blue, and for the same reason Calculations' mono output will render skin tones darker. To bring out more tones in green, such as in the striped flag here, you'd pick Green in one or both Channel drop-down boxes.

2 Experiment with the Blending drop-down box and its accompanying Opacity box, where you can vary the ratio of each channel's value that goes into the output document.

When the preview shows a mono image that you like, click OK, and Photoshop sends the combined mono image to a brand new document. You're no longer just switching off the color you're manipulating and controlling how it is rendered in black and white. Once you start using the channel values, mono conversion starts to become a creative process.

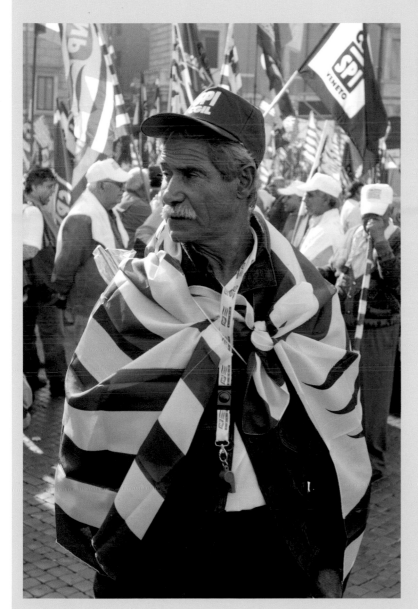

Left: *Calculations lets you control how Photoshop blends the color channel values into a new black-and-white document. Here, Red channel values lighten and soften the subject's face, but they also make the mostly red background so blown out that it distracts from the subject.*

THE TOOLS OF THE TRADE

We have discussed many of the older methods of converting a color image to black and white. These techniques can do the job, and often well, but they all date from earlier eras in the history of Photoshop black and white, and limit your creative choices while being difficult to control. Worse still, color channel data is lost so you can't come back and fine-tune your work at a later date.

Today's best conversion techniques let you creatively exploit the image's color channel information and fine-tune the mono conversion. You can make the conversion separate the colors, so greens and reds might be distinguished by differing shades of gray. In Calculations, we saw one example of how channel manipulation could vary the background's brightness relative to the picture's subject. Modern methods give you an enormous degree of control over the tonal balance and scope for choosing how the composition should work in black and white. And they all use adjustment layers, so you can revisit, improve, or completely reverse the conversion any time you want.

INDIVIDUAL CHANNELS

On the following pages we are going to examine the main techniques that are applicable today. But whichever method you prefer, the first step is to assess the color image.

Even if you only do black-and-white work occasionally, it is worth changing Photoshop's Preferences so the color channels are displayed as grayscale. Go to *Edit > Preferences > Interface* and uncheck the option to Show Channels in Color. This switches off the red, green, or blue overlay that makes it difficult to assess the information that is in each channel.

When I start a black-and-white conversion, I almost always begin by cycling quickly through the channels. In the Channels palette, you can click each channel's eye icon in turn, but the keyboard shortcuts always seem easier.

First press Ctrl/⌘+1 to see the red channel, Ctrl/⌘+2 for the green, Ctrl/⌘+3 for the blue, and Ctrl/⌘+ ~ (tilde) to return to a normal RGB image. This is a very quick operation—you may want to repeat it a couple of times—and has two main purposes.

At a basic level, it tells you the characteristics of the three channels

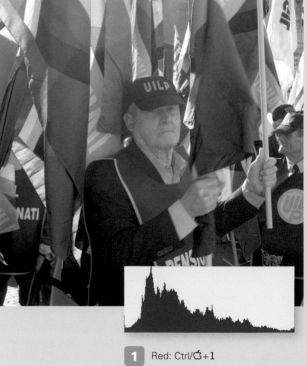

1 Red: Ctrl/⌘+1

Original

which make up the color image. Each image is different. Looking at the examples below, the Blue channel picture shows the man's face is very dark in that channel, while the background and his vest are very bright. That would be their appearance in the final black-and-white image if you stressed the Blue channel in your conversion. During this process you are looking at specific details within the photograph. Pressing Ctrl/⌘+2 for Green makes the vest look dark, making the lettering stand out, and tones down the background, while Ctrl/⌘+1 for Red produces the brightest facial detail.

My initial diagnosis of this picture is that the Green channel produces the best overall conversion, but the face works better with the Red channel, so I need a second adjustment layer. In other words, before you add an adjustment layer to make the image black and white, the Ctrl/⌘+1–3 cycle tells you which sliders you may want to adjust, and whether you might need to make some selective mono conversions with extra adjustment layers.

The second reason for this cycle is far less tangible. Seeing the three channels' individual black-and-white representations is a really quick way to

see three alternative interpretations of the photograph. There are times when this completely changes how you initially intended to compose your black-and-white image. I don't pretend looping through the channels is a magic bullet, but try it and see if your results improve.

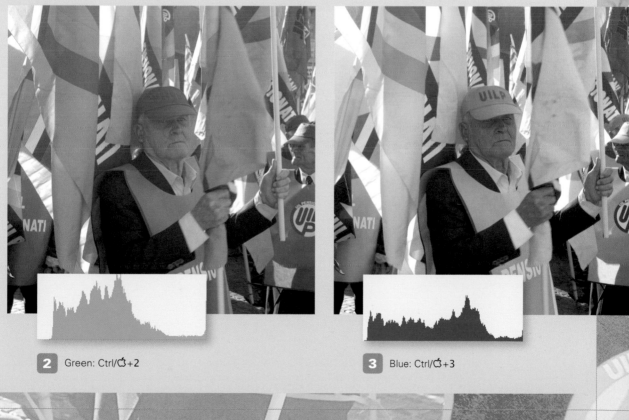

2 Green: Ctrl/⌘+2

3 Blue: Ctrl/⌘+3

THE CHANNEL MIXER

The Channel Mixer method has long been a popular way of converting an image to black and white and gives you creative control over the proportions of each channel's value in the mono image. Since the technique uses adjustment layers, you can always return to the file and change the settings, and layer masks let you apply local conversions too. One disadvantage is that, if you are not careful, Channel Mixer can clip the highlights and shadow tones, but on the other hand it functions in a way that is very natural for photographers with experience of colored lens filters and black-and-white film. If that includes you, it can be a big plus.

USING THE CHANNEL MIXER

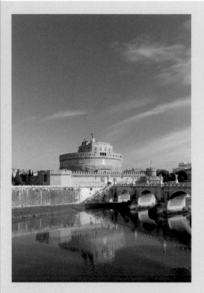

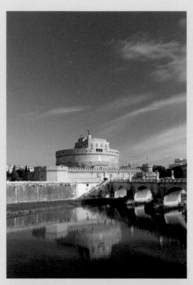

Left: *The Red channel (Ctrl/⌘+1). The top of the picture is dark, the clouds are well-defined against the sky, and the fortress is very bright.*

Below Left: *The Green channel (Ctrl/⌘+2). Similar to the Red channel, though the sky is slightly less dark. The fortress is much less bright.*

Below: *The Blue channel (Ctrl/⌘+3). This version is obviously unacceptable—the sky is far too pale, which makes the clouds pale, and also lets the viewer's eye drift up and away from the picture's subject. Black-and-white film shooters would never have used a blue filter for this scene.*

Above: *It's early one winter morning, the sky is a rich blue, and the fortress, Castel Sant'Angelo in Rome, is resplendent in warm colors. A black-and-white film enthusiast would probably have used an orange or red filter for this scene.*

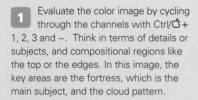 Evaluate the color image by cycling through the channels with Ctrl/⌘+ 1, 2, 3 and ~. Think in terms of details or subjects, and compositional regions like the top or the edges. In this image, the key areas are the fortress, which is the main subject, and the cloud pattern.

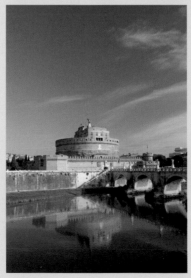

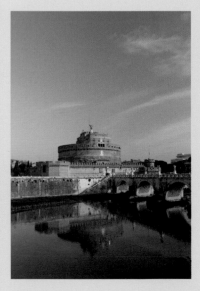

A variation on the Channel Mixer technique is to split the channels and reassemble them as pixel layers. Go to the Channels palette, and select Split Channels from the palette menu. This produces three grayscale documents. Shift and drag each of the new images back into one document, and use masks or vary the layer opacities. Also include a layer created by converting a duplicate using the Lightness method. Adjustment layers are more convenient, and in principle there are no differences in final output quality.

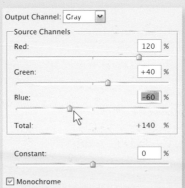

2 Once you have assessed the image, and hopefully gained an idea of how you want to render it, add a Channel Mixer adjustment layer and tick the Monochrome checkbox. Photoshop previews the resulting image in black and white, though initially with a rather uninteresting mix of channel values.

There is also a Channel Mixer command in the *Image > Adjustments* menu, but this changes pixel values directly so you can't revise your work after you close the file. For versatility, always use adjustment layers—notice from the Layers palette how the color information is preserved, so you can always revise the mono conversion.

3 Drag the three Channel Mixer sliders and review how they affect the black-and-white output. In general, try to keep the contrast at 100%, but concentrate less on overall image contrast—which can be fixed later—and more on key details and the overall compositional balance of the image. Here the Red is high, darkening the sky. Increasing it further would burn out detail in the fortress, so the Green value was increased instead, and Blue reduced to keep the overall brightness in balance.

Right: The Channel Mixer is a technique that comes naturally to black-and-white film photographers. To darken the sky, use more Red filtration.

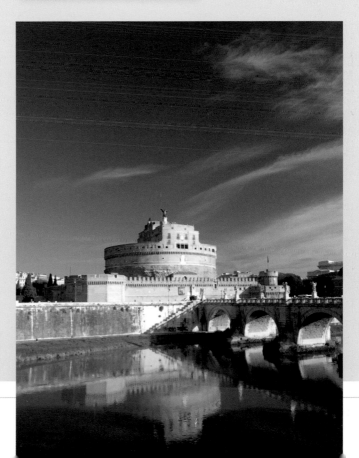

49

"FILM AND FILTER"

The "film and filter" method is also known as "twin hue and saturation" because it relies on a pair of Hue/Saturation adjustment layers. Made popular by Adobe's Russell Brown, you add one Hue/Saturation adjustment layer that represents how black-and-white film records the scene in monochrome, and another that filters the overall image color.

Film and Filter is less intuitive for film enthusiasts than the Channel Mixer, and produces an image that is lower in contrast, so it is more likely that you will need another adjustment layer to fine-tune brightness and contrast. This isn't a problem, though, because it mentally separates overall contrast issues from the more creative thought processes required to make the various grayscale blocks work well together in the black-and-white composition. The example on these pages shows how that happens in practice.

USING THE "FILM AND FILTER" METHOD

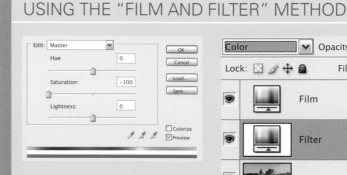

1 Add a Hue/Saturation adjustment layer and drag the Saturation slider all the way to the left. Since this layer's purpose is simply to make the image grayscale, name it "Film."

2 Activate the Background layer and add a second Hue/Saturation adjustment layer, which should be below Film in the layer stack. Like the film user's colored lens filters, this layer's purpose is to control the colors that the Film layer will capture. Name the new layer "Filter" and change its blending mode to Color.

3 Double-click the Filter layer's Hue/Saturation icon and adjust the Hue slider until the image looks right. You can also alter the Saturation and Lightness sliders if you wish.

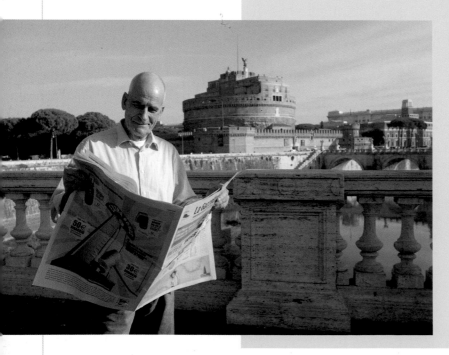

Left: *The final mono print needs to be realistic but that's not necessarily the same as being faithful to the original. In the black-and-white conversion, you are able to control how you interpret the scene.*

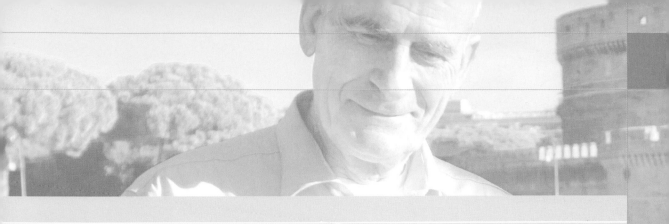

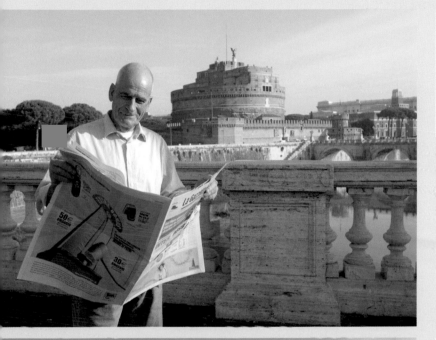

Left: *This Hue setting makes this image a black-and-white photograph of a well-tanned man. Notice how his skin tones are darker than the sky. It's realistic and believable.*

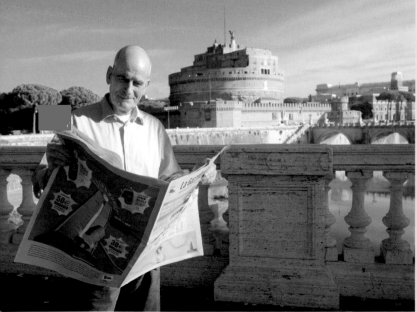

Left: *With all channel-based conversion techniques, you interpret the scene for the viewer. In this version, simply by changing the Hue, the eye is drawn to the man because his skin is much lighter and is set against a darkened sky.*

CS3 BLACK AND WHITE

Photoshop CS3 introduced a new tool for the mono enthusiast; the Black and White adjustment. It shares all the main characteristics of other modern techniques, with creative channel-based control via six color-specific sliders and availability as an adjustment layer, and it also integrates toning or tint in the same dialog box.

But what really marks CS3 Black and White apart—and the reason it is used throughout this book—is its "targeted adjustment tool." This makes the cursor into a sort of brush which you use to stroke the image and control your mono conversion interactively. Even better if your use a tablet and pen, it's as though you are painting your black-and-white rendition.

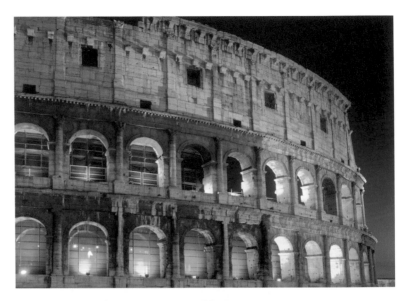

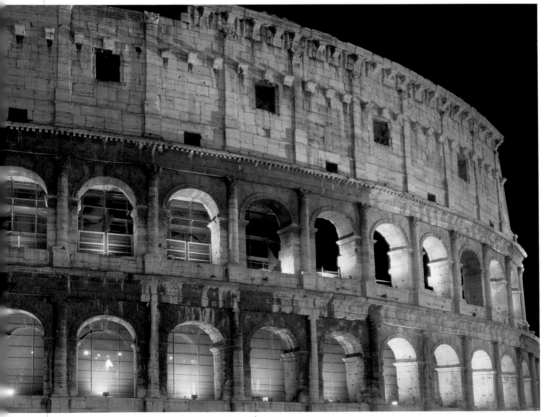

Above: *Just after nightfall, there is not enough color in the sky.*

Left: *The final version has a lot more punch; the sky is near black and there is plenty of highlight detail.*

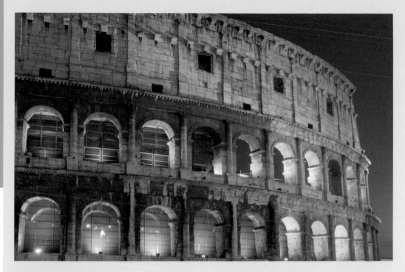

Above: A simple grayscale conversion is too bland.

Black & White 1

Background

1 Add a new Black and White adjustment layer, and Photoshop applies a default conversion and displays a preview. To lighten how an individual color is rendered in grayscale, drag the corresponding slider to the right. Dragging it left has the opposite effect. So, in this example, moving the Yellow and Red sliders to the right would brighten up the arches.

2 Black and White is all about controlling the conversion process interactively, so I'm not so fond of the Auto button, but notice the Preset drop-down box which contains a selection of slider value combinations. They are equivalent to colored lens filters and even if you've got no black-and-white film experience, Presets is often a great starting point.

3 The true glory of Black and White is the targeted adjustment tool. Sliders are all well and good, but the image preview is in monochrome and you can very quickly forget what the picture looked like in color.

So, instead of dragging sliders, move the cursor over a part of the picture that you would like to brighten, such as the arches in this night photo. Hold down the mouse button and drag to the right in a painting-like motion.

Photoshop detects the colors in that area and makes the grayscale rendition lighter, moving the dialog box's sliders for you.

To darken an image area, like the sky here, drag the cursor across that area in a leftward motion. Use a number of short strokes to build up the effect gradually, or use a single longer action. It'll soon start to feel like a very natural, creative process.

PAINTING BLACK AND WHITE

The Black and White adjustment layer's real strength is how it makes the cursor become a powerful creative tool. Stroke image areas and Photoshop will adjust the grayscale brightness of the corresponding colors.

In other words there's no need to know which sliders produce the right black-and-white treatment. This means you can safely push the Black and White dialog over to the side of the screen, well out of your way, and you're left to focus all your attention on the picture—which seems a pretty good concept, don't you think?

Above: *The default Black and White adjustment makes the red oil similar in grayscale tone to the workbench's green edge. But you can exploit such color differences to produce much more interesting treatments of the subject.*

Left: *The final image. The best way to use Photoshop CS3's Black and White adjustment is to stroke image areas with the cursor. Here, the oil can has been made brighter and the background darker.*

Above: *Stroke image areas with the cursor. A leftward motion darkens how the area's color appears in black and white, while dragging to the right brightens the color's grayscale output.*

1 Decide which parts of the picture you want to darken, then click and drag the cursor over those areas in a leftward direction. Use a series of short strokes, or single longer ones, in a painting or sketching-like action. Where you want an area to be brighter, the stroking motion should be to the right.

I felt this picture needed the oil can to be brighter and more obvious, and the bench and the background to be darker. So I stroked the can to the right, reviewed the result, and then stroked it a little more until it looked bright enough. Photoshop detected I was stroking an area containing red values, and moved the corresponding slider to the right, brightening their grayscale appearance. Likewise the image's greens were darkened by dragging to the left over the workbench's green edge, and the background was treated in the same way.

2 It's vital to understand that this isn't dodging or burning, or changing the brightness of a selected area of the image. Photoshop samples the colors in the area which you stroked, and changes how brightly those colors are rendered in grayscale tones, moving the dialog box sliders for you. So you are adjusting the grayscale brightness of the colors that were found in that area, not the brightness of the area itself. Just watch the sliders in the dialog before you release the mouse button to see this in action.

3 Because the stroking action is really targeting and adjusting colors, you also need to keep a close eye on the rest of the picture. It's very easy to inadvertently lighten other areas which share the same color as the area or object that you are stroking.

Because I had stroked leftward over the bench's edge, Photoshop had reduced the grayscale brightness of greens and yellows, but this made the Shell logo unacceptably dark. To try to resolve this, I experimented and dragged left over the can and to the right elsewhere. The logo's appearance was much improved and this also produced an interesting alternative treatment of the overall subject.

4 This emphasizes how there is no one correct black-and-white interpretation. But while I quite liked the alternative version's much oilier-looking can, and certainly preferred the logo detail, I still preferred my initial treatment for the picture as a whole. Another photographer might decide differently, but in my mind were thoughts about the composition's balance, since the can's darker appearance seemed to make the background all the more distracting. So to restrict the alternative conversion to the logo, I simply added a mask to that adjustment layer.

BLACK AND WHITE PRESETS

The Black and White adjustment's cursor can control the tonal composition and guide the viewer's interpretation of the subject (see pages 54–55). While the cursor technique is quick and easy, you can also set the Black and White sliders using one of the built-in Filter Presets. There's nothing wrong with that, and it's a very natural approach for photographers familiar with colored lens filters and black-and-white film. Presets can be a great timesaver and a good starting point, providing you then focus on the image and on what the grayscale rendition says about the subject.

Above: *The original image is quite soft and the woman's lined face isn't unusual for her age.*

Right: *The Red, Orange, and Yellow Filter presets are usually kindest to faces and produce softer-looking skin tones.*

3 When you evaluate the results, it's important that you don't dismiss an interpretation because of overall brightnesss and contrast. You can resolve these later. Here, for example, a Curves adjustment layer has brightened the midtones and highlights.

Above: *The default Black and White adjustment is very neutral or natural.*

1 Photoshop ships with a selection of Presets which set the dialog box's slider values to mimic black-and-white photographers' commonly used colored lens filters. Start off by looping through them, evaluating each one's effect on the image, and then choose the one that best suits your intended interpretation of the picture.

2 Skin tones have low Blue channel values, so typically the Blue Filter preset isn't the best choice for portraits; certainly not of women or children. Applying the Blue Filter preset to this image darkens and separates the woman's facial tones, bringing out details and exaggerating the signs of aging. It's one interpretation, but not a flattering one.

4 While the overall brightness and contrast are now acceptable, the end result is a little "chalk and charcoal" and suffers badly from the Blue Filter's unflattering interpretation of the subject. The Red, Orange and Yellow Filter presets would all produce softer-lloking softer-looking skin tones. If the skin tones become too light, just add a Curves adjustment layer for a more natural appearance.

CAMERA RAW AND SMART OBJECTS

It's not new to use your RAW converter to make a picture black and white, and there is a certain attraction to working directly on the RAW file's high bit data before it is demosaiced. It does mean applying a single tonal balance to the entire image area, and Photoshop supports 16-bit imaging. But Photoshop CS3 and Adobe Camera Raw 4 give the black-and-white photographer new opportunities that are really worth investigating.

In earlier versions of Photoshop, opening a RAW file invoked Adobe Camera Raw or another conversion plugin, and you could set Saturation to 0 and produce a crude mono rendition. Alternatively, standalone raw converters like Nikon Capture, Capture One, or Bibble included channel-based sliders to output more considered black-and-whites. Like the newer Lightroom and Aperture, you could then "send to" or "edit with" Photoshop.

These methods deliver a file to Photoshop with no RGB values. So you're out of luck if you later want to fine-tune the black-and-white rendition—for instance, to see how a red filter would affect the tonal balance and separate similar tones, or to try a blue filter on a portrait of a man. And there's no chance at all of making a color version from the same working file. You have to redo the RAW conversion and lose any retouching time.

Photoshop CS2 introduced the idea of "placing" the raw data in a new document, and you could double-click the "smart object" layer and update its RAW conversion settings. But there still wasn't enough black-and-white control in the RAW converter, and it was still better to deliver a color image to Photoshop and do the

mono conversion with the channel-based adjustment layer techniques. The method lacked versatility and remained a rather obscure trick. All that changed with Photoshop CS3 Smart Objects and Adobe Camera Raw 4 black-and-white conversions.

Right: The final image combines the power of Photoshop CS3 Smart Objects and Adobe Camera Raw 4 black-and-white conversions. Because the output is a Smart Object, the raw conversion remains editable.

Below: The original color image presents a a great deal of raw data which it is wise to preserve during conversion.

USING ADOBE CAMERA RAW AND SMART OBJECTS

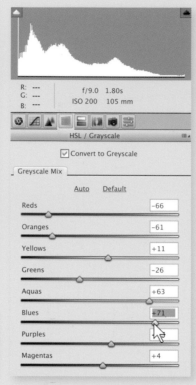

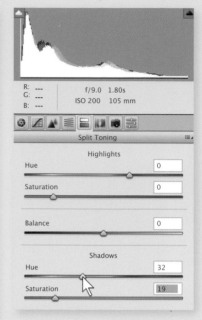

1 In Adobe Camera Raw 4, tick the Convert to Grayscale check box. This switches the image preview to black and white using a default setting.

2 Activate the HSL/Grayscale tab, the fourth one along with the sliders icon. This is where you can tune the black-and-white treatment. Dragging a slider to the left darkens that color's grayscale rendition; the opposite happens when you drag it to the right. Here, I wanted to brighten and draw the eye to the picture's focal point, the oil can, and make the label and background darker. This meant dragging the Blue and Aqua sliders to the right, and Red and Orange to the left.

3 The fifth tab, Split Toning, lets you add color during the raw conversion stage. Start by moving the two Saturation sliders to the right, and then drag one or both of the Hue sliders. The swatches below the Hue sliders are quite small. To be sure about the exact color, a good trick is to hold the Alt/⌥ key as you drag the sliders.

4 You can save the combination of slider settings for reuse on other images. From the small menu on the right-hand side of the Adobe Camera Raw dialog box, choose Save Settings. Pick the settings carefully—after all, you wouldn't want your saved preset to apply exposure adjustments as well as the black-and-white conversion and split toning settings. Click Save.

Left: *The pure monochrome result visible as you adjust the sliders under the HSL/Grayscale tab.*

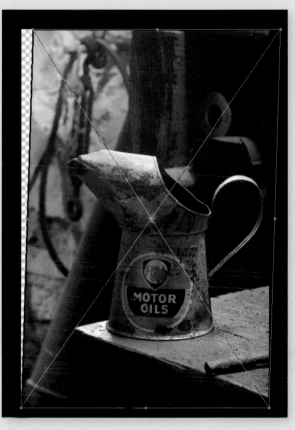

5 These settings can then be called up when one or more RAW files are selected in Adobe Camera Raw. They are also available in Bridge's grid view, so you could apply them to large numbers of RAW files by right-clicking and choosing the setting.

Photoshop CS3 Smart Objects can be transformed, sharpened, or blurred— all without damaging the image data.

6 Before Photoshop CS3, you would have clicked Open Image after making your RAW conversion adjustments. That choice remains available, but there is a new option that keeps the raw conversion editable: Open Object.

Hold down the Shift key and the Open Image button changes temporarily to Open Object. To change it more permanently, click the Workflow Options hyperlink below the image and tick Open in Photoshop as Smart Objects. Click this Open Object button and the RAW file is sent to Photoshop's editing environment as a "smart object", a special kind of layer that contains the raw data.

7 Why would you do this? The obvious benefits are versatility and a non-destructive workflow.

Regardless of RAW conversion and specific black-and-white issues, smart objects are worth using because they can be big timesavers. When they were first introduced, you could add adjustment layers as normal, but you could also do things like apply *Edit > Transform* to correct converging verticals and reverse or fine-tune those transformations when needed. Photoshop CS3 went further and introduced Smart Filters, which mean you can also apply filters like Unsharp Mask or Gaussian Blur to the smart object, and change or remove those settings without damaging the image.

You can change the RAW conversion settings of a RAW file smart object. Just double-click the smart object's thumbnail in the Layers palette. This launches Adobe Camera Raw and afterwards Photoshop applies any filters and layer styles. Since the smart object contains the RAW data, you can save your work and adjust it on another computer or send the file to a colleague or client.

CONVERTING SELECTED IMAGE AREAS

Today's best black-and-white conversion techniques rely on adjustment layers. With enormous hard drives, there's no longer much point in flattening your working files and losing the chance to change your mind, tweaking or completely reworking your black-and-white interpretation. Adjustment layers have another big advantage, however, and that is in enabling you to make different mono conversions in different parts of the picture, using the channel values that are right for those areas.

This is important because when you browse through the channels, one part of the picture may look at its best in the Red channel and other areas be better in the Green. At worst, features may be unacceptable in one or other channel. The newer adjustment layer techniques allow you to have the best of both worlds, while older "one-size-fits-all" methods like Grayscale, Lightness, and Calculations forced you into uncomfortable workarounds. In black-and-white film terms, these new techniques are like having an infinite range of colored lens filters, red-green grads, yellow-red spots, and whatever other "exotic" you might need for the subject.

To apply more than one mono conversion, you simply need additional adjustment layers with different conversion settings, and you use their layer masks to target particular image areas. We'll look at an example of how you do this, and note a few other Photoshop techniques that make the work quicker and easier.

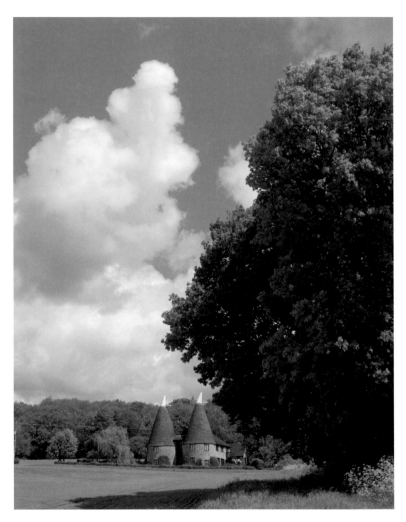

Above: *In the original image, a polarizing filter turned the sky a rich blue and made the grass and trees look particularly verdant. One mono conversion layer might not be enough.*

Left: *The final image. You can have the best of both worlds by using two—or more—masked Black and White adjustment layers. One renders the sky, the other the tree and the foreground.*

USING MASKS

| Normal | ⌄ | Opacity: | 100% | ▶ |

Lock ⊠ ✐ ✛ 🔒 Fill: 100% ▶

👁 ▣ Black & White

👁 🖼 *Background* 🔒

| Preset: | Custom | ⌄ | ≡ | | OK |

Reds ■ -120 % Cancel

Yellows 110 % Auto

Greens ■ -10 % ☑ Preview

Cyans ■ -50 %

Blues ■ -99 %

Magentas ■ 120 %

☐ Tint

Hue

Saturation

| Preset: | Custom | ⌄ | ≡ |

Reds ■ 60 %

Yellows 199 %

Greens ■ 127 %

Cyans ■ 50 %

Blues ■ 0 %

Magentas ■ 0 %

1 Add your conversion adjustment layer. Here I chose the Black and White technique and dragged the cursor a long way left in the blue area of sky. This renders blue as near-black in grayscale, but rendering the sky in this way has left the tree and foreground looking very dull.

Above: *Paint on the adjustment layer's mask. This allows you to convert important image areas using different black-and-white settings.*

Above: *The Black and White adjustment layer has darkened the blue sky but made the tree and field unacceptably heavy.*

2 Paint black onto your existing conversion layer's mask so those areas will be left unaffected by the adjustment layer. You can use any of the painting tools, such as the Brush (B) or the Gradient (G). Here, I activated the Brush tool, used the [and] keyboard shortcuts to set a large brush size, and then Shift+[to soften its edges. I then painted black onto the mask so the tree and foreground remained in color, ready for the second adjustment layer.

3 Add a second adjustment layer with different settings. There is no need for this layer to have a mask—it will not affect any image areas which have already been made monochrome. Here I dragged the cursor to the right across the tree and foreground, causing Photoshop to sample those areas and move the corresponding sliders to the right, lightening their grayscale rendition.

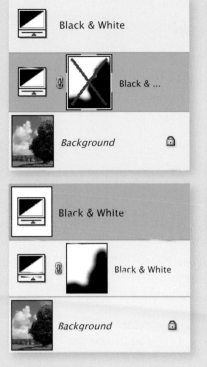

Black & White
Black & ...
Background

Black & White
Black & White
Background

Above: *Dragging the Green and Yellow sliders to the right makes the foreground and the tree are more luminous and spring-like, but the sky and clouds look weak.*

4 In this sort of work, you often need to compare the output with and without your adjustments. You can click the eye icon next to the adjustment layer and toggle its visibility, but that gets more awkward when one of the layers is masked. Another way is to delete the mask and then Undo by pressing Ctrl/⌘+Z.

A less well-known trick is to Shift+click the layer's mask. This temporarily disables the mask so the adjustment applies to the entire image area. In this example, while the red X is present, you can see how the image would look if only that layer were present. Shift+clicking the mask again will switch the mask back on. To see the layer mask on its own, Alt/⌥+click it.

5 The Gradient tool can also be used to paint the mask. Its default behavior is to replace any existing mask, but you may want to add to a carefully painted mask. Switch its blending mode to Lighten or Darken—here I chose Darken—and then drag the Gradient diagonally from the bottom right.

6 When the mono conversion is done with more than one adjustment layer, the transition needs to be smooth. For example, my Red and Green adjustment layers render the tree very differently and a join would be obvious, evidence of a Brush edge that was too hard.

You can adjust the mask's contrast with regular image adjustments like Levels or smooth transition areas by applying filters like Gaussian Blur. Make sure you click the mask before applying a filter so you don't change the image pixels. You should see the mask's simple black and white in the filter's preview.

7 You can also move and stretch the area affected by the adjustment layer. Try using *Edit > Transform* on the mask, dragging the corner points outwards or reshaping it with *Edit > Transform > Warp*.

This emphasizes a key point— the versatility of the adjustment layer-based conversion techniques. You may start off with one idea of how different areas should be rendered as grayscale tones, and then save and close your work, but you always retain the opportunity to completely revise the conversion and the resulting interpretation of your picture.

CREATIVE CONVERSION : PEOPLE

In the previous pages we have looked at today's best ways of converting color digital images to black and white. It's all very well knowing most of the techniques, and it's essential to distinguish the good ones from those that are now largely obsolete. But the art of black and white is not a mechanical process where "best" can be determined objectively. There is no scientifically perfect contrast range or histogram shape. You have choices and creative decisions to make.

There is a lot more to black and white than turning down your TV's color saturation, or pressing an auto button in Photoshop. The mono conversion step is where you make key compositional choices and determine how you want to interpret the digital negative. A number of black-and-white renditions can be made from the same color original, changing the composition of grayscale tones or telling the viewer a different story about what is depicted. To see what this means in practice, let's examine one image, focusing a lot less on the technique and a lot more on interpreting the picture's subject. This is a process I call creative mono conversion.

Left: *The color original shows a well-tanned man with a pale blue shirt, but the conversion only needs to present the viewer with a realistic image—not one that is faithful to the original.*

Above: *The final interpretation of this picture is just one way to depict the subject in mono.*

GRAYSCALE

If you merely want the black-and-white image to represent the original's tone, choose the Grayscale or Desaturation methods. Both methods are quick, and Grayscale produces smaller output files and is the only way to prepare a picture for a true Duotone. Grayscale's rendition is realistic and is close to how the eye captures color (that's the basis for Photoshop's use of 59% green channel, 30% red, and 11% blue).

But more often than not—and it's certainly the case with this portrait—the results are rather flat and lifeless. Do you really want to surrender your creative opportunities?

LIGHTNESS

For inherently neutral results, try the Lightness method. Again, you have no control—you simply choose the command *Image > Mode > Lab* and then delete the "a" channel from the Channels palette. What remains is the image's brightness values alone, and the black-and-white output is unaffected by the colors present in the original; any color information is discarded forever.

The Lightness version is usually the most faithful to the original color picture. Is accurate recording of brightness what you really want to achieve?

These methods share a huge shortfall. They're destructive. While you are still working on the file, you can only fine-tune or reverse them by undoing subsequent work, up to the number of History steps available. Once you save and close the file, the conversion is fixed forever. These methods were fine for an earlier era of computing and in earlier versions of Photoshop. Stick with them if you never change your mind later, but why rule out that possibility forever?

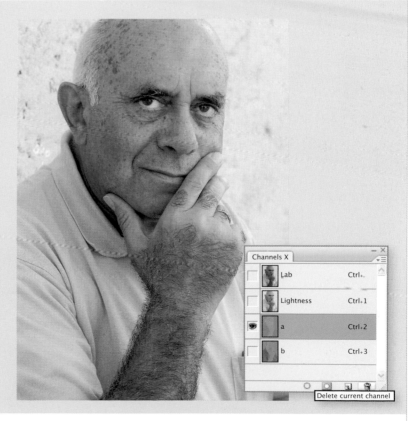

CREATIVE CONVERSION : PEOPLE

Forget for a moment the color image on the previous page, as if you had never seen it, and ask which of these pictures you believe fairly represents the subject. Below sits a dark-skinned man wearing a very light shirt. In the next shot, the man remains heavily tanned, though his shirt is darker, while in the third his face is lighter and less rugged and the shirt darker still. Without the color original, you have no way of knowing which is "true." Each is credible, each tells a different story about the subject.

The only difference between these three shots is the way I chose to set the Channel Mixer, using the Blue, Green, and then Red presets. There's just a single adjustment layer, no masking or different conversions applied to selected image regions, and no Curves or Levels. I could have done precisely the same with the other two adjustment layer methods—Black and White and Film/Filter—which also allow the user to exploit the picture's channel information. It's not the technique that matters so much, it's how you use it to express the image. Photoshop CS3 introduced the Black and White adjustment, which offers six rather than the three tones I've examined here, but these are the primary colors. The principle is to choose which one to emphasize, and the extra three color groups in CS3 are really just a bonus.

BLUE

The pixels which record skin tones have low values in the Blue channel and higher ones in the Red. So if you want to make skin look dark, you might use only the Blue channel values. Add a Channel Mixer adjustment layer, tick Monochrome, and set the Blue slider at 100% and the others at zero. Alternatively, add a Black and White adjustment layer and use the cursor to drag left from the face.

In each case, the Blue treatment darkens skin tone and also reveals more details and blemishes too, so it usually works better for subjects where you're aiming to express age and experience.

Also consider how the image is composed and where the grayscale tones are positioned in the picture. Here the shirt is a pale blue, so its pixels have high Blue channel values, which turn into very light grayscale tones. That may be desirable in some cases. Here, to my eye, it unbalances the picture. With black and white, the viewer is drawn from dark areas to the highlights. Here, attention is drawn to the eyes, which is good, and then straight down to the shirt; less good. A selective adjustment is one possible solution.

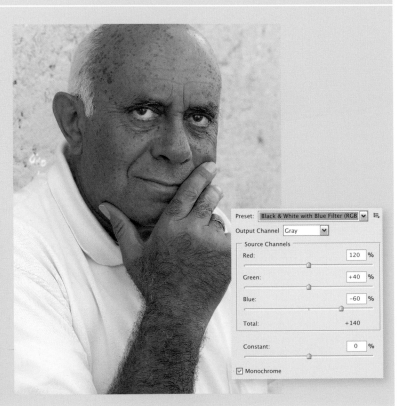

GREEN

Because the human eye records green more than red or blue, you can render the image more naturally by choosing the Green Filter presets in Channel Mixer or Black and White dialog boxes. In Channel Mixer, this sets the Green slider at 100% and the others at zero. With portraits, Green tends to be somewhat average and in this case it is the least interesting or attractive version.

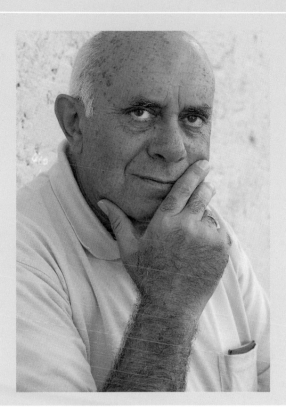

RED

Red channel values are higher in skin tones, so to make them brighter grayscale tones, pick the Red Filter presets in Channel Mixer or Black and White dialog boxes.

The Red Filter style produces softer, more attractive skin tones. Some men may well appear insufficiently butch, too gentle, but it can suit women and children better than a blue-bias conversion.

As well as subject appearance, also consider compositional impact. Here, the blue shirt is now darkened and is hardly noticeable. Again, contrast that to the Blue Filter treatment. On the other hand, if the shirt had in fact been bright red, it would have continued to distract from the face.

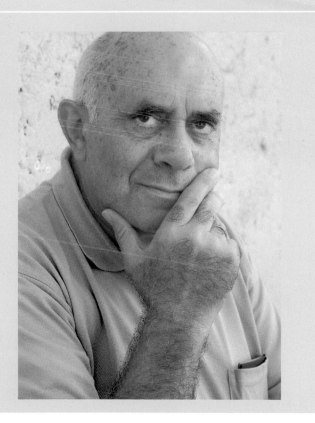

CREATIVE CONVERSION : LANDSCAPES

No book on digital black-and-white photography can avoid providing a recipe for Ansel Adams-style landscapes. Nor should it. Adams himself, who died in 1984, wrote about how much he looked forward to electronic imaging, and his pictures and writing continue to inspire and influence many of today's photographers. Equally, such a digital recipe should not be overblown. Instead, it should be more a starting point for expressing your own style of black-and-white landscape photography.

Above: *If there is a typical Ansel Adams scene, it often contains strong skies with cloud detail, as in this shot from one of his old stamping grounds, Zion National Park.*

Right: *The final image has strong sky details and a landscape full of tonal information. It's the result of using the black-and-white conversion as a key step in the creative process.*

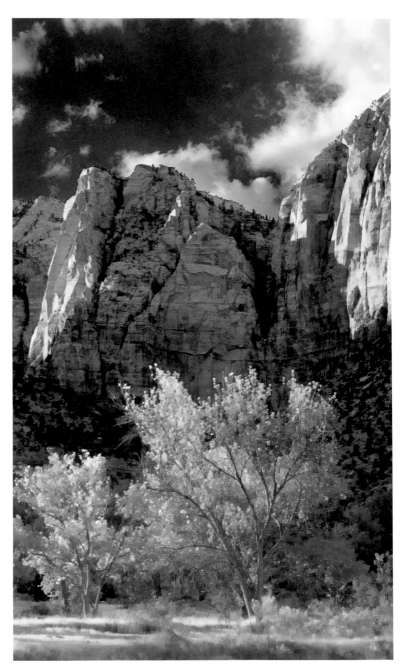

Above: *A simple* Image > Mode > Grayscale *produces a black-and-white image but the result is lackluster. The red rock canyon wall and the trees become similar grayscale tones.*

Above. *The sky contains lots of pixels with high Blue channel values, so Ctrl/⌘+3 shows it as very bright grayscale tones, in fact so pale that cloud detail is greatly reduced. The canyon wall becomes very dark and the trees look dead. So if you wanted to brighten the sky and darken the landscape, you could add a Channel Mixer or Black and White adjustment layer and choose the Blue Filter preset.*

Above: *Ctrl/⌘+1 shows the Red channel. Like the black-and-white film user's red lens filter, this makes the sky very dark and makes the clouds stand out. Both the canyon wall and the trees become much brighter and are separate tones. Pick Channel Mixer or Black and White's Red Filter preset*

1 The hard work isn't applying a particular technique, Channel Mixer or Black and White, or using masks. It's evaluating the picture and deciding how you want to interpret it in your black-and-white composition. Film photographers often tried out different colored filters, attaching them to the lens or sometimes holding them up to the eyes. It's the same thing when you run through the channels with Ctrl/⌘+1, 2, 3, ~ (tilde); you get a good idea of the scene's mono appearance and expose yourself to alternative treatments.

2 So for a typical Ansel Adams-style landscape, add a Black and White adjustment layer and choose the Red Filter preset as a starting point. Then drag the cursor over areas whose tone you want to modify. Here I clicked in the sky and dragged left, making Photoshop darken that area in the black-and-white rendition. The rock wall was then lightened by dragging the cursor to the right in that area.

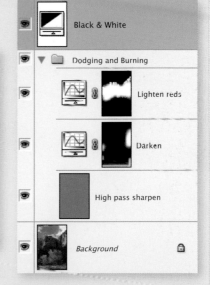

3 Adams was an enthusiastic and highly skilled darkroom printer and was a master of dodging and burning, brightening and darkening selected areas of the print. We'll see how to do this in Photoshop later—for now, notice how the work has been done with Curves adjustment layers and grouped together.

TONAL SEPARATION

We've seen two examples of the kind of creative choices you can introduce during the conversion to black and white. In those cases we focused on interpretation, on why you control the conversion, and how its grayscale output might tell the viewer something about the subject. Each treatment also affected the basic composition—the brightness of the man's shirt unbalancing the image, or the darkened sky drawing attention to the canyon wall and the tree. So, for a third example, let's look at how you might add some compositional creativity, and tonal separation, to the black-and-white conversion process.

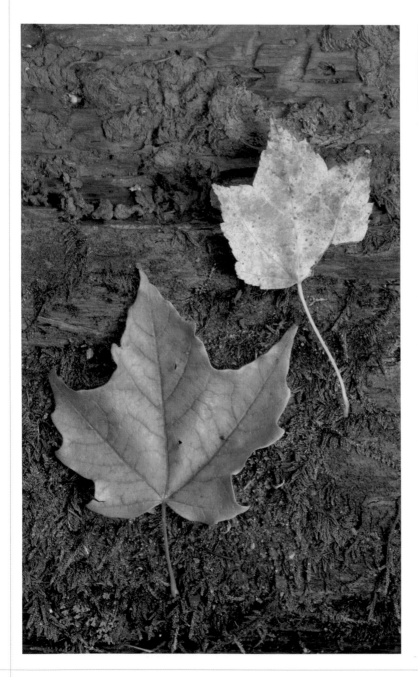

Above: *The original image. The leaves differ in brightness, but an important part of the color composition is the line between the wet bark and the green moss.*

Right: *Any of the channel-based adjustment layers can produce excellent results and let you choose how to compose your black and white. In this final image it seemed important to separate the leaves' tones and darken their background.*

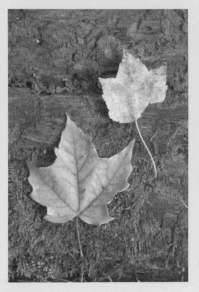

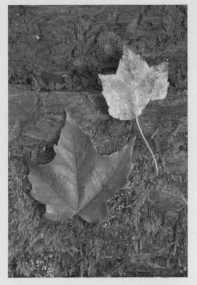

Above: *The Blue channel or Blue Filter presets (Channel Mixer or Black and White adjustment layer) make the leaves look close in tone. Blue values are low in red and yellow. There's a lack of tonal separation that seems to make the composition less interesting.*

Above: *Emphasizing Red in either the Channel Mixer or Black and White Filter shows the viewer that the leaves differ in color. There's not as much tonal separation as in the Green Filter output (right), and notice how the lower red leaf is also much brighter. Is that desirable? There's no simple answer; it's for you—the creative performing the conversion—to decide.*

Above: *In this picture, the Green Filter presets produce the most tonal separation between the key elements of composition. The red leaf is now a lot darker and, since it is lower in the frame, this seems to anchor the picture. Again, whatever your preferred conversion technique, this is where judgement rightly takes over.*

1 It's worth asking why tonal separation plays a part at the conversion stage. After all, switching the image to Grayscale mode might be "good enough," and masked Curves and Levels can "dodge and burn" key features and image regions. Looping through the channels makes it easy to discover alternative black-and white renditions. It's also quicker and more versatile to use the color channels for selective mono rendition than to build masks which target specific areas, and it doesn't leave traces. You can still dodge and burn as well.

The new Black and White adjustment layer is the most interactive of the tools, helping make creative experimentation simple. Start with a preset—I picked the Green Filter—and click and drag the cursor on the image, moving to the right to brighten the area in the conversion, or left, as I am here, to darken the red leaf.

2 One size rarely fits all. While the Green Filter preset worked well for the leaves, I wanted to darken the bark and moss, so I added another adjustment layer and carefully masked out the leaves.

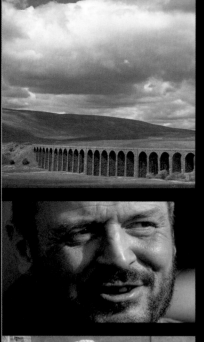

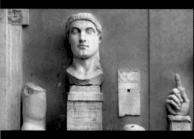

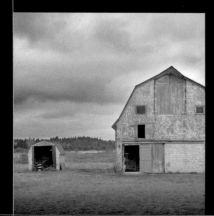
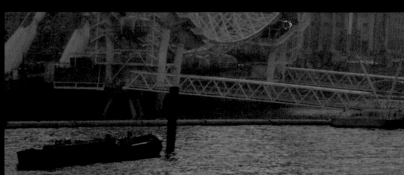

THE DIGITAL DARKROOM 2

FINE TUNING THE PHOTOGRAPH

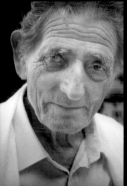
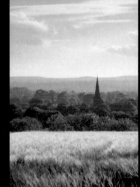

SETTING THE BLACK AND WHITE POINTS

Converting the digital picture from color to mono, and fixing overall image contrast, need to be seen as distinct steps. Without pushing the analogy too far, the black-and-white film photographer chooses a colored filter to control where tones are distributed around the negative, and sets the final print's contrast by picking the right grade of paper.

In the digital darkroom, you don't have just one shot at setting the most pleasing tonal composition and contrast, and there's a very good case for not trying to do so. Contrast may not be irrelevant when you look at the preview and adjust the Channel Mixer or Black and White sliders, but it is secondary to using the creative mono conversion step to compose in grayscale blocks, and secondary to fully interpreting your subject. You can sort out the contrast later.

Not every photograph needs to contain the full range of tones from pure black to pure white, but it certainly helps. So first set the black and white points.

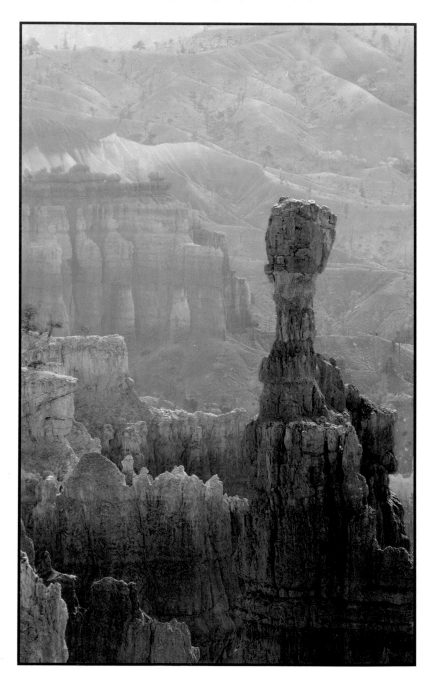

Right: *As well as setting the black and white points with Levels or Curves, a black border helps anchor the tones in the final image.*

TONAL RANGE: LEVELS OR CURVES?

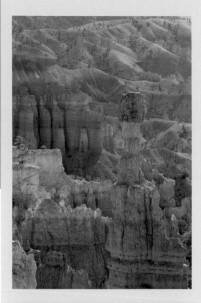

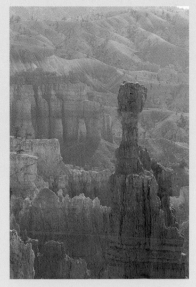

Black & White 1

Background

Above and Left: *Using the Blue Filter preset exaggerated Bryce Canyon's heat haze and, unlike Red and Green, it also separated the hoodoo from the background. Although the overall contrast range was lower, this separation was very important to the picture. Pure blacks and whites can be restored as a distinct step.*

Channel: RGB

Input Levels:

| 56 | 1.00 | 229 |

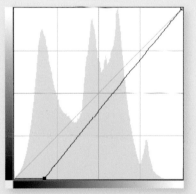

1 Until Photoshop CS3, setting the black and white points meant adding a Levels adjustment layer. In the Levels dialog there is a histogram, and beneath it are three triangles. Drag the white triangle to the left until it reaches the far-right limit of the histogram (the edge of the shape). This makes the image's brightest pixels white. Similarly, drag the black triangle to the right until it reaches the histogram's far-left limit.

2 With Photoshop CS3, you can use the Curves dialog in the same way. As with the Levels dialog box, drag the white and black triangles below the histogram. Because Curves give you so much more tonal control than Levels, it's likely that this will be the better way to work from now on.

3 A helpful tip is to hold down the Alt/⌥ key while you drag the triangles. This works in either Levels or Curves and makes Photoshop display the image in clipping mode. As soon as detail becomes visible, you know the white or black point is mapped to the image's content and those areas are "clipped" and contain no visible detail. Especially with the shadows, a tiny amount of clipping anchors the tonal range, but large areas are generally unattractive.

OVERALL BRIGHTNESS AND CONTRAST

After fixing the image's black and white points, the next task is to review the balance of dark and light tones—the proportions of shadows, midtones, and highlights. Brightness and contrast say a lot about the picture. We talk positively of high-key images and might apply such a bright palette to weddings, fashion, or children. A darker, grittier realism seems more appropriate to photojournalism or reportage images, while a more even spread of tones can suit landscape shots with realistic or natural aspirations.

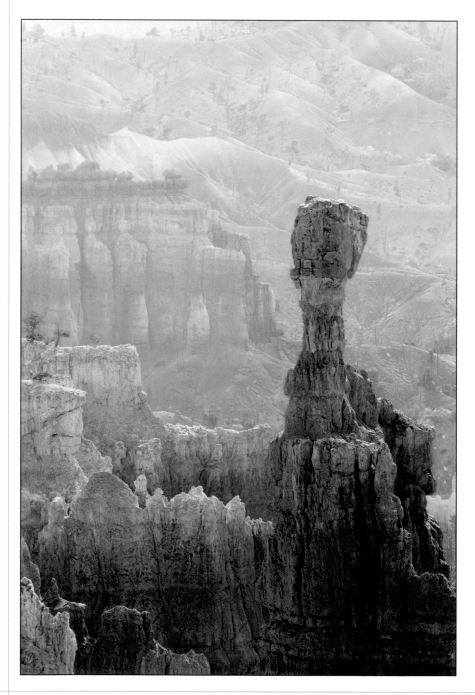

Left: *The final image has a slightly greater contrast and remains high key, but Curves is a very versatile tool, offering very precise contrast and brightness control.*

Above: *After setting the black and white points, you need to assess and set the overall image contrast.*

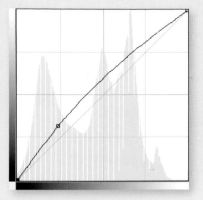

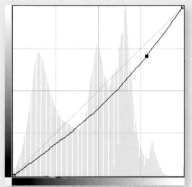

1 To brighten all image tones, click anywhere on the curve line and drag it upward, looking all the time at its effect on the image. An inverted U-shaped curve brightens all tones.

Curves have a daunting reputation but aren't really that difficult; a few tricks can get you a long way. The principle behind the Curves dialog is that the bottom of the chart or X axis shows the brightness values in the underlying image. The curve maps these input values to the values at which they will be output, shown on the left side or Y axis. If the chart doesn't make sense at first, keep an eye on the Input and Output values in the surrounding dialog box. Here a dark gray value of 60 will be output as 80.

2 Darkening the image is done by clicking the curve and dragging it downward. So here a mid gray value of 200 will be output as 180. You could do exactly the same by dragging the top slider in the Brightness and Contrast dialog box, or by dragging the gray midpoint slider in Levels. Curves are much more flexible, as we are about to discover, but for now it's important to remember that a U-shaped curve like this darkens all tones from shadows to highlights.

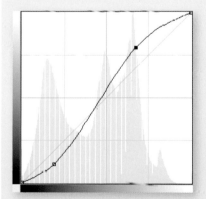

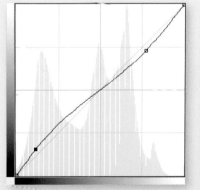

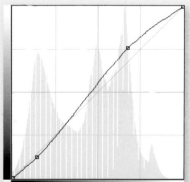

3 Adding contrast to a picture obviously means making the shadow tones darker and the highlights brighter, and the Curves adjustment layer is ideal for controlling this process. Drag down the lower left region of the curve and drag up its top right. Here it is exaggerated, but its characteristic shape means the contrast-increasing curve is commonly called an S curve.

4 A reversed S curve makes shadows lighter and highlights darker, reducing overall contrast.

5 The beauty of Curves is the subtlety you can introduce. The key is to think first in natural terms about what the picture needs—in this case, a very gentle increase in the shadows' contrast and the brighter midtones and highlights to be lifted a little. So here the curve's dip below the diagonal "neutral" line is very brief, and then it runs gently above.

FINE CONTRAST CONTROL

Control of the black-and-white image's brightness and contrast would be a pretty blunt tool if you could only adjust the shadows or highlights as a whole. Some pictures benefit from adjustments that change the character of just the very darkest tones, lifting their brightness so the viewer notices detail in the deepest shadows. The highlights might need to be pulled back a touch so they don't appear featureless; or part of the picture may contain midtones that look too similar, or would look better if they were brighter or darker. Fortunately, once you have got the hang of creating U-shaped curves for brightness control and contrast-increasing S-shaped curves, it's easy to move beyond this and target individual tonal ranges.

Above: *The finished image. The shadows are more interesting than their previous near-black state, while the brighter highlights make the valley seem sunnier. Notice how the sky is much brighter.*

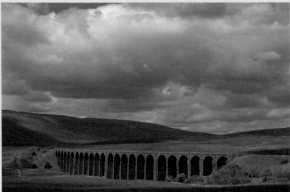

Above and Right: *While the Green Filter preset rendered this landscape as a flat and uninteresting black and white image, the creative mono worker needs to utilize the full range of tones that the image contains. The arches' shadows are too deep, but elsewhere the conversion contains plenty of usable detail.*

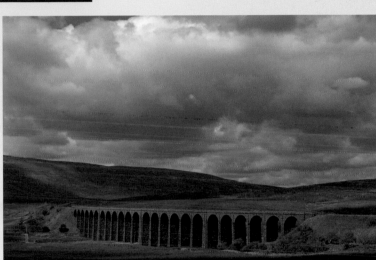

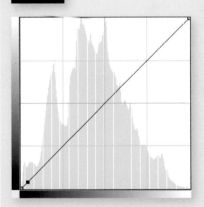

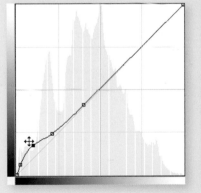

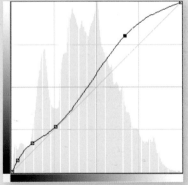

1 The key to fine brightness and contrast control is to move beyond S and U shapes, and add extra points to the curve that identify and target individual tones. Hold down the Ctrl/⌘ key and click the image area containing the tone whose brightness you want to control. This makes Photoshop sample the image and add a point on the curve.

2 You can drag this point immediately or sample other tones from the image and add more points to the curve. Here I initially wanted to brighten up the darkest shadows, but leave the darker midtones and highlights unchanged, so the curve returns to the neutral line after its brief upward movement.

Above: *Curves can control more than one tonal range. As well as lifting the shadows, this curve brightens the highlights but leaves the midtones relatively unchanged.*

ADDING CONTRAST SELECTIVELY

Some pictures only need one contrast or brightness adjustment, but other pictures benefit from more selective application of contrast curves. Although this may seem like a new development, it isn't: as digital loomed over the horizon, darkroom techniques continued to develop and variable contrast papers appeared, enabling photographers to print their work with varying contrast levels in different parts of the frame.

This valley landscape is a good example of where contrast needs to be added in one area of the picture. Even before opening up the arches' shadows, the sky looked relatively light and the image seemed unbalanced. The initial black-and-white rendition was improved by adjusting the shadows, but every photographer has a style to express, and for me this picture was always more about the stormy clouds than it was about the viaduct. Such creative interpretation of the scene often means you need to apply more than one adjustment to its brightness and contrast.

Below: *The sky's contrast is very different in the final version, but this was possible because the mono conversion stage focused on providing a full tonal range rather than on getting overall image contrast right. There was plenty of detail in the sky and this could be exploited to fully interpret the scene.*

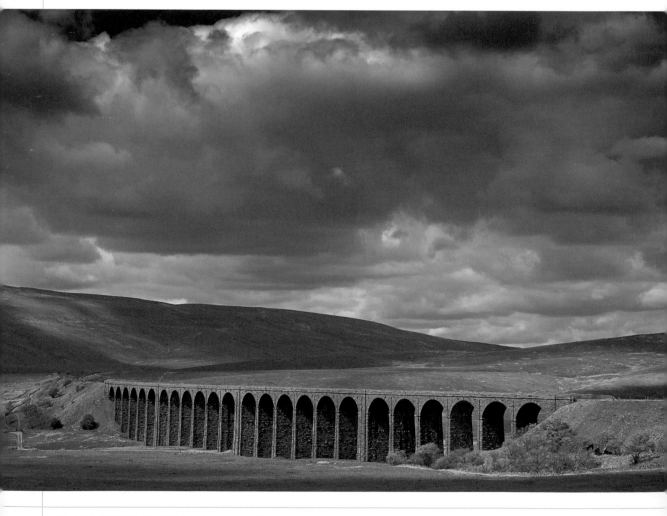

CURVES: WORKING WITH MASKS

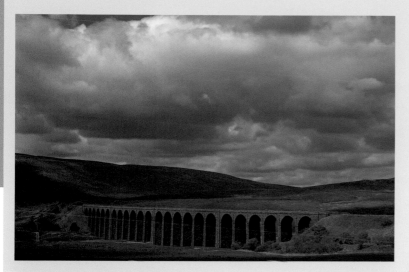

Left: *Compared to the rest of the initial mono version, the sky here was relatively weak, but what was more important was that it contained valuable detail and a complete tonal range.*

1 Add extra Curves adjustment layers to control contrast, targeting each one on specific parts of the frame by painting onto the layer mask. The Gradient tool is useful for this, especially on landscapes with obvious horizons. Click and activate the mask, then draw the Gradient across the image in a long stroke to smooth the transition between adjusted and unadjusted areas.

2 Subtle contrast differences, like dark and light cloud areas, are there to be exploited. Double click the Curves adjustment layer, and, rather than guessing where their brightness values are on the curve, use the cursor and Ctrl/⌘+click each side of the contrast edge. This samples the image and adds points to the curve, which you can then drag apart to increase the contrast between those tones.

3 Use as many masked Curves adjustment layers as you want, using different gradients. Ctrl/⌘+J duplicates an existing Curves adjustment layer, so you can quickly see the result of doubling the adjustment effect.

A good little trick is to switch the Curves adjustment layer blending mode to Multiply. This is like adding two adjustment layers at once and saves on disk space, and you can always use Undo or moderate the effect by reducing its opacity percentage.

LOCAL CONTRAST

Contrast control usually applies to the whole image or to those areas deliberately chosen by the creative photographer. But a more surprising application is local contrast adjustment using a method borrowed from sharpening techniques, and which is sometimes known as wide area sharpening.

The idea is that you apply the Unsharp Mask filter but with settings very different from those needed for sharpening. This provides a contrast boost that is sensitive to the image's contents, and the local contrast increase is subtle enough not to completely distort the picture's overall appearance.

Right and Below: *Wide area sharpening gives the image a contrast boost without unbalancing the picture's overall contrast.*

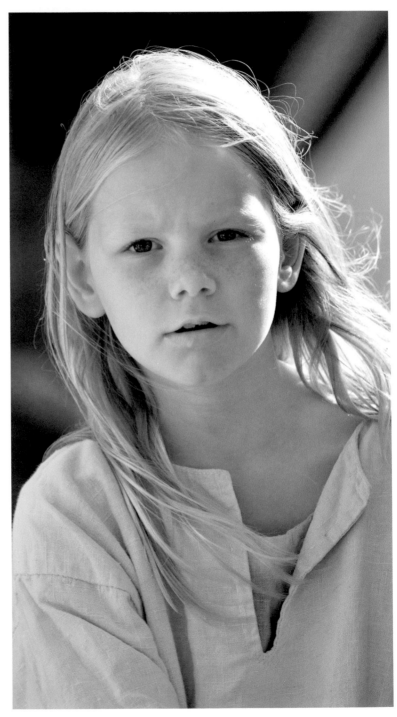

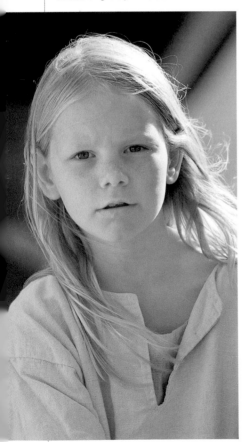

WIDE AREA SHARPENING

1 If you are using Photoshop CS3, wide area sharpening can take advantage of the new Smart Filter feature. Select the merged layer and choose Convert to Smart Object from the Layers palette, or pick the *Filter > Convert for Smart Filters* command. This changes the layer into a Smart Object so you can apply the Unsharp Mask or other filters and remove or adjust them later.

2 If you are using an earlier version of Photoshop, wide area sharpening needs to be applied to an image pixel layer. Duplicate the background layer, or hold down the Alt/⌥ key, and choose Merge Visible. This copies all your work into a single layer. You can always reduce the layer's opacity to moderate the effect.

3 Apply *Filter > Sharpen > Unsharp Mask* and choose values such as 20% for the Amount and 150 for the Radius, but always leave Threshold at 0 so you don't get any artifacts. The required Amount and Radius vary; Amount is more like the contrast strength and 20% is about the maximum, while Radius is the affected area and is dependent on the picture's size and on the details which it will affect.

Wide area sharpening should produce a subtle effect, so it can be a good idea to zoom in or to work in full screen mode (F) and remove distractions such as the palettes (Tab).

CREATIVE CLIPPING

Clipping the highlights or shadows is something you often avoid, but that doesn't necessarily make it wrong. Completely clipped or burnt-out highlights might convey an overwhelming sense of luminosity, while solid shadows can invoke emotions of gloom or make the subject look threatening. You can also use clipping to hide distractions and imperfections. For instance, high ISO images contain digital noise and the shadow areas may be darkened without unduly affecting the subject.

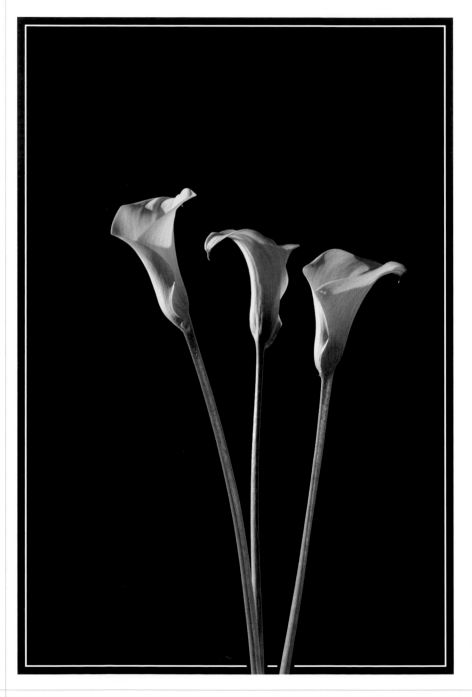

Left: *This image was shot with such strong natural sidelight that a little fill flash was added to balance the flowers' shadows. But the on-camera flash produced shadows of the stems on the background.*

Above: *Clipping the shadows realized this picture's original intention—complete highlight detail in the flowers and a pure black background.*

R :	15/ 3	C :	73/ 75%
G :	15/ 3	M :	67/ 68%
B :	15/ 3	Y :	66/ 67%
8-bit		K :	82/ 90%
		8-bit	

| X : | 22.86 | W : | |
| Y : | 30.65 | H : | |

Doc: 57.4M/57.4M

Click image to choose new color

2 The Info palette is almost as valuable. With the Curves dialog open, move the cursor over pixels in your image and the palette shows their Input and Output values in the RGB section. Here a tone with a brightness value of 15 will be output as 3.

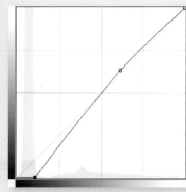

3 To clip shadows aggressively, drag the curve's bottom left point to the right. Here the point has been moved to 27, and Output is shown as 0. This means that any pixels darker than a brightness value of 27 will be output as 0 or pure black.

Hisogram ×

Channel: RGB

Uncached Refresh

Compact View
✓ Expanded View
All channels View
✓ Show Statistics
✓ Show Channels in Color

Source: Entire Image

Mean:	29.30	Level:	97
Std Dev:	34.60	Count:	540
Median:	20	Percentile:	93.66
Pixels:	156816	Cache Level:	4

1 Even when you already have a Curves dialog box open, you can open up Photoshop's histogram and get statistical confirmation of what your eyes detect. Here there's a gap at the shadow end of the chart, indicating that there are no real blacks in the image.

SHADOWS AND HIGHLIGHTS

You can't always shoot an image in such a way that both the shadows and the highlights are captured properly. Sometimes you simply have to choose which is the more important; at other times the most important thing on your mind is to capture the fast-changing action. Bright backgrounds may cause the camera to set the exposure correctly for the background, underexposing the main subject and leaving it dark and unpromising. But when there is detail in the shadows, all is not lost.

There are now a few post processing techniques to deal with underexposed subjects. While you can always use masks and Curves adjustment layers, a group of more automated alternatives simulate the shadow-brightening effect of using fill flash at the time of shooting. A new approach is to use the RAW conversion step and Adobe Camera Raw's Fill Light slider. Another is Photoshop's Shadow/Highlights adjustment.

Right: *Underexposing the subject often works out better than underexposing the background—the camera captures plenty of interesting detail in the background, and Photoshop's Shadow/Highlights adjustment can rescue the subject.*

Black & White 1

Shadow/highlight

Background

1 The Shadow/Highlights adjustment changes pixel values, so always work on a copy of the image layer or convert it into a Smart Object using the command *Filter > Convert for Smart Filters*. As a Smart Object, the original pixel values are retained even when filters or Shadow/Highlight adjustments are applied, so you can always remove or fine-tune those adjustments later.

Shadows
Amount: 50 %

Highlights
Amount: 0 %

2 *Image > Adjustments > Shadow/Highlights* is an "adaptive" adjustment and examines the image for ranges or areas of similar brightness. That's very different from Curves, for instance, which examines and changes each individual pixel separately. So here it will examine the image, find the larger areas of shadow and lift their values.

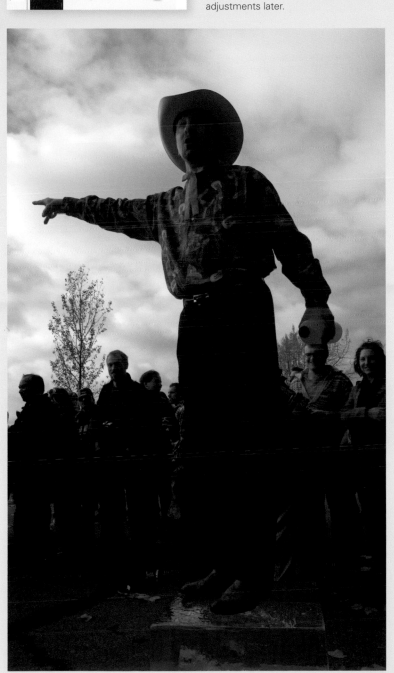

Shadows
Amount: 50 %
Tonal Width: 61 %
Radius: 56 px

OK
Cancel
Load...
Save...
☑ Preview

Highlights
Amount: 0 %
Tonal Width: 50 %
Radius: 30 px

Adjustments
Color Correction: +20
Midtone Contrast:: 0
Black Clip: 0.01 %
White Clip: 0.01 %

Save As Defaults
☑ Show More Options

3 Tick Show More Options in the Shadows/Highlight dialog box and you will have access to even more control over the way Photoshop treats the shadows and highlights.

Left: *When the scene is fast-developing, you don't always get the time to get the exposure spot on. Here the camera exposed for the bright sky and left the subject underexposed.*

CONTACT STRIPS

Darkroom workers calculate the correct brightness and contrast by making contact strips. You cover the photographic paper with a card and switch on the enlarger light for a second; move the card, then switch on the light again, and so on. Eventually you have a picture with a series of graduated strips, each a little darker than the previous one. By comparing the results, you can pick the "right" exposure for the final print. You also gain a good idea of how the picture will respond to alternative exposures, which makes any dodging and burning a much more conscious and creative process.

In the digital darkroom you can gain similar insights by varying an adjustment layer's opacity, by duplicating it, or by switching the layer's blending mode to Multiply or Screen. While these are all valuable, there are times when judging results side by side works better than changing slider values. And in any case you may just prefer to assess the image from contact strips on a test print and get better final results than examining the image on screen. This is a quick method that works not just with contrast and brightness, but with any adjustment layer technique.

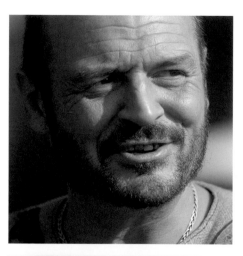

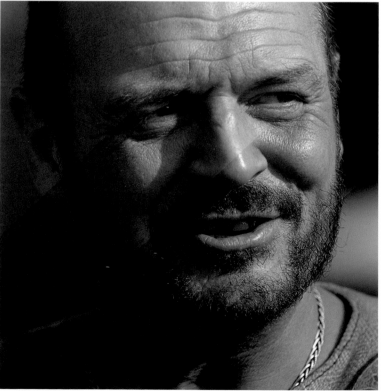

Top Right: *The original image. Portraits of men often look best with relatively high contrast, but it's easy to go too far.*

Right: *The final image. The Gradient tool and the Posterize adjustment were used to create contact strips just like in the darkroom. Seeing the alternatives side by side, you can easily decide which contrast level best suits the subject.*

1 Add an adjustment layer as normal. In this case I was interested in the effect of reducing image contrast, so the curve is shaped like a reversed S. This lifts the shadows and darkens the brighter tones.

2 Make sure the adjustment layer has a mask, and click to activate it. Then pick the Gradient tool (G) and choose a basic foreground to background preset.

3 Paint across the mask in a direction that follows the image's important contents. Here any direction would work, but a left-to-right direction would work better for a landscape, ensuring each of the mask's tones includes sky and land.

4 With the mask still activated, choose *Image > Adjustments > Posterize* and select a value between 4 and 10. This posterizes the mask into a series of strips. Examine the image, decide which treatment works best, and then remove the mask or press Undo to remove the posterization strips.

5 The same technique can easily be used with other adjustment layers, such as during the black-and-white conversion stage. Here my initial thought had been to apply the Blue Filter preset, but I then experimented with Green instead.

DODGING AND BURNING : THE TOOLS

Dodging and burning has always been fundamental to the art of monochrome. Great photojournalists like Don McCullin or Sebastião Salgado had their negatives worked by experienced darkroom printers, and Ansel Adams was just one landscape master who loved to get his hands wet. Lightening or darkening parts of the picture can emphasize some features and subdue others, balance or wholly change the composition, or direct the viewer into and around the frame, all the while rendering an interpretation of the scene that remains believable.

We'll look at the tools of the trade, first at older techniques such as the Dodge and Burn tools and Overlay layers, and then at the more flexible Curves adjustment layers and Masks. But it's one thing to know what the tools are, and quite another to wield them creatively. So the focus will switch firmly to the whys of dodging and burning and to the thought processes you to might want to invoke with your own pictures. It's not going out on a limb to say that dodging and burning are the key to expressing yourself in black and white.

Below: *The original image. Do your black-and-white conversion first, then adjust the overall brightness and contrast before you dodge and burn.*

Bottom: *The final image. Overlay layers increase contrast and your painting should perhaps be more careful than mine—notice the rim of brightness around the roof.*

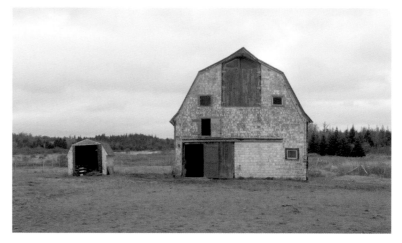

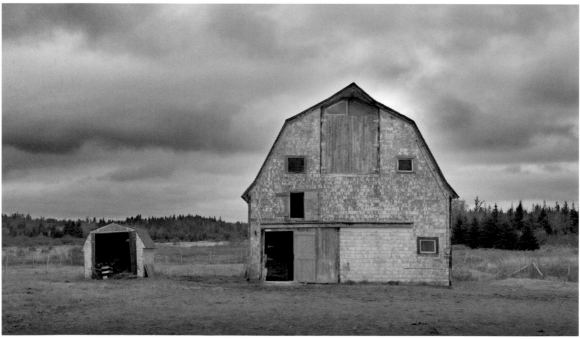

STRAIGHT FROM THE DARKROOM

When new Photoshop users have darkroom experience, they immediately understand the Dodge and Burn tools (O) which in many ways mimic their darkroom counterparts. Select the appropriate tool and then just use it directly on the image.

The Dodge and Burn tools work directly on a layer containing image pixels, something which feels very natural to darkroom enthusiasts. When you activate either tool, its options let you change the softness and size of the tool, rather like varying the tool's distance from the enlarger lens. It's a good idea to reduce the Opacity percentage and build up the effect gradually. You can also target certain tones, so for instance choose Highlights if you want to brighten the whites of the eyes without affecting the pupils.

Over time I've largely moved away from using the Dodge and Burn tools, perhaps just using them for whitening eyes and teeth. Because they change pixel values forever, they are "destructive," and you should always copy your image into another layer if you suspect you will want to fine-tune your work later.

OVERLAY LAYERS

Another venerable dodging and burning technique is to paint on a new layer with its blending mode set to Overlay. As you click the Layers palette's Create a New Layer icon, hold down Alt/⌥, change the blending mode to Overlay, and tick Fill with Overlay-Neutral Color (50% Gray).

This Overlay layer is transparent at first, but you can paint it with the Brush, Gradient, or any other painting tool. This lightens the composite image when you paint with white or a gray lighter than 50% Gray, and darkens it if you use black or a tone darker than 50% Gray. Overlay layers allow much scope for

fine-tuning now or in a later Photoshop session. You can have as many layers as you need, so you might segregate different dodging and burning steps, boost the effect with the Ctrl/⌘+J duplicate layer command, or cut it back by reducing their opacity percentage.

On the other hand, I've also tended to abandon using Overlay layers. Essentially I find Curves and Masks much more convenient. The Overlay blending mode increases contrast and you need to use more shades of gray, then paint around details with various brush sizes and softness. It takes time to produce subtle results.

ADJUSTMENT LAYERS

Curves adjustment layers are the most powerful and flexible way to dodge and burn a picture. They may not feel as familiar to darkroom workers as the Dodge and Burn tools, but Curves can change every brightness level in a picture and control contrast in each tonal range. Adjustment layers don't change pixel values forever, so you can always fine-tune your work later. Dodging and burning is essentially local contrast and brightness control, so you use the same techniques to manipulate the curve.

Photoshop's masks are ideal for performing dodging and burning work, given the ease of painting different levels of gray, or even disabling the mask altogether. Just make sure you're working on the mask layer when you start painting.

Above: *Using the Blue channel in Channel Mixer made the most of the limited color contrast between the wall and the exhibits in the original image.*

Below: *The final image. The more you get used to dodging and burning with Curves adjustment layers, the less you'll focus on the tools. Instead, the important part—how you want to interpret the picture—prevails.*

TOOLS: DODGING AND BURNING

Above: *Increase contrast by making an S curve with the curve's lower left dragged downward and its top left pulled upward.*

Dodging and burning with Curves is really about how you paint the adjustment layer's mask and control where the curve adjustment applies. It's a good idea to start by making a rough Lasso or Marquee selection of the area you want to dodge or burn. Then add the Curves adjustment layer by clicking the icon in the Layers palette. Your selection is immediately converted into a mask.

TOOLS: GRADIENT

An alternative to the Brush is the Gradient (G) tool, which paints a smooth transition onto the mask. Vary its opacity and choose different presets as you need. Another handy control is the blending mode—set it to Darken or Lighten and you can apply multiple gradient fills to the same mask.

Just like working with regular image pixels, you can adjust the mask with filters such as Gaussian Blur. This can be useful if your masking wasn't smooth enough and your dodging or burning adjustment is too obvious. Make sure the mask is active, and then either blur the whole mask or make a selection and choose *Filter > Blur > Gaussian Blur*.

TOOLS: THE BRUSH

The Brush (B) is one of the easiest ways to paint the mask. Use a soft-edged brush and vary its opacity; some people like to set it to under 50% and build up the mask. If you only want to dodge or burn small parts of the frame, it might make sense to fill the mask with black and then paint white over those areas. Conversely, if you want the Curves adjustment to affect most of the picture, leave the mask white and just paint black over those areas where it should not apply.

Above: *Use as many masked adjustment layers as you need to do your dodging and burning work, and use tools like the Brush and the Gradient to paint the masks.*

Equally, you can reshape the masked areas with *Edit > Transform*. This technique can be useful to stretch the mask and spread the Curves adjustment's effect over a wider area.

Or you can select Transform's Warp option and drag the guidelines to reshape the mask. The Liquify filter can be used in a similar way.

DODGING AND BURNING: LANDSCAPES

Part of the art of black and white has always been dodging or lightening some areas of a picture, and burning in or darkening others. At the risk of exaggerating a point, it's worth repeating Ansel Adams's analogy of the print as the performance of the negative's score. Your work can be planned very deliberately, or it can result from intuitive trial and error which can perhaps be rationalized after the event. Usually it's a bit of both.

Right: *To preserve the mistiness of this London scene, I used the Blue Filter preset in the Black and White adjustment layer—exactly how I would have worked with mono film.*

Below: *Lifting the highlights and midtones brings more life to the picture, while diagonally masking the lower third draws the eye across the River Thames to Big Ben and away into the mist.*

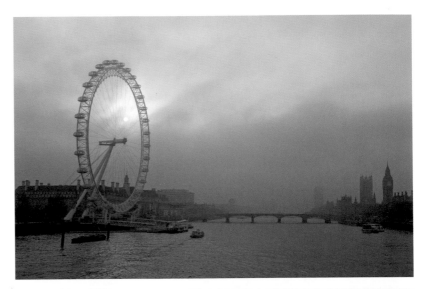

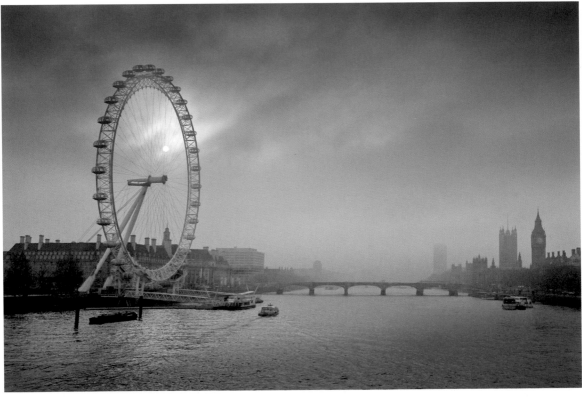

THE THOUGHT PROCESS

By the time I had reached central London to take this shot, the sun was cutting through the morning fog, so to retain the sky's highlight details I underexposed the photograph by 2 stops and left the shadows to look after themselves. The result is that, while the sky contains plenty of interest, the lower third of the frame is dominated by darker tones which make the straight picture feel very bottom heavy. So I needed to lift contrast in the shadow tones and reveal more detail in the lower part of the picture.

I also felt that the straight print lacked compositional direction as well as shadow contrast. At first glance, the picture seems to comprise a heavy lower third of the frame, and the big wheel on the left. My eye then wanders straight up into the sky and away. Most of all, the picture fails to emphasize an important narrative element—it's not just a big wheel, it's that one opposite Big Ben. Darkening the sky, like shooting with a neutral grad, would

top the frame. And keeping the bottom right could lead the eye diagonally from the bottom left, past the wheel, and then across the river to the Houses of Parliament and into the distance.

Highlights must not change

Keep strong

Lead eye into the distance and over to Parliament

Lift shadows

THE INTERPRETATION

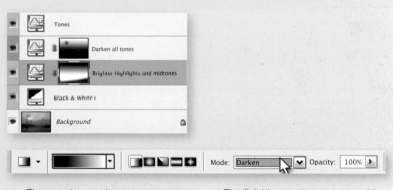

Mode: Darken Opacity: 100%

Most of the work is done with the Curves adjustment layer "Brighter highlights and midtones," which dodges the middle area, lifting the highlights and the midtones. Notice the point to its lower left; I also experimented with a contrast-increasing S curve but ended up with one that simply anchored the strength of the darkest shadows.

The curve's most important aspect is the masking. To protect the lower right and sky, the Gradient tool (G) was much faster than painting black with a brush. Notice how three white to black gradients have been applied: one directly upward, one diagonally to the lower right, and a small one at the bottom left that seals that corner. To paint multiple times with the Gradient filter, change its blending mode in the toolbar to either Lighten or Darken. Setting it to Darken means that it only paints where it will darken the mask.

The finishing touches were to add two Curves adjustment layers. One was needed to burn in the sky and so was limited to the top of the frame by painting the mask with the Gradient tool. As often with landscapes, I started the gradient just below from the horizon, but then protected the sun with a soft black circle. The second layer added the cold blue tone—as usual, setting the adjustment layer's blending mode to Color so it didn't change the brightness and contrast.

DODGING AND BURNING: PORTRAITS

Dodging or burning small features can make a big difference to the final image and can often give portraits that crucial finishing touch. Gently burning in the sides of the face can emphasize bone structure and, perhaps rather like applying makeup, can make the person look slimmer. Meanwhile, toning down a man's receding hairline is another common request. Dodging is every bit as useful, whitening teeth or drawing attention to the eyes while still retaining the photograph's convincingly natural appearance.

Above: *The original image. The Black and White adjustment layer's Red slider was dragged to the right to soften the man's rugged skin tones, but the plain mono rendition doesn't draw enough attention to a face that really is full of character.*

Right: *Dodging the man's eyes and burning in the coat makes the final image a much truer portrait.*

THE THOUGHT PROCESS

From the initial image, it's clear the man is working in a shop or pharmacy or some other environment where a certain amount of cleanliness is required. In fact it was in a food market. While his white coat helps you determine the picture's context, its brightness seems to overwhelm the portrait. First, it tends to pull the eye away from the man's face, the character of which is by far the most interesting part of the shot. Second, the white coat and the shirt's open collar direct the eye downward and unbalance the image, making it top heavy. This image needs the coat to be burnt right down, and the background needs to be toned down at the same time.

With portraits, it's always a good idea to check the eyes. They're usually the picture's most important feature, the first thing the viewer examines, so you would probably have checked their sharpness before you decided to make a black-and-white print. Here, in planning my dodging and burning, what seems important is the eyes' brightness relative to the rest of the picture—the

whites are not different enough in tone from the rest of the face. Just like in the traditional black-and-white darkroom, a little careful dodging can work wonders.

Ear and side of face too light

Both eyes too dark

Background cluttered and distracting

Shirt and coat very bright; they need to be toned down

THE INTERPRETATION

If you're using masks to localize your adjustment work, the order in which you dodge and burn is usually up to you. So I started work by dodging the eyes with a Curves adjustment layer. Dragging the curve upward, roughly at first, I then filled the layer mask with black before using a small, soft-edged brush to paint back the shape of the eyes. Now that any further work wouldn't affect the rest of the picture, or distract me, I changed the curve a couple of times, all the time watching the effect on the image. Don't try to get it right first time—the beauty of the adjustment layer is that you can go back and fine-tune the curve or the mask. In this case I dragged it up a little more until the eyes were nice and bright.

Toning down the coat's pure white was the key to what I wanted from this picture: a portrait rather than a snap of a man in a white coat. So I burnt the coat in with a particular type of Curves adjustment layer. To render whites as midtones, you drag the curve's top right point directly downward. It's a distinctive curve and, as it ruins true whites elsewhere in the image, not one I ever use without painting the mask. Here, I used the Gradient tool to paint the effect in from the bottom of the page, and then burnt in the background by painting white with a soft brush around the man's head. Not all parts of

Above: *Grouping the dodging and burning layers makes it easier to adjust their opacity together and reduce their effect.*

a picture need the same amount of darkening, so notice the mask's upper left has a gray area painted with the brush opacity set to 50%.

DODGING AND BURNING: REPORTAGE

Dodging and burning isn't always about grand changes of emphasis. While a finished landscape photograph might contain an element of performance, there are other times when the photograph would simply be devalued if the viewer felt it had been manipulated in any way. Let's look, for example, at a such a photograph, in this case a reportage shot from Speakers' Corner in London's Hyde Park.

Right and Below: *The basic black-and-white conversion was done with a single Black and White adjustment layer. The Greens slider was dragged to the left, rendering the grass and leaves much darker than in the original image and emphasizing the picture's subjects.*

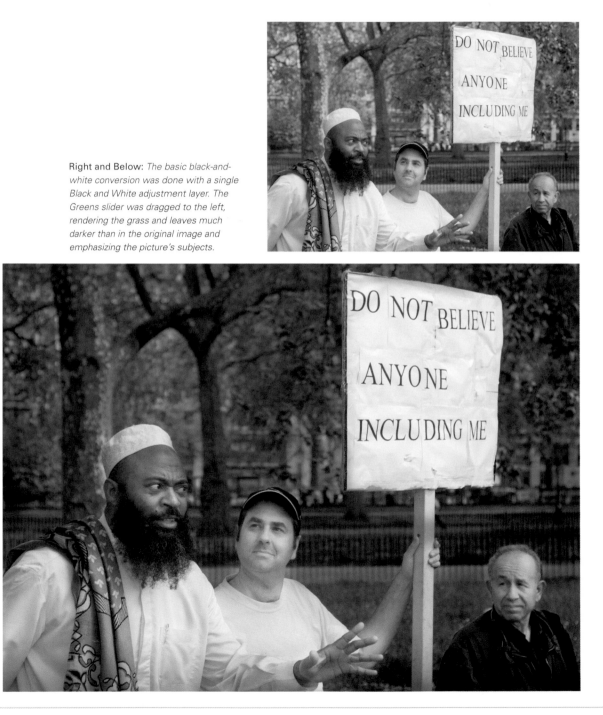

THE THOUGHT PROCESS

As always, step back for a moment to consider how you want to interpret your image. Decide what's important, what isn't, and identify anything distracting.

This picture is clearly about the preacher, his hand gesture, the two listeners, and the placard. They tell the viewer what is depicted, but as well as a simple documentary purpose they also help the viewer navigate the frame. Working from left to right, my eyes go straight to the preacher, then follow the line of faces and loop up to the placard; or alternatively, they follow his hand and the listener's arm up to the placard, and then see the third man. These key features really need to stand out.

The rest of the scene, already thrown out of focus by an ƒ4 aperture, is almost completely irrelevant. But some buildings do seem too obvious in the background, and some contain the highlight tones close to the placard that draw your attention away from it. As well as subduing the background, these highlights need to be toned down.

It's an identical thought process whether you're working in the darkroom or with Photoshop. You have to judge each picture on its merits. Overall, I feel a more subdued background that obscures the buildings will make the subjects sufficiently prominent and also suit the composition. It's a highly subjective decision.

Background needs to be darkened to help the faces and banner stand out

Distracting highlights

Hand needs to be emphasized, so darken the tones around it

Left: *Heavy manipulation of this image would detract from its journalistic character, but subtle changes can enhance the subject and composition*

THE SOLUTION

The dodging and burning is done with a group of three Curves adjustment layers. Don't be afraid to use as many as you need. Each layer's mask was painted with a soft-edged brush. Where the mask is white, the adjustment affects the image. Where it's black, the image is unchanged by the adjustment.

The Darken Shadows Midtones layer (also the Edge Burn layer), is a conventional U-shaped curve. Notice how I've painted on the mask so the faces and the placard are unaffected.

The Darken Highlights adjustment layer is the most interesting and deals with the problem buildings and other distractions. Dragging down the curve's white point, the top right corner, made Photoshop darken the brightest tones until they were no longer noticeable. To avoid darkening the shadow tones as well, I added extra points on the curve and dragged them upward, helping my work blend in. Following that I painted on the mask, targeting just the buildings, paths, and one or two other highlights.

Burning in the background makes the faces and placard stand out, but maintains the picture's realism. In cases like this it's important to maintain the photo's documentary character.

GENERAL SHARPENING

Digital images consist of a grid of usually square pixels and that makes them inherently soft. When the camera stores the picture as a JPEG, it applies certain sharpening settings, but RAW captures are just the raw and unsharp data and so they need sharpening at some stage. This sharpening is an increase in contrast between neighboring tonal areas, the edge's darker side being darkened and its lighter side being lightened, and it's an optical trick that makes the picture appear sharper and more focussed.

Sharpening is a "destructive" process, changing pixel brightness values, so it generally needs to be done late in the editing process—though Bruce Fraser convincingly distinguished between three sharpening phases. First, a little "capture" sharpening may be applied at the start of the editing process—using default values from Adobe Camera Raw, for example. Then there is an optional "creative" phase where you select features like the eyes and sharpen them. Finally, you always need to apply "output" sharpening to the final image that the viewer will examine.

Output sharpening is usually the most important and you need to relate its amount or strength to the final image's physical dimensions and to the resolution of the output device. Whichever sharpening technique you choose, different settings apply to 300 ppi inkjet prints and 1000 by 600 pixel web site JPEGs. The goal is to apply as much sharpening as you can without it being identifiable in the final output. To do this well, you need to understand the basic techniques, how to apply them selectively, and how to make it easy to fine-tune the effect after you examine the final output.

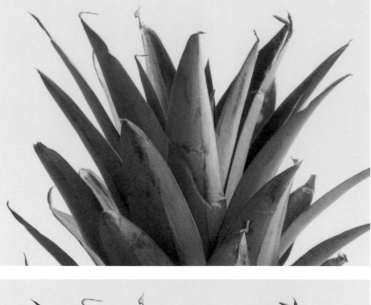

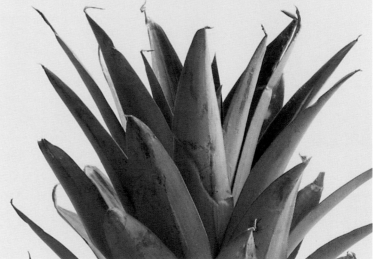

Top: *The original image, like all digital images, is initially soft and needs some form of sharpening. The camera does that for you when it is set to save your pictures as JPEGs, but RAW captures require sharpening in post processing.*

Above: *The sharpened image. Sharpening's effect needs to be judged at the final output resolution. On-screen views can be misleading. For web output, it matters little as the pixel is the final unit, but the final print is likely to be at 300 ppi so needs to be examined carefully.*

UNSHARP MASK

1 Sharpening is inherently destructive and is best done on a copy of the image layer as one of the final steps before printing. This keeps your options open if you want to alter or fine tune your work later.

At that point, there may well be a number of layers— separate ones for retouching, black-and-white conversion, and contrast control, for instance. Before you make a merged layer, hide any layers which might affect the sharpening or which might restrict you.

In this case, some marks on the wall needed cloning away and this work was done on its own layer—which needed sharpening like any other image pixels. Another layer contains a 10-pixel border which would show as a nasty sharpening halo, so that layer has been temporarily hidden. The other layers are hidden because I prefer to sharpen an unadjusted color image—to avoid repeating my sharpening work if I ever produce a color version of the picture.

2 Once you have checked the correct layers are visible, hold down the Alt/⌥key and choose Merge Visible from the Layers palette menu, and make the other layers visible again. Of course, should you decide to do any further retouching after sharpening, you would have to repeat these steps.

3 *Filter > Sharpen > Unsharp Mask* is a well-established sharpening tool and produces great results. For general sharpening for print, choose an Amount between 100 and 200, a Radius of 1–3, and a low Threshold value.

4 Immediately after applying Unsharp Mask to color pixels, choose the command *Edit > Fade Unsharp Mask*, or use the keyboard shortcut Shift+Ctrl/⌘+F. Set the blending mode to Luminosity, and click OK. This quick step makes Photoshop apply the sharpening to the picture's brightness values and not to the color values, and so eliminates the chance of color artifacts becoming visible.

HIGH PASS AND SMART SHARPENING

Building on the "traditional" Unsharp Mask method are a number of newer, and frequently more effective, sharpening methods. Which one you use is, of course, a matter of personal preference, but don't discount them—especially Smart Sharpen—because they're not the most commonly used. A lot of people are just using old books.

SMART SHARPENING

Smart Sharpen is the newest of the main sharpening techniques and combines sharpening and artifact protection in the same dialog box.

On the Sharpen tab, Amount and Radius have similar functions to their namesakes in Unsharp Mask. More interesting is the Remove drop-down box which gives you the choice of counteracting different types of image softness. Gaussian produces results similar to Unsharp Mask, and Motion is geared to motion blur, but the best choice is Lens, which is designed for optical blur.

Choose the Advanced options so you have separate control of sharpening in the highlight and shadow areas. Work first on highlight sharpening, as the brighter details tend to be more obvious than those in the shadows. The key control here is Fade, which is your safeguard against artifacts.

Left: As well as sharpening the church steeple, look out for artifacts such as the mottling in the background. These excessively high Radius and Amount settings have quickly degraded the image.

Right: The key to sharpening is to apply as much as you can without anyone noticing. Unsharp Mask, High Pass, or the newer Smart Sharpen can all produce great results. But always examine the final print and don't rely on your monitor.

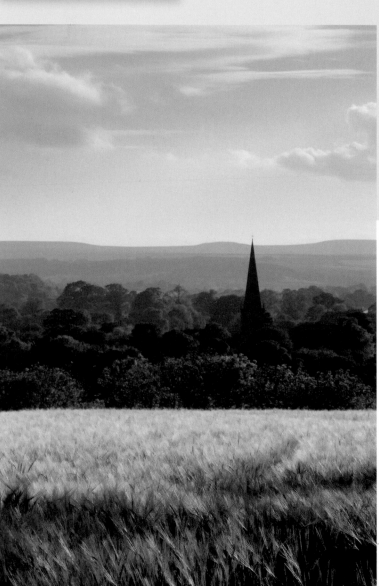

THE HIGH PASS METHOD

The third main sharpening method is High Pass. First, it's very important to set the merged layers' blending mode to one of the contrast-increasing modes: Overlay, Soft Light, or Hard Light. Then choose *Filter > Other > High Pass*.

Hard Pass's only control is the Radius slider, but it produces good, rather aggressive sharpening that is ideal for printing.

SMART OBJECTS

Sharpening needs to be judged by examining the final output, the print or web output. You may not always get it right first time, so it makes sense to keep your options open. Photoshop's Undo function and the History palette are useful enough, but Photoshop CS3's Smart Objects feature is a big timesaver when redoing sharpening would mean hiding and merging a number of layers. It is ideally suited to fine-tuning your work and works with any of these sharpening techniques.

To convert the merged layer into a Smart Object, either choose Convert to Smart Object from the Layers palette's menu, or use the menu command *Filter > Convert for Smart Filters*.

Then apply any of the sharpening filters. If you subsequently change your mind about the effect, just double-click the filter layer in the Layers palette and you can change the sharpening settings.

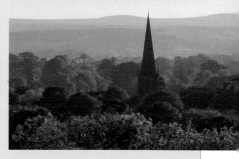

Above: *The Smart Object layer is a merged duplicate of the layers beneath it, so it's always possible to return to the image and make adjustments without having to re-do your sharpening.*

SELECTIVE SHARPENING

Sharpening should never be seen as a standard recipe. You need to examine the inkjet print, web JPEG, or whatever the final output may be, and individual pictures require different degrees of sharpening. A portrait may contain areas of gentle skin tone or a blue sky may contain smooth gradations which require no sharpening. Other pictures may require sharpening in some areas, but not in others, something only the artist can determine. This is what is meant by "creative" sharpening.

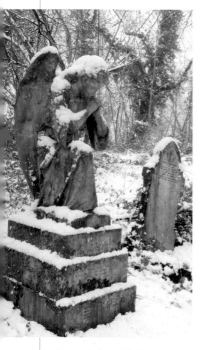

Above: *In the original image a long depth of field has rendered everything broadly in focus.*

Right: *In the final image, the cemetery's background was left soft and unsharpened, as were the less distracting twigs and branches on either side of the monuments.*

Left: *Creative sharpening is all about considering each image on its own merits. This cemetery's background contains lots of small branches, but finely rendering their detail is not necessary. If they were sharpened, they would become more obvious and a distraction.*

1 Instead of applying sharpening to the whole merged layer, you can use the selection tools to identify just those areas which need it. So the sharpening isn't too obvious, the selection's edges need to be softened or "feathered" using Alt/⌥+Ctrl/⌘+D. Or, as shown here, you could paint a selection in Quick Mask mode, blur its edges, and then apply your sharpening to the target area.

2 Layers and masks offer more versatile control. You can target sharpening on certain features, protect other parts of the image, and fine-tune the settings in later Photoshop sessions. This works the same way as with selective black-and-white conversion or dodging and burning, so let's examine a more modern approach using a couple of the latest Photoshop CS3 features.

There are a few tricks going on in this Layers palette. Most of all, the image isn't on a Background layer but is a Smart Object—notice the icon in the thumbnail. The original RAW file was opened via Adobe Camera Raw 4, and I applied the grayscale conversion there.

But more importantly I held down the Shift key at the same time as clicking the Open button. This makes Photoshop "place" the picture as a Smart Object, and has a couple of uses. First, the RAW conversion remains editable—double-click the thumbnail and Adobe Camera Raw reopens. This can be very useful

with difficult RAW conversions, or in this example I could go back, remove the grayscale setting, and then do the mono conversion with one or more regular Black and White adjustment layers. Second, the sharpening adjustment can be added as a Smart Filter which can also be edited or completely removed in the future. For good measure, a border was also added as a Layer Style.

So by using the Smart Object and Smart Filter in conjunction, a single layer can hold the RAW conversion, black-and-white rendition, selective sharpening, and a border. It is all non-destructive so you can reverse or fine-tune every setting. In fact, the Photoshop file actually contains the original RAW image data, so a colleague could change the RAW conversion. While it's not necessarily an approach that one would always recommend, it illustrates the powerful possibilities of a highly versatile way of working.

EDGE SHARPENING

A big danger of sharpening is that it can damage evenly toned image areas. Artifacts may appear, for instance in a child's skin or blue skies, and this is especially harmful if you are working in 8-bit mode or on a JPEG original. Sharpening may also have other undesirable side-effects, such as making digital noise more obvious.

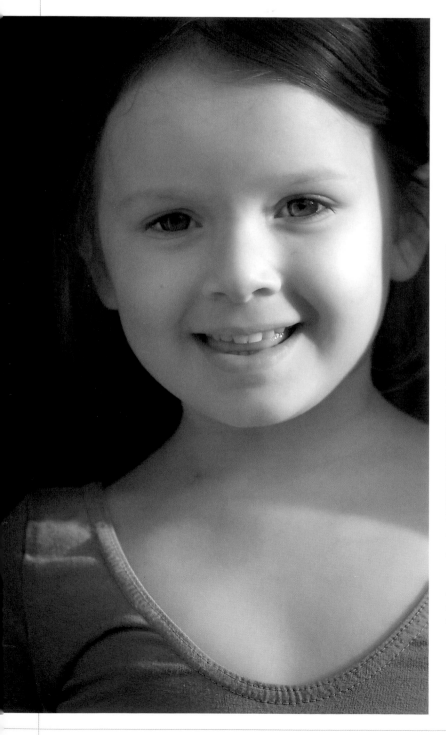

Sharpening is inherently destructive, so it needs to be precisely targeted. The contrast edges are the important feature for sharpening, so if you could select only the image's edges, you could then safely apply much more sharpening to those areas and make the end result look very sharp indeed. This technique is often called "edge sharpening."

Left: *The final image has been dodged and burned a little, and the edge sharpening technique has been applied.*

Above: *At exactly the same zoom level, it is apparent that the original image is considerably softer than the final.*

1 Edge sharpening is a destructive technique that changes pixel brightness values, so make sure you duplicate the image layer first. Then choose *Filter > Stylize > Find Edges*. This converts the duplicate picture into a grayscale line drawing.

2 Because the black parts of the line drawing will be sharpened and white parts will be unaffected, we need to eliminate any gray areas and clean up the whites. To do this, apply *Filter > Blur > Gaussian Blur* with a low value and use *Image > Adjustments > Levels* to make the blacks and whites much purer. You may need to apply each technique a couple of times, and also consider painting the drawing with a soft brush as a way to target or protect selected features.

3 Select just the black areas. Activate the Magic Wand (W), adjust its options to a high value such as 30, and make sure the Contiguous check box is not ticked. Zoom in on a black line and click it with the Magic Wand. To avoid unnatural edges, feather the selection using Alt/⌥+Ctrl/⌘+D. Here I used a value of 5 and switched to Quick Mask mode (Q) to check detailed selections.

TIP

The edge sharpening technique is ideally suited to being recorded as a Photoshop action, but make sure you include enough dialog box pauses and don't just apply the action without creative input.

Below: *The edge sharpening technique has sharpened the eyes without affecting the rest of the face (right). The same Unsharp Mask value is unacceptably sharp when applied to the entire image (center).*

4 When the selection looks right, hide the line drawing layer. Make another copy of the image layer or make it into a Smart Object, and with the selection active, apply the Unsharp Mask using *Filters > Sharpen > Unsharp Mask*. Here I applied a sharpening amount of 500—far more than would be safe without this edge selection technique—and the selection becomes a mask on the image layer.

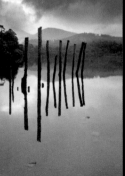

CREATIVE EFFECTS
DIGITAL IMAGE WORKFLOWS

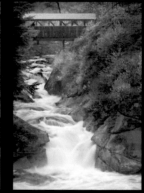

TONING

The art of black and white extends beyond shades of gray, with the very word monochrome meaning one tone but not saying which. Adding a colored tone is a long-established darkroom technique for finishing the photograph and making it express other qualities and meanings. In the digital environment, toning no longer involves often-unpleasant quick-fix solutions, and experimentation no longer carries the risk of ruining your work. With Photoshop, your toning palette has no limits.

Some photographers have a strong preference for tones such as sepia and blues that are familiar from the darkroom. But there is much more to such traditional tones than stubborn conservatism. Blues can convey coldness, while sepias can denote warmth and romance. A subtle brown might mimic a darkroom technique, such as the cyanotype, or the tone may suggest a period of history. A purplish brown or sepia suits 19th century themes yet can look wrong for times before the invention of photography, which we see more through black-and-white lithographs. Non-traditional tones, reds and greens, or primary colors can move the photograph into the realm of graphic art.

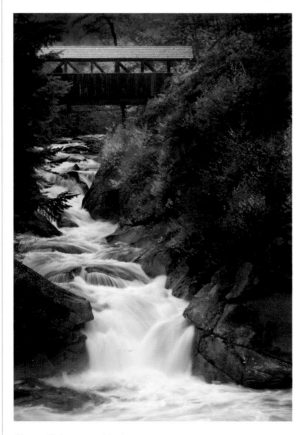

Above: *Before you add a tone, convert your image to black and white as creatively as you can, squeezing out the most detail and the best balance of tones.*

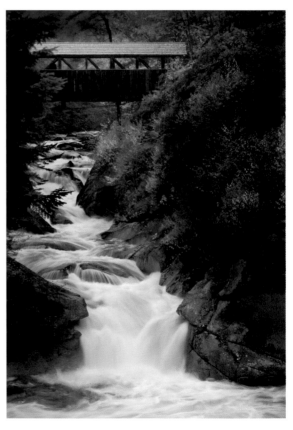

Above: *Using either Hue/Saturation or Photoshop CS3's new Black and White adjustment, a cyan tone can make the image convey a cold, detached feeling.*

1 The simplest way to add a tone is by adding a Hue/Saturation adjustment layer to your black-and-white picture. Tick Colorize, and then adjust the Hue and Saturation sliders. Here I've dragged the Hue into the cyan-blue range and then cut back the tone by dragging the Saturation slider to the left.

2 Photoshop CS3's new Black and White adjustment introduces another quick way to add a tone. Tick the Tone checkbox at the bottom of the dialog box and drag the Hue and Saturation sliders—they work just like the Hue/Saturation adjustment.

1 For more advanced work, it's generally better to separate the adjustment layers you use for the black-and-white conversion from the one that adds the tone. Here, for instance, I wanted to use two Black and White adjustment layers. The Blue Filter preset rendered more detail from the yellowish water—blue being yellow's opposite—while the Green Filter preset revealed more tones in the foliage. Using masks meant I would have needed to repeat the toning on each layer.

2 Using Curves for toning offers the most flexibility and so it is the method I prefer. It's important to set the Curves adjustment layer's blending mode to Color so it targets the image's color and doesn't change its contrast and brightness.

TIP

Whichever toning method you prefer, save a preset so it's easy to apply your favorite tone to other images later.

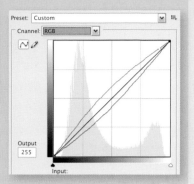

3 Using the Channel drop-down box, drag the Red, Green, and Blue curves separately. Make the tone more red by dragging the red curve upward, and less red by dragging it downward, and adjust the other curves in the same way. Here the particular combination of more red and less blue has produced a cold sepia or brown tone.

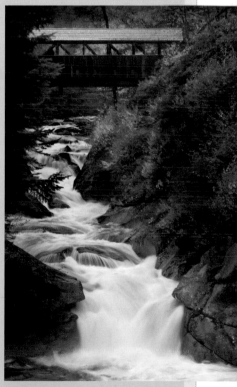

Above: *This cold sepia-brown tone, added with a Curves adjustment layer, gives the picture a historical feeling. A warm sepia would make it look more romantic.*

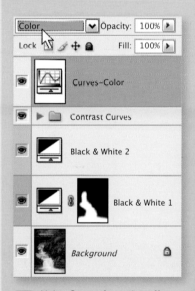

SPLIT TONING

Split toning is adding more than one tone to a black-and-white image. In the darkroom, a print can be taken from one toning solution after only the highlights have been toned, and placed in another solution whose effect first appears in the shadows. The highlights are tinted one color, the shadows another, and the result can be very interesting and attractive.

Photoshop offers a choice of methods. I used to like to add a Color Balance adjustment layer, dragging the sliders to separately color the shadows, midtones, and highlights. Now I prefer Curves for single tones, partly because they make it easier to experiment with split tones, too. You can save your favorite curves as presets, so Curves offer efficiency and consistency gains as well as fascinating combinations of color.

Below: *Before you add a tone, convert your image to black and white and do any necessary dodging and burning. Leave the image in RGB mode.*

TIP

Save your favorite curves as Presets. This makes it very easy and efficient to apply an identical tone to a series of pictures. Save your presets in a folder that is covered by your backup procedures and won't be overlooked when you buy a new computer.

Save Preset...

Load Preset...

Delete Current Preset

SPLIT TONING: USING CURVES

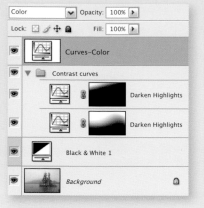

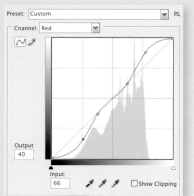

1 Hold down Alt/⌥, add a new Curves adjustment layer, and set the blending mode to Color. This means the Curve will only change the picture's colors, and won't affect its contrast or brightness.

Below: *The final image. Curves make it easy to experiment with split tones—effective combinations can be produced almost by accident.*

2 From the Channel drop-down box, choose one of the channels and drag its curve downward at one end and upward at the other. Here I've dragged down Red's lower left part and pulled up the upper right—this reduces the red channel brightness in the shadows and increases it in the highlights. Initially this produces blue-green shadows and a pink tone in the sky. Notice too that I also added some points and dragged the curve so that the midtones remained unchanged.

3 Repeat the steps on another channel, but this time drag the curve in the opposite direction. You don't have to be too precise—part of the beauty of split toning with Curves is the way you can discover attractive combinations. I wanted to tone the shadows blue and the highlights sepia, so here the combined RGB view shows that I lifted Blue's lower left and pressed down its highlight area.

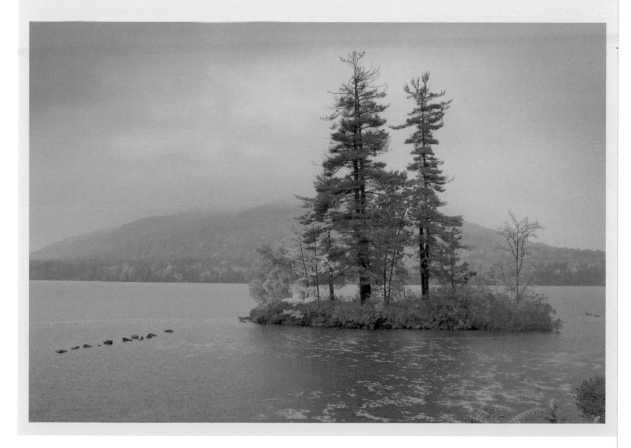

DUOTONES

People sometimes speak of making "duotones" in Photoshop, but you can't always be sure if they are really referring to split toning or are indeed processing an image in Duotone mode. The latter refers to a process in which a grayscale image is printed with two printing plates, and there is also Tritone and Quadtone for three- and four-plate printing.

Though Duotone mode applies to commercial reproduction and presses rather than inkjet printers, some black-and-white workers enjoy, or have grown used to, applying tone with this technique. It has drawbacks, though, not least that Photoshop CS3 requires the image to be in 8-bit mode and that switching an RGB image to Duotone mode will destroy existing layers. So if you've done any work on layers—carefully masked adjustment layers, for instance—save the file and use a duplicate for Duotone work.

Above: *Simple black and white subdued the original image, leaving me convinced that it could be stronger.*

Below: *A cold blue-and-black Duotone reminded me of the bleak, wet day I spent hiking along the coast.*

CREATING A DUOTONE

1 Use your preferred channel-based conversion technique to make your black-and-white rendition, and then save the file or consider working on a duplicate. Working in Duotone will destroy your adjustment layers and any careful masking. In the *Image > Mode* menu, switch to 8-bit mode, then to Grayscale, and lastly choose *Image > Mode > Duotone*.

2 The Duotone Options dialog shows the inks that replace your black and white, listed darkest first, and you can choose various presets by clicking the Load button. After you close this dialog box, choose *Image > Mode > Duotone* again to reopen it.

3 Change the ink color by clicking the colored square to open the Color Libraries dialog, and consider saving your tone as a preset.

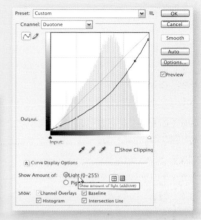

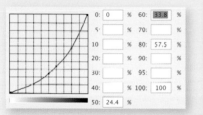

4 You can change how ink responds to brightness values by clicking the chart thumbnail—which opens the Duotone Curve dialog—and dragging the curve in a similar way to the regular Curves dialog.

5 You can add various adjustment layers to an image that is in Duotone mode. Some adjustments are unavailable in Duotone mode, especially those affecting image color.

6 In Duotone mode, Curves are available for contrast and brightness control and for dodging and burning. By default the Curves dialog works the opposite way round to how it works in RGB mode, but if you find this confusing, click the Curve Display Options button and set the display to show Light rather then Ink (or pigment).

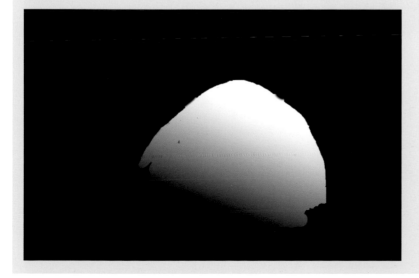

Left: *The Mask Layer (see step 5) highlights the sharp edge of the rock and uses a gradient to softly fade away where the Curve is less needed.*

A MEASURED TONE

When you prepare a collection of toned black-and-white pictures, it can be a nice touch if the tone is consistent. As with most things in Photoshop, there's no single way to do it. When the source tone is in a digital image and was created with an adjustment layer, you can just drag the toning layer from one image to another. If you have flattened the layers in the toned image, or if the source is a scanned darkroom print, try the Image menu's Match Color adjustment. It can work well, though it can be a bit hit-and-miss, and is also destructive, changing the actual pixel values.

A far more flexible method is to measure the source tone and then transfer those values to a Curves adjustment layer. It's not a difficult task. In short, open your source file in Photoshop, make a black-and-white copy of the toned layer, and measure the difference between the toned and the black-and-white layers. Photoshop's Color Sampler tool is the key.

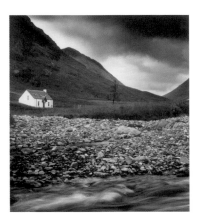

Left: *My tone's source was a 10 year-old darkroom print. Its reddish tone resulted from my choice of paper, developer, and selenium toning.*

Below Left: *My target image was a more recent digital capture that I'd converted to black and white with a Channel Mixer adjustment layer.*

Below Right: *The final digital image now has a tone sampled from a scan of the original darkroom print.*

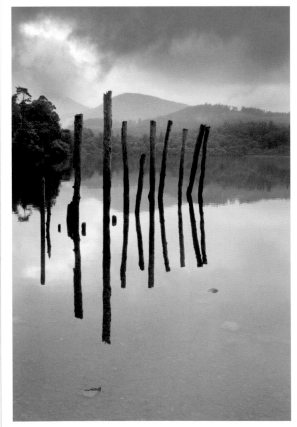

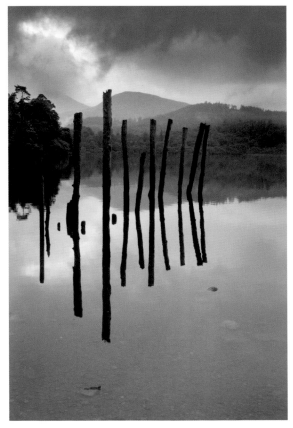

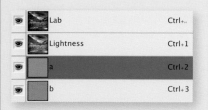

1 Open the source image in Photoshop, check its layers are flattened, and make a duplicate of the image. Change the duplicate image's to Lab Color mode with *Image > Mode > Lab Color*, and delete the "a" channel in the Channels palette. This reduces the duplicate image to its brightness values.

2 Change the duplicate image's mode to Grayscale with *Image > Mode > Grayscale*, and, while holding down the Shift key, drag the duplicate's image layer and drop it in the source image's window so it contains two layers—the toned source and the pure brightness version. You can now discard the duplicate file.

3 Activate the Color Sampler from the Tools palette. Set its options to Point Sample—this lets you mark individual pixels. With the pure black-and-white layer active, zoom in on an area with a mixture of tones, such as the rocks in the stream. You need to see individual pixels—here a 500% zoom was enough—and use the Color Sampler to click pixels with three or four different tones. Click and mark a couple of midtones, a shadow, and a highlight.

MARKER	CHANNEL	BW	TONED
1	Red	19	26
	Green	19	18
	Blue	19	29
2	Red	115	88
	Green	115	86
	Blue	115	91
3	Red	159	132
	Green	159	130
	Blue	159	134
4	Red	217	204
	Green	217	200
	Blue	217	203

Channel: Red

Input: 19
Output: 26

4 Examine Photoshop's Info palette—its lower section shows the RGB values for each marker. Write down the values for each pixel.

5 Hide the pure black-and-white layer and write down the RGB values for each pixel—these will no longer show identical values since the markers are now measuring the toned original. You should now have a little table that compares the black-and-white value to its toned version. If you wish, you can measure more RGB values and extend the table.

6 These values can now be transferred into a curve. Add a new Curves adjustment layer to your target image, select the Red channel, and click the curve. Then type the two red channel measurements into the Input and Output box. Here a brightness value of 19 will be output as 26. Repeat this process for the other markers' red values, adding a point and entering the corresponding values, and do the same for the pairs of green and blue measurements. Click OK. The curve will produce a tone that will often very close to the original, and can be dragged and fine tuned until it's just right.

CLASSIC TONES

Tones can come from a simple decision to make an image a certain color, or just be the happy offspring of experimenting with Curves. But they can also be the result of a more conscious thought process, for instance to add warmth to a sunlit scene or stress the cold of a wintry day. They can allude to older photographic techniques, which perhaps only the initiated might recognize, or, like the classic sepia tone, they can evoke historical periods. Sometimes they are the perfect finishing touch, so here are a few recipes—and, just as important, some of the thoughts that made me apply them to specific images.

PALLADIUM

Until it became much more expensive in the 1920s, palladium was used instead of silver for photographic paper, and some darkroom enthusiasts still use the process. I chose to apply the tone to a statue which belongs to a series erected during that period. Palladium generally adds a soft, warm tone and it might be best suited to expressing more romantic or nostalgic feelings.

Create a palladium tone by pushing the Red channel a little upward on the curve, especially in the highlights, and pulling the Blue channel down across the whole range of tones.

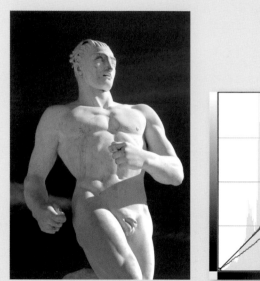

PLATINUM

Platinum was used in another common type of photographic paper that fell into disuse and was then revived as a fine art material. Typically it looks colder than palladium, but that seems to make it suitable for more different types of image—less the warmth of palladium, and much more black-and-white with a twist. I tried applying all the tones to this Venice carnival picture but platinum seemed most appropriate.

Make a platinum tone by adding a Curves adjustment layer and dragging the Blue channel curve down. Push Red up, but only in the shadow tones.

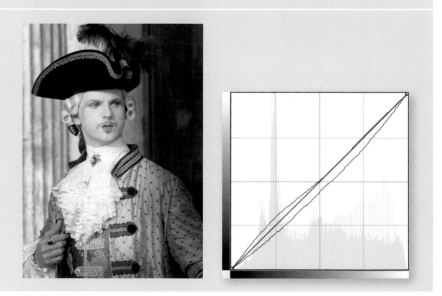

CYANOTYPE

A cyanotype is a 19th century printing process named after its distinctive color. You can apply the tone to try to evoke pictures of the era—still life is good subject material—or you might simply use it to make the scene look chilly. Here I've applied it to a foggy morning scene, taken when such thoughts of stillness and cold were uppermost in my mind, as well as Whistler's nocturnes.

To create a cyanotype tone, add a Curves adjustment layer and drag the Blue channel curve sharply upward, and the Red sharply downward. As usual, set the layer's blending mode to Color.

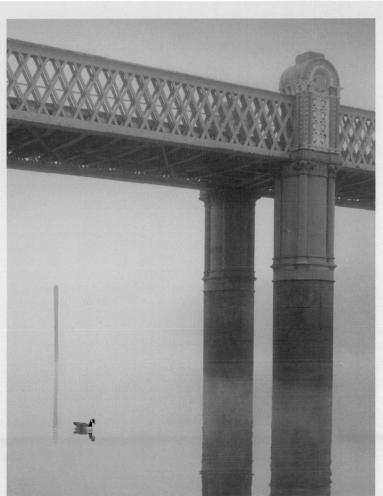

SELENIUM

Selenium is a toner that the darkroom worker can use on a chosen photographic paper and give the print a wide range of tones. The chemical also increases archival life, and was popular in the 19th century. That's why I chose to apply it to this picture; a cold sepia might have worked equally well, but I'd seen some prints in a museum that had this deep purplish brown.

A selenium tone results from dragging down the Green channel, just a little, dragging the Reds up in the shadows, and adding an S curve in the Blue channel.

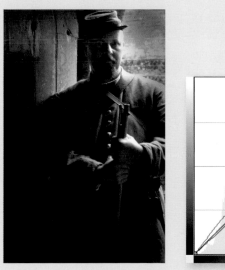

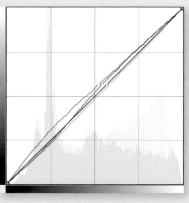

CALOTYPES AND SALTED PAPER PRINTS

The Calotype was one of the earliest photographic processes that permitted multiple prints of the same image. A "paper negative" was usually made by contact printing. This was a process of sandwiching the negative and a sheet of sensitized "Salted Paper," and then exposing them to bright sunlight. In Photoshop they're quick and fun to mimic and can produce striking graphic results.

Above: *The forest is a good place to find the kind of simple objects that were popular subjects for Calotypes.*

Above: *This final image became part of a series, and sometimes I made the leaf into a negative with an Invert adjustment layer.*

CREATING A CALOTYPE EFFECT

Right: *Scan some textured material into Photoshop using File > Import.*

3 You can paint on the picture's mask to make the pictures blend more haphazardly. Here I first used *Select > Color Range* to isolate the leaf. Once the dialog has been invoked, click on the leaf. Shift+click a few more times to be sure—Color Range will add similar colors to the selection.

1 The starting point is a pair of images combined into one layer stack. Here I scanned in some textured paper, opened my leaf picture, and dragged it into the paper's window. I then resized the leaf with *Edit > Transform*, made the image black and white, and adjusted the contrast with a Curves adjustment layer.

Early photographic processes had greater sensitivity to blue light, so skies were recorded lighter and skin tones darker, so for this effect use higher blue channel values and don't make the image too contrasty.

2 The key is to make use of one of Photoshop's most underused but powerful features: blending modes. Changing your image layer's blending mode to Multiply will make the paper layer's texture show through.

Unlike modern photographs, where the image physically lies on the paper's surface, Calotypes formed part of the salted paper.

4 To finish, use a Curves adjustment layer to add a gentle sepia tone, pulling the Red channel curve upward and the Blue curve downward.

HAND COLORING

People have been coloring black-and-white photographs since the 19th century. The print was often prepared by being toned and was then painted by hand with a fine brush, building up the color gradually until a near-realistic color effect was achieved. Even after color processes removed this basic need, the technique remained valuable for its artistic effect, evoking historic techniques, offering an interesting alternative to real-world colors, or sometimes just adding a striking splash of interest.

Starting from a digital color image, there are essentially two approaches. First we will look at what I call "partial conversion," which is selectively leaving some of the original image color in the black-and-white version. Then we'll go a lot farther and manually color a mono photograph—digital hand coloring. And why not combine the two approaches?

MASK METHOD

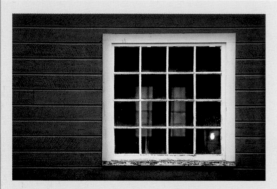

1 Sometimes you've produced your black-and-white image, and spent time dodging and burning, and it still doesn't look right. That was the case with this picture. I felt the weatherboarding and the windows within windows were better in mono, but the overall image seemed less interesting once the table lamp's color was removed and it became just a blob of white. So why not have the best of both worlds?

2 This approach is very easy: just paint the mask of the adjustment layer that converted the image to black and white. Activate the Brush tool (B) and use the [and] keys to set its size, also holding Shift to change its softness. Then paint black onto the adjustment layer's mask. You don't need to be good at painting to do this. Switch to the Eraser (E) or use Undo to correct mistakes. The lamplight fell off very gradually, so I used the Brush at its softest setting and just painted the mask black where I wanted to restore its original color.

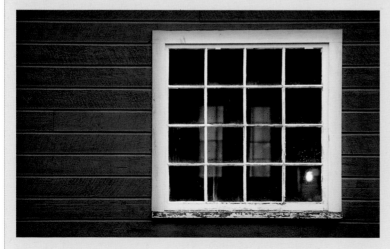

Left: The final image. Paint on the black-and-white adjustment layer's mask and choose where the original color should show through.

HUE/SATURATION METHOD

This method is to convert the image to black and white using a Hue/Saturation adjustment layer. From the Edit drop-down box, choose each color and drag its saturation down to -100. Leave one or two complementary colors set to 0 or above. In this example the Cyans are set to +44 but all others are -100.

Below: *Manipulating the black and white adjustment layer can quickly colorize the image and make a great starting point for adding color manually.*

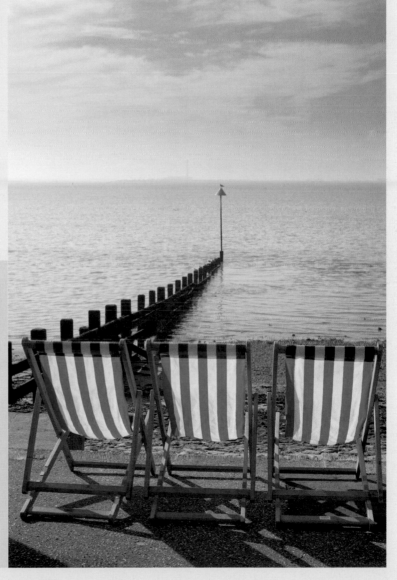

Alternatively, add your favorite black-and-white conversion adjustment layer as normal. Then right-click the layer in the Layers palette, choose Blending Options in the Layer Styles dialog that appears, and select your color from the Blend If drop-down box shown. Drag the Underlying Layer triangle to the left until your color starts to show on the black-and-white picture. The hold down Alt/⌥ and drag half of the triangle away from the other, smoothing the transition between black- and-white and color.

HAND COLORING

As we've seen, you can manipulate the RGB channels during the picture's conversion to black and white, and this is a quick way to produce a mono image with interesting splashes of color. But creating a colorized picture usually means doing a little Photoshop painting. It's not a difficult technique, and can be great fun.

An interesting next step can be applying an overall tone to the image before you begin to colorize any specific areas. A sepia or a blue, even just a faint one, can often form a base that unifies the image and makes the painted color look less artificial. Then paint color on onto a series of layers whose blending mode is set to Color— details show through, but in whatever color you choose.

Above: *Start with your best black-and-white rendition. The setting may be a little drab, but the car is cute and the picture could be transformed with a touch of color.*

Right: *Coloring black and white prints is a technique almost as old as photography itself. Add an overall background tone and as many colors as you want.*

COLOR LAYERS

Hue/Saturation

Color blending mode

1 Add a base tone with a Curves or Hue/Saturation adjustment layer and remember to set its blending mode to Color.

2 To start coloring the picture, add a new layer and set its blending mode to Color so that image details will show through your color. Then activate the Brush tool (B), choose a color, set the brush size with the [and] keys, and adjust its softness with Shift and [or]. Then paint directly onto the layer.

3 If you wish, you can paint other colors onto the same layer, but it's generally best to add a new layer for each color. This gives you more control of each color's strength—you might reduce the layer opacity or apply filters or adjustments to it.

Let's say that you decide you want to change one layer's color. There are a few ways to do this. Ctrl/⌘+click the layer in the Layers palette, which selects only the painted pixels, then press Alt/⌥+Backspace and fill the selection with the current foreground ground. Alternatively, activate the layer, go to *Image > Adjustments* and choose Curves, Levels, or Hue/Saturation, among others.

A more flexible method is to add an adjustment layer immediately above the color layer, and group them together. Add the adjustment layer as normal, then hold down Alt/⌥ and move the cursor over the line between the two layers. Click when it changes to a lock, and the adjustment layer will appear indented and will only affect the color of the layer with which it is grouped.

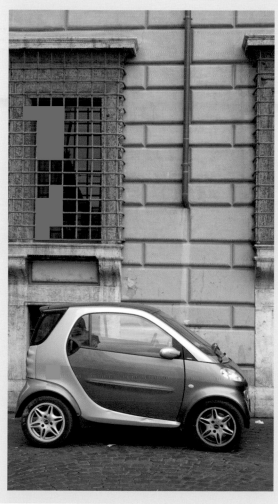

Left: *Compare this version with the final image on page 126. For me, the absence of a background tone seems wrong.*

An alternative coloring method is shown on this Layers palette. Instead of using a standard transparent layer, you add a Color Fill adjustment layer and paint on its mask. The advantage of this technique is that you can change the color very easily—just click the thumbnail in the Layers palette.

INFRARED EFFECTS

We looked earlier at how to capture infrared light with a digital camera, but there is an alternative to the real thing, and that is simulating infrared photography in Photoshop. Faking is usually easier if you start with a shortlist of the key features you want to simulate, and black-and-white infrared film does have three or four main characteristics worth noting. It only captures infrared light, so atmospheric haze is eliminated and clouds stand out clearly against skies that are nearly black. Secondly, because chlorophyll reflects infrared light, foliage such as grass and trees are rendered very brightly and also tend to shimmer. Lastly, the most common infrared film is usually very grainy indeed. So what you need to imitate are the tonality of the skies and the foliage, the shimmering, and the obvious grain.

Many darkroom workers like to print infrared negatives using techniques like lith printing or toning, and such combinations work equally well in the digital environment and are definitely worth trying. Another alternative is hand coloring.

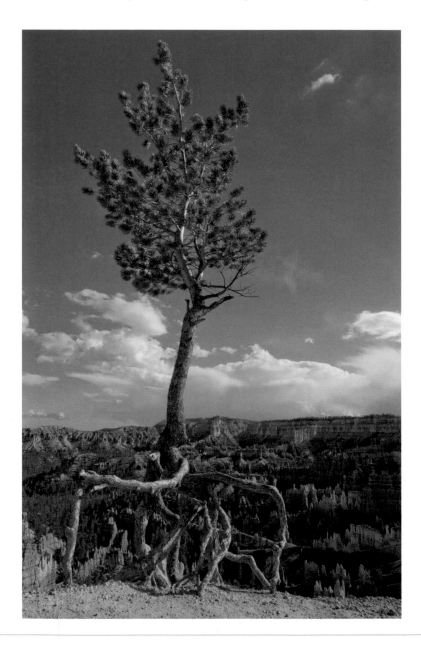

Right: *The original image. Infrared, simulated or real, often suits pictures containing blue skies with puffy clouds, and trees and other foliage.*

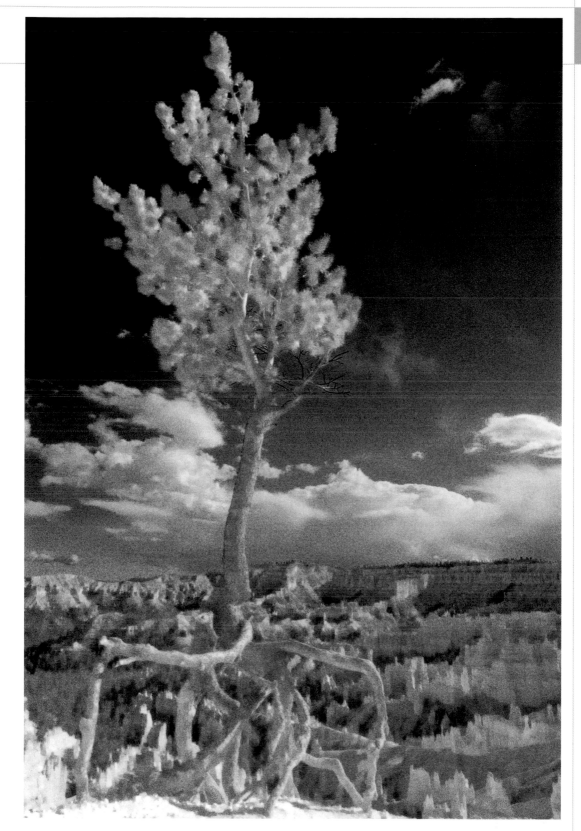

Final Image: *Making the tree's leaves appear bright is crucial to this infrared-style Photoshop treatment.*

INFRARED EFFECTS

BUILDING THE IMAGE

1 Infrared's distinctive tonality is the most important characteristic that you have to mimic. The key is that your black-and-white conversion should darken blue skies until they are almost black, while foliage should appear almost white.

If you have Photoshop CS3, add a Black and White adjustment layer and try the Infrared built-in preset. It renders greens and yellows—foliage colors—very brightly and makes blues and cyans very dark, exactly what we need for simulated infrared.

2 While the preset is a pretty good starting point, fine-tune the settings to match your image. Either adjust the color sliders or drag the cursor across areas of the image. Here the pointer is over the canyon's red rocks, so dragging up or to the right will brighten the reds.

3 Alternatively, add a Channel Mixer adjustment layer. Since Photoshop CS3 this has also come with an Infrared preset. Again, it's only a starting point and I preferred a stronger effect.

I dragged the Blue slider far to the left and moved Red to the right. Notice how all three channels' percentage values add up to 100%.

4 With the key black-and-white adjustment layers done, we now need to imitate the shimmering effect. This happens partly because light bounces off the foliage and partly because infrared focuses at a different point from visible light (this is why some lenses have infrared settings markers).

Remember that we're not rendering greens as very bright mono values because they are green. What's important is that green foliage contains chlorophyll which reflects a lot of infrared light. You don't want other green objects to be unusually bright in black and white, and a similar consideration applies to things that happen to be blue which you wouldn't want to darken as much as the sky. So mask such objects in the infrared adjustment layer and use further adjustment layers to render them at a more suitable level of brightness.

Copy only the foliage pixels to a separate layer, and then apply some blur. You need to activate your color image layer and make a selection of the foliage. While the obvious way to do this is to use the Lasso tool and feather the resulting selection, I prefer to use *Select > Color Range*. That's because infrared is best suited to landscapes and it takes time to lasso all those trees and leaves.

This method works best if you first set the foreground color to a shade of green that matches the foliage. Temporarily hide the black-and-white adjustment layers and use the Eyedropper to and sample a leaf color, then choose *Select > Color Range*. The dialog previews the selection it will make from similar greens in the picture. Add other green tones by holding Shift and clicking the image, adjust the Fuzziness slider, and Photoshop will make a selection that is precise and is already feathered.

5 Use Ctrl/⌘+J to copy your foliage selection into its own new layer. You may have to use a mask or the Eraser tool to remove green objects that don't reflect infrared. Then use *Filters > Blur > Gaussian Blur* to apply a small amount of blur to the layer. You can also reduce the layer's opacity—the effect should be subtle.

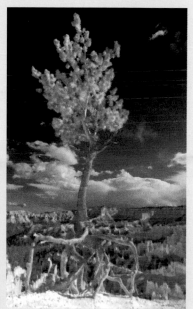

| Overlay: | ▼ | Opacity: | 100% | ▶ |

Lock: ☐ ✎ ✛ 🔒 Fill: 100% ▶

👁 ▮ Film grain

👁 ▨ Black & White 1

☐ ◕ Channel Mixer 1

👁 🌲 Shimmering foliage

👁 🌲 Background 🔒

6 Last of all, add a coarse grain layer at the top of the layer stack. To do this, Alt/⌥+click the new layer icon, set the blending mode to Overlay, and fill it with mid gray. Then set the foreground and background colors to mid gray and black, and apply *Filters > Artistic > Film Grain*. If your image is in 16-bit mode, you may need to create this grain layer in a new 8-bit document and then drag it into your picture. Punchy skies, shimmering foliage, and plenty of grain are typical characteristics of black-and-white infrared.

SOLARIZATION AND THE SABATTIER EFFECT

Solarization commonly refers to the darkroom technique in which a partly developed print is exposed to a flash of light. The development process is then completed and the result is a black-and-white print with partially reversed tones, and sometimes with lines around tonal edges. It is also known as the Sabattier effect and is often associated with Man Ray's work in the 1920s.

It's very easy to mimic the range of solarization effects in Photoshop, and there are numerous recipes in books and on the web. Photoshop itself has a Solarize filter, available under *Filter > Stylize* in 8- or 16-bit mode. It needs to be applied directly to a pixel layer and is "destructive," changing those pixels forever, so work on a copy of the image layer. Either hold down Alt/⌥ and choose *Layer > Merge Visible*, or use Photoshop CS3's new *Filter > Convert for Smart Filters* command to change the image layer into a Smart Object. This lets you reverse any filter operations applied to it. So what's wrong with the built-in version? Nothing much, except it's possible to do better.

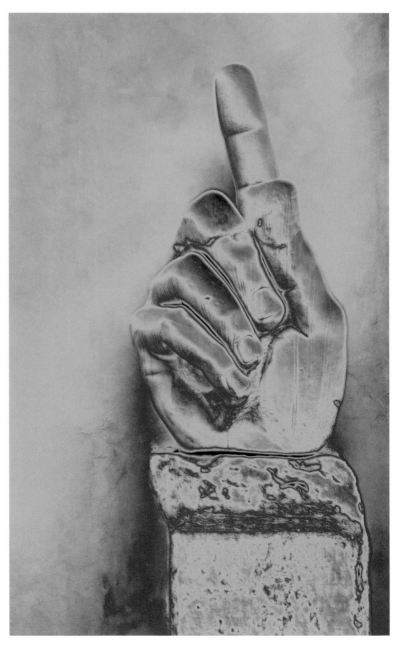

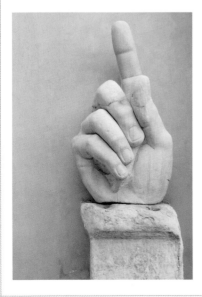

Left: *The original image. Solarization is best suited to pictures with clear outlines.*

Above: *Solarization can be the final step, or you can continue and add interesting tones to finish the picture.*

SOLARIZATION WITH CURVES

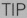 Digital solarization recipes mimic the partial tonal reversals that can be achieved in the darkroom. Since the results vary, it's not surprising to find a variety of approaches. Some of the most convincing are commonly known by their letter shapes—V, W, and M. That's because their underlying principle is essentially the same: to imitate a partial tonal reversal, you partially invert a Curves adjustment layer.

Start with your black-and-white conversion and add a Curves adjustment layer. Drag the top-right corner of the curve downward, and drag a midtone point directly up. That's a V curve, and W and M are variations on the same theme. My own feeling is that the M curve comes closest to what I've been able to achieve in the darkroom, but experiment and see which letter shape works best with your picture.

2 To imitate the lines around tonal edges, you need to add a soft outline to your picture. Make a copy of the image layer, desaturate it, and apply the Find Edges filter so the layer becomes a line drawing. Apply the Gaussian Blur filter and use a Levels adjustment to make the highlights pure white. Then change the layer's blending mode to Multiply. The white becomes invisible and the layer adds its shadowy outline to the composite picture.

As an alternative to the blurred Find Edges method, change the copy layer's blending mode to Overlay and apply the High Pass filter.

TIP

Solarization is an ideal task to record in an action, which reminds you of your steps and makes it quick to experiment on new pictures.

SIMULATING LITH

Lith printing is a darkroom technique in which certain photographic papers are developed in a very dilute "lith" developer to produce distinctive high-contrast prints. Typically there is a strong split-tone effect with the shadows remaining cold and grainy and the highlights becoming very warm, with strong peach and brown tones. The results can be subtle and very beautiful, and lith still holds its own in fine-art photographic circles.

Replicating the three main characteristics of lith printing—contrast, split tone, and grain—is a reasonably straightforward Photoshop task and is also one that is ideally suited to being recorded as an action. The same high-contrast recipe doesn't suit every picture, so as long as you work with adjustment layers, you can quickly experiment with your lith action's effect on other pictures and fine-tune the output later. So first we will look at the mechanics of digital lith, and then consider how the basic treatment works with other types of photograph.

Left: *The original image contains strong patterns, and a nice sense of depth, but lacked much interest as a simple black and white.*

Above: *The finished picture had such high contrast that I felt a strong border was needed to contain the image.*

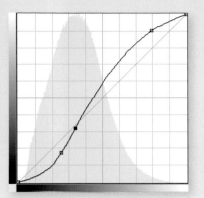

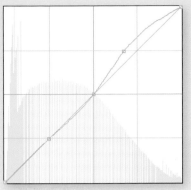

1 Lith prints are characterized by high contrast with harsh shadows, few midtones, and delicate peach and brown highlights.

Make a black-and-white conversion as normal and add a Curves adjustment layer. The curve's exact shape will depend on the image, but in general it should be a steep S curve with its shadows pulled down so they are harsh and high-contrast, and the highlights dragged up and tailing off gently.

2 It's usually better to control contrast and image color separately. Hold down the Alt/⌥ key and add a second Curves adjustment layer, setting its blending mode to Color. This means that the adjustment will only affect the image color and not change its luminosity or contrast.

From the Channel drop-down box, select Red and drag upward at the highlights area, the curve's top right. Initially, this will add red to all the

picture's tones, so restrict the color shift to the highlights by clicking the curve near its midpoint and again in shadow tones. Pull the points down so the midtones and shadows are neutral. Then go to the Green channel and repeat the process.

A realistic lith print tone can range between a warm peach and a cool brown, so there is no formula for how far you manipulate the Red and Green channel highlights.

3 Lith prints tend to contain harsh, gritty shadows, so use your preferred method to add a grain layer. Here I created a new 8-bit blank document that was the same size as my picture, added an Overlay adjustment layer, applied some grain with *Filter > Artistic > Film Grain*, and then held down Shift as I dragged the layer into my picture.

4 Limiting the grain to the shadows is quick, thanks to Photoshop's conditional blending feature, Blend If. Right-click the grain layer and select Blending Options and go to the Blend If area at the bottom of the dialog box. Now drag the Underlying Layer slider's white triangle hard to the left, and you should see that the grain layer no longer shows in areas where the image brightness value lies to the right of the

white triangle. If the image brightness value lies between the slider's black and white triangles, then grain is shown.

Adjust the white triangle until the grain is only visible in the darker shadows. This can create ugly transition lines, so hold down Alt/⌥ and pull the two sides of the white triangle apart. You can now adjust them separately and control how the grain fades away in the midtones and highlights.

ACTIONS

Lith prints vary widely, and it can be tricky to repeat exactly the same effect twice in the darkroom. Equally, while you often end up throwing away many spoiled copies, people do appreciate the differences between individual prints. Photoshop actions make repetition rather too simple, and are always a short step away from applying a one-size-fits-all lith recipe that doesn't respect the actual photograph.

One way to avoid this is to record the action and then edit it so that it pauses at important points. In the Actions palette, click the empty square to the left of the key step and a small dialog box appears. Here I have set the action against the step which adds the color adjustment layer—I might do the same with the step that adds the contrast adjustment layer. When I next run the action, Photoshop will pause and display the Curves adjustment dialog, letting me click OK to confirm the recipe's color, or adjust it and then continue.

Left: *Infrared effects are very suitable to being recorded as an action, especially if you use adjustment layers. Set pauses so you can fine-tune the results each time you play the action.*

USING YOUR ADJUSTMENT LAYERS

An equally good approach is to let the action run, and then take advantage of adjustment layers. Record the action so the contrast, color, and grain are added with adjustment layers, not with the destructive *Image > Adjustments* commands. Play the action on a new image, then double-click the Curves adjustment layers and fine-tune their effect to suit the picture.

You can also vary the strength of the lith tone by changing the adjustment layer's Opacity slider, or further restrict its effect by using the Blend If control in the layer's Blending Options.

Right: *Reduce the layer opacity to change the strength of the tone, contrast, or grain layers.*

Above: *A warm peach seemed wrong for this image—the tail end of a hurricane reaching New England. Reducing the layer's opacity produced a more balanced lith tone.*

INFRARED

For some reason infrared seems especially suitable to a lith finish, and, though it's only anecdotal evidence, a high proportion of darkroom lith prints seem to be from infrared negatives. Two factors may be at work here: infrared and lith share a more graphic appearance than simply realistic photographs, and they are both naturally high in contrast. That's partly speculation, but the infrared-lith combination seems to work well whether the picture is captured digitally or simulated in Photoshop. One thing to watch out for is the contrast— since infrared images are high-contrast, there's less need to introduce additional contrast in the lith effect. So a much less sharp S curve should do the job.

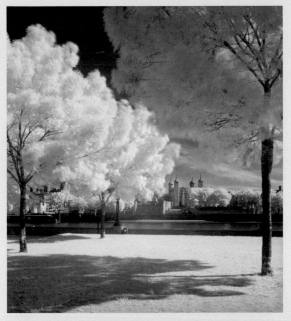

Left: *Black skies and bright, shimmering foliage are sure signs of infrared capture.*

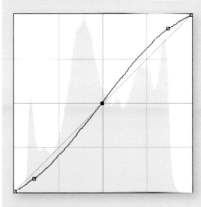

Above: *Infrared images are naturally high-contrast, so your lith effect contrast can be much milder.*

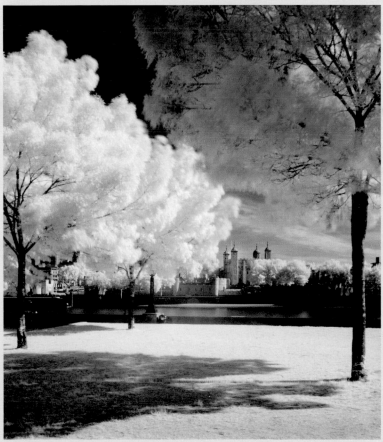

Above: *The final image retains strong, neutral blacks, while the trees and grass contain lots of soft, warm highlights.*

GRAIN AND NOISE

While the best that can be said for digital noise is that it's a small price to pay for the ability to set capture sensitivity on the fly, film grain has always seemed to divide photographers. Some abhor it so deeply they stick to slow film and fine-grain developers—and these pages will not be for them—while for others grittiness is the very essence of black and white. Now, in the digital era, film grain is no longer fixed forever by your choice of film stock. It's simply a creative way to finish the picture.

It's worth thinking a little about why you might seek to degrade the image quality, given the effort you probably put into producing the best possible picture in the first place. For one thing, the subject may itself help you make the decision. A reportage-style picture may be captured digitally but fit better into its intended genre with the addition of grain—for instance, Don McCullin's 1960s photographs of war and poverty have lots of grain. You may want the picture to look less clinical, less perfect than the hi-res digital original. In portraits, such graininess can emphasize character, while some landscapes may benefit from a pointillist-style softness or a coarse quality that matches foul weather. Last but not least, try using grain to add interest to imperfections such as blown-out highlights—or indeed to disguise digital noise.

Below: *In the original image, a Black and White adjustment layer emphasized yellow and green, making the grass lighter and the walls correspondingly stronger. But there's only so much you can do with a foggy December afternoon.*

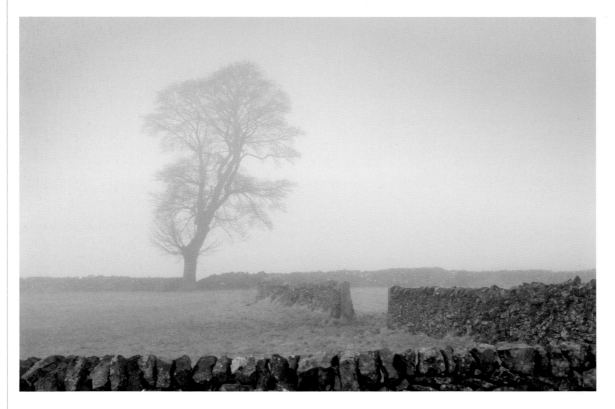

ADD NOISE FILTER

1 It's best to keep the film grain on a separate layer so you can vary its opacity percentage, as well as leaving the picture editable. Hold down Alt/⌥ as you add a new layer, set the blending mode to Multiply, and tick Fill with Overlay-neutral color. Then choose *Filter > Noise > Add Noise*, select Gaussian and tick Monochromatic, and adjust the slider to suit the image.

Alternatively, you could try using the Film Grain filter which is found under *Filter > Artistic*.

2 One problem with grain and noise is they can remove some important details or at least make them less obvious. Here's where the separate layer is so useful—paint on the layer's mask and reduce the grain's effect in those key areas. The Brush opacity generally needs to be set low so you can build up the mask gradually and avoid grain-free patches.

Here I painted the tree and the walls because the tree was already indistinct, and the gap in the stone wall contained interesting gatepost detail. To cover up my work, I also applied some Gaussian Blur to the mask.

3 Noise can be helpful to hide blown-out highlights. Here is a detail from the same shot, although I've crudely increased the exposure in Adobe Camera Raw and made the sky white. It may not be to everyone's taste, but I think adding the noise creates some much-needed detail in the sky.

Below: *Grain and a cold blue tone brought the most out of this gray and foggy landscape. To make the grain more obvious in print, I also sharpened the noise with the Unsharp Mask.*

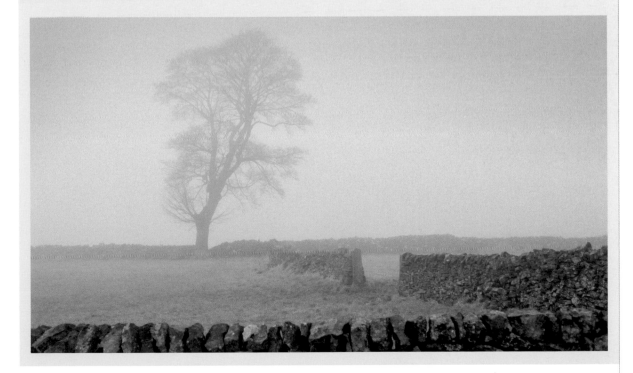

SIMULATING FILM TYPES

One of the most popular Photoshop effects has always been to simulate the appearance of favorite film stocks. You can easily find dozens of recipes in books or on the web that try to give digital color pictures that saturated Velvia look, and you can compare such slide films' typical characteristics by examining actual transparencies on a lightbox or projected onto a screen.

There are also many methods for simulating specific black-and-white films. Some of these involve standalone programs, though the best are usually Photoshop plug-ins that add a command to the Filters menu. It's definitely worth pausing to ask if you're fooling yourself by thinking mono films like HP5 or TriX ever have a "typical" look. The basic choice of film stock is just one variable. That film's color response could be controlled with a colored lens filter, for instance, and its grain character varied with the developer, dilution ratio, and agitation technique. Beyond that even the paper and contrast grade had an effect. In the digital age we need to ask ourselves, "How are we printing this supposedly typical TMax or PanF negative?" To my mind, those are quite big limitations, and that's before we question why we should seek imitate the film medium in the first place. But bearing that in mind, download the plug-in trial versions and decide for yourself.

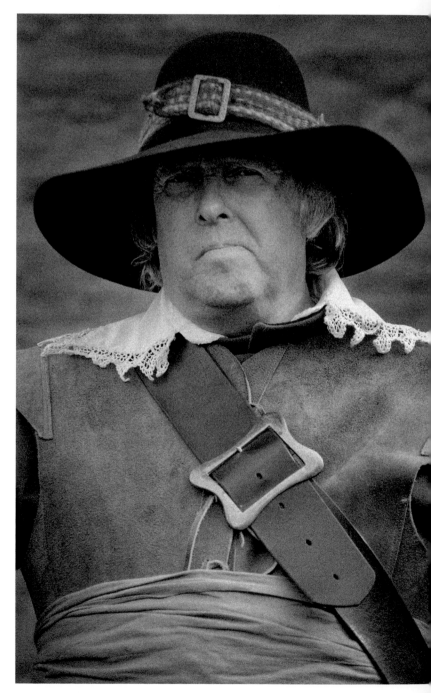

Right: *In a single dialog box, a well-designed Photoshop plug-in like RealGrain can approximate the tonality and grain patterns of various types of film stock.*

USING THE REALGRAIN PLUG-IN

Right: *The colors in the original image are all quite similar. Converting it to black and white can add definition and exaggerate the differences between them.*

3 As well as letting you vary the canned recipe's grain, RealGrain also seeks to mimic the use of colored lens filters. Choosing a filter preset varies how the colors are mapped to black and white, and works in a manner similar to Photoshop CS3's Black and White adjustment.

To me this poses a dilemma: do you want to imitate a film, or do you want the most pleasing black-and-white tonal composition? You'll need to resolve that one for yourself.

Last Filter	Ctrl+F
Convert for Smart Filters	
Extract...	Alt+Ctrl+X
Filter Gallery...	
Liquify...	Alt+Ctrl+X
Pattern Maker...	Alt+Shift+Ctrl+X
Vanishing Point...	Alt+Ctrl+V
Artistic	▶
Blur	▶
Brush Strokes	▶
Distort	▶
Noise	▶
Pixelate	▶
Render	▶
Sharpen	▶
Sketch	▶
Stylize	▶
Texture	▶
Video	▶ Noiseware Professional...
Other	▶ RealGrain...
Digimarc	▶
Imagenomi	▶

1 Let's look at one plug-in that's available for both PC and Mac—RealGrain from Imagenomic. Others to look out for include Alien Skin's Exposure, Power Retouche's Black/White Studio Pro, and Convert to B&W from theimagingfactory.

Like most of these tools, RealGrain is essentially a black-and-white conversion adjustment with grain pattern noise. It isn't an adjustment layer but is "destructive," directly adjusting pixel values, so always make a copy of the image layer first. Then launch the plug-in from the Filters menu.

2 These plug-ins generally let you choose from a list of popular film types and then adjust the grayscale rendition of colors to match the film's typical spectral response and grain pattern. RealGrain mimics color films too, so here I've chosen the black-and-white group and picked the HP5 preset.

4 Another aesthetic issue is that plug-in filters operate on the entire image and there are many instances when one overall conversion isn't the optimum black-and-white treatment. Here the color of the battle re-enactor's jacket is a little too close to his skin tones. Ideally it needs to be darkened to draw more attention to his facial expression, but darkening the jacket also renders the face in darker grayscale tones. To get round this, use masks and multiple image layers.

SIMULATING PINHOLE CAMERA PHOTOS

While some photographers feel the need to own the latest and most expensive equipment, others take equal delight in showing what they can achieve with the simplest and cheapest. Many pinhole cameras are little more than a wooden box with a tiny lens. The resulting pictures can be of good quality, but perhaps the most charming aspects of pinhole images are their imperfections. But all is not always what it seems. Recently I watched an enthusiast circumvent a major landmark's tripod ban by placing a taped-together box (with pinhole) directly onto the ground. It was a bit of a disappointment when I learnt he would scan the resulting negative and finish the picture in Photoshop, but then I thought, why not take a digital capture and make it look like a pinhole camera picture?

Imitating an effect is usually a matter of listing a few key characteristics and then being a little resourceful. The best starting point for a "typical" pinhole image is probably a wide-angle shot with a small aperture and good depth of field. Even better if it has obvious signs of a long exposure too, but blurred motion and vignetting can be added in Photoshop. You'll never fool everyone, nor should you, but it's a fun effect and well worth experimenting with.

Below: *Choose a wide-angle shot with good depth of field. Many pinhole images are square format, so use one which works well with a near-square crop.*

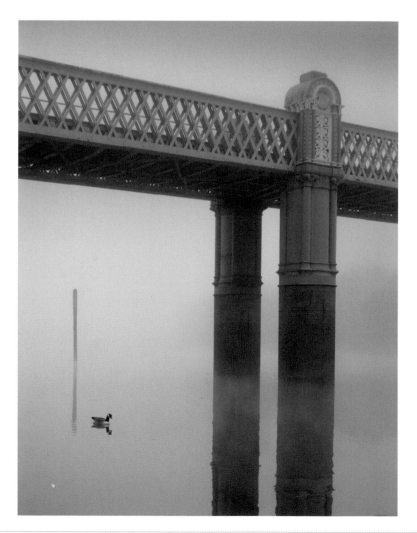

USING SURFACE BLUR

and behind the object, obscuring its shape. While this might resemble a pinhole exposure, it makes my goose an ugly, unrecognizable blob. One solution would be to clone the bird away, or you could restore some detail by reducing the layer's opacity. In this case, I painted black onto the layer mask so that the motion blur was only visible behind the goose.

1 The Surface Blur filter can be useful for eliminating subtle details while preserving larger shapes. In this picture it helps simulate how a slower exposure smoothes the water—notice how the ripples of the post's reflection in the original are gone in the finished version.

2 Less fluid objects like clouds, vehicles, or this goose would have moved during a long pinhole exposure. Try selecting and copying them into their own layer, and then applying the Motion Blur filter.

This filter blurs the selection along the plane of movement, both in front

3 Vignetting is characteristic of many pinhole images. After doing routine dodging and burning, add a Curves adjustment layer and darken the highlights and midtones.

Next, activate the adjustment layer's mask. Pick the circular Marquee tool, hold down the Alt/⌥ key, and drag outward from the center of the image. If you cropped your image into a rough square format, like many pinhole images, also hold down Shift as you drag—this constrains the Marquee to make a circular selection.

Fill the selected part of the mask with black so the Curve only darkens the corners. Then clear the selection and blur the mask—the vignetting needs to remain obvious but blend in gradually.

Left: *I finished this pinhole-style picture by distressing it with a Multiply blending mode layer. The Clouds filter was applied with the opacity was reduced to 10%, retaining that home-brewed quality so typical of pinhole images.*

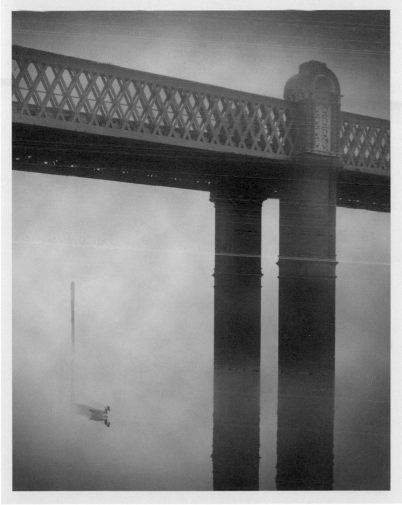

PHOTOREALISTIC LINE DRAWINGS

I've looked many times at the lithographs and woodcuts by great Renaissance artists like Durer, or those of unknown 17th century engravers, and wondered how one might make photographs look that way. While I have a strong interest in photographing historical subjects, you can also see more modern examples of similar, related techniques. A quick search around the house turned up a selection as diverse as computer manual covers, banknotes, and cultural tour brochures, all which use photorealistic line drawings to convey tradition and timeless value.

Reproducing these effects in Photoshop always seemed challenging. They are essentially line drawings with the density of shading built up by cross-hatching strokes. Most modern examples involved the sort of drawing skills few possess—Michael Halbert, for instance, combines scratchboards and Photoshop—and I've balked at buying plug-ins. But the idea has never been far from my mind. Creating a line drawing was an easy step. Bigger obstacles were how to select areas for shading less laboriously, creating line patterns that "tessellated" or repeated perfectly, and how to accumulate or multiply the lines so they could form the cross hatching that built up the shading. I hope you'll agree it's an interesting combination of techniques.

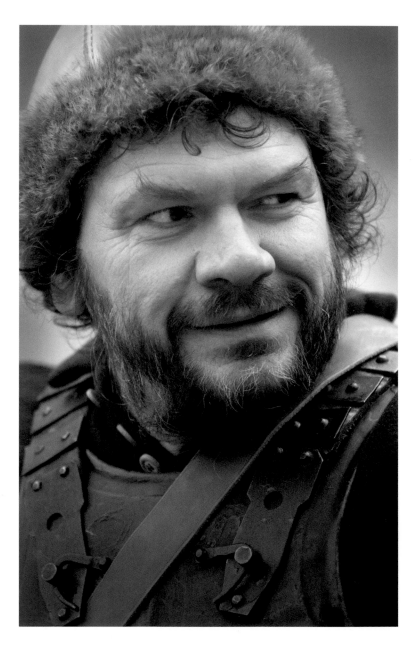

Right: *The first few times you try this technique, use an image with relatively simple detail.*

Far Right: *Once you have constructed the line drawing and added the cross-hatched shading, a nice finishing touch is to manually fine-tune the shading. Activate the Brush tool and paint the layer masks.*

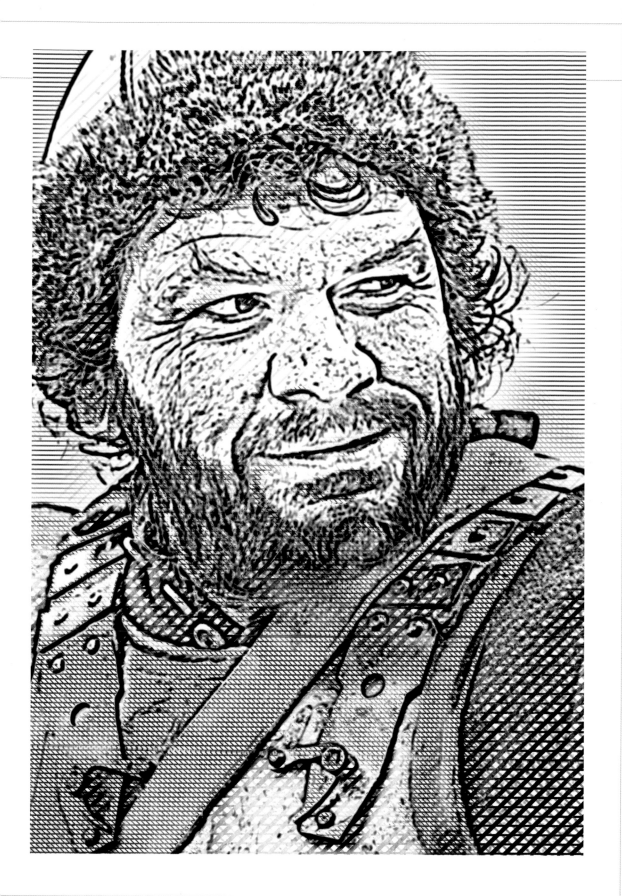

PHOTOREALISTIC LINE DRAWINGS

LAYERED METHOD

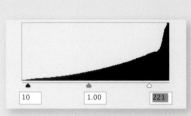

1 The first task is to prepare the edge drawing. Start off with your picture in 8-bit mode, with any layers flattened, and converted to black and white. Create a copy of the image layer using Ctrl/⌘+J, then reset Photoshop's colors by pressing D, and select *Filter > Sketch > Photocopy*. Push the Darkness slider up to the maximum, and then adjust the Detail slider until the layer is rendered as a coarse drawing.

2 The edge drawing will probably contain some small details; these should usually be removed so the image looks less like a photograph. Apply Gaussian blur with a radius of 5-10.

3 Increase the contrast by choosing *Image > Adjustments > Levels* and dragging the white and black points inward. If necessary, repeat the process or use the Eraser tool to remove any distracting detail. Your picture should now have two layers, the original and the edge drawing.

4 Turn now to making the patterns of diagonal and horizontal lines—the key to making the picture resemble an engraving. The most obvious and elegant method is with Pattern presets. Create a small, square document and draw a pattern similar to mine. Notice the two lines, one just in the corner, and imagine how the corners would match up if the pattern were repeated like wall tiles. The goal is to create a tessellating pattern, so it fills an area with matching lines. You could try zooming right in and painting individual pixels with a 1-pixel hard-edged brush.

When you're done, choose *Edit > Define Pattern* and add the pattern to your presets. Create a second, mirror image with *Image > Rotate Canvas > Flip Canvas Horizontal*, and also save that as a preset.

5 Making a tessellating pattern often proves very tricky and, for all the care you take, you can still end up with jagged lines. Test your preset by adding a new Pattern adjustment layer to a blank image.

6 I prefer a more prosaic way to make the patterns. Create a new document that is the same size as your picture, duplicate your image, and delete all the layers. Make sure it is in Grayscale mode, and fill the background layer with a pale gray. Then switch it to Bitmap mode. Set the output resolution to 600 pixels/inch and choose Halftone Screen as the method.

7 Halftone Screen gives a choice of the pattern used to simulate the pale gray as a halftone. Select Line from the Shape drop-down box, and choose an angle—here, minus 45 degrees will produce a diagonal line.

At the same time, set the Frequency—but not too high. A number between 15 and 20 lines per inch will print well with each line being distinct.

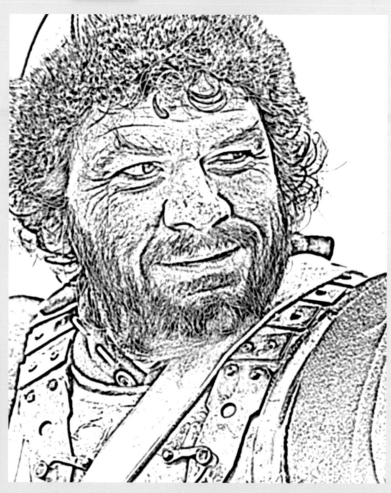

right: *You can make photographs into line drawings with a number of different Photoshop filters. I preferred Photocopy in this case because the results are quite coarse, more craftsmanlike.*

TIP

Once you follow how this technique works, leave the base image in color and keep any conversion adjustment layers. You can then use Select > Color Range *to select individual color areas and vary the cross hatching.*

PHOTOREALISTIC LINE DRAWINGS

LAYERED METHOD (CONTINUED)

TIP

Line patterns don't always display properly in Photoshop if you have zoomed out and made the image fit your display. To check a pattern's true appearance, zoom in to 100%.

8 Then select the entire image and use *Edit > Define Pattern* to save this pattern. You will also need a couple of alternative line patterns, so use Ctrl/⌘+Z to revert to a Grayscale image. Then make it Bitmap mode, but with a plus 45 degree angle. Save the pattern and repeat the process with 0 degrees so that the lines are horizontal.

9 Once you have saved the line patterns, it's time to return to the main image and apply them. First make the Photocopy layer invisible, then reset Photoshop's Foreground color (D), and choose *Select > Color Range*. Drag the Fuzziness slider until the shadows are a distinct, recognizable shape. Click OK.

10 Photoshop now has the shadow tones selected. Hold down Alt/⌥ and add a Pattern adjustment layer, choosing one of your Halftone patterns, and set the blending mode to Multiply, which will make the pattern's white areas invisible. Click OK and Photoshop adds your pattern and turns the selection into a mask.

Left: *Pattern Fill adjustment layer dialog.*

11 The shadows need to be cross-hatched more densely, so add further Pattern adjustment layers using the Minus 45 and Horizontal patterns. Remember to use the Multiply blending mode, too. But instead of creating masks on these layers, hold down Alt/⌥ and click the dividing lines between the three layers—this applies the lower layer's mask to all three. Here I grouped them into a Layer Set.

12 Now lighten the foreground color to a mid gray and repeat steps 9, 10, and 11 for the dark midtones. *Select > Color Range* will make a selection of the base image's mid grays. With the selection active, you then add Pattern adjustment layers. Reduce their opacity percentage—50–60% works well—and consider varying the pattern, perhaps by only using the Horizontal pattern.

Follow the same process for the light grays, using 10–20% opacity. Forget the highlights; the finished picture needs pure white space.

At any time you can peek at how the final picture is building up by just toggling the Photocopy layer's visibility.

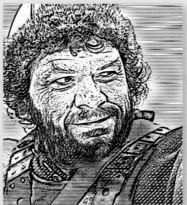

Before *After*

13 Switching on the Photocopy layer's visibility, the result is now a line drawing with cross-hatched areas of tone. The lines can look a little mechanical, so you can paint on the masks to change how the adjustment layers are applied. Or duplicate an adjustment layer and choose *Layer > Rasterize > Layer*, which converts it to a standard pixel layer.

This opens up many possibilities. For example, you can use *Edit > Transform > Warp* and bend some of the lines, use the Smudge tool, or apply a filter to the rasterized layer.

Adding more cross-hatching lines, or increasing the layers' opacity, doesn't really reflect how lithographs use wider lines to darken the shading. To do this, press the keyboard's Up and Left arrows and nudge the rasterized layer a few pixels upward and left. Four or five pixels is enough. Don't let a gap appear between the lines.

SOFT FOCUS

Many darkroom enthusiasts fashion a variety of tools to add soft focus to their prints. Often these are as simple as shrinkwrap stretched over an old picture frame which you hold between the enlarger light and the print, just moving the tool gently so you avoid any telltale shadows. In the digital era the tools are more sophisticated. They are so numerous, and the effects so varied, that you need to develop good habits to make experimentation easier and more productive.

Soft focus has many uses. It might give a picture a romantic, dreamy, or Impressionistic appearance. With portraits, you may wish to hide imperfections in the skin or simply soften their appearance, in the same way as manipulating the channels in the black-and-white conversion. Equally, low key images can be made more gloomy and menacing when the details are indistinct. And let's not forget that adding soft focus later can disguise the fact an original image wasn't completely sharp.

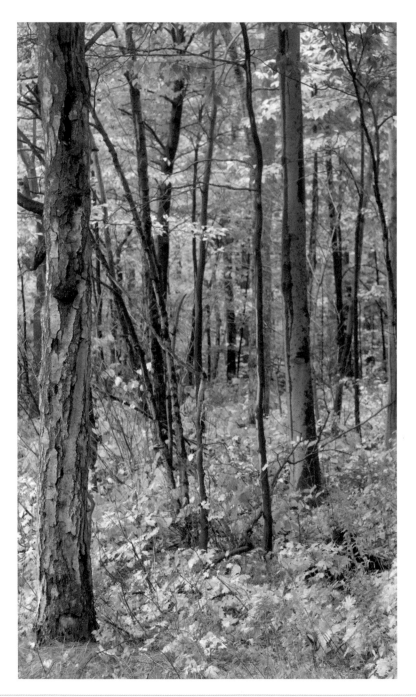

Right: *The original image is not entirely sharp, and lacks any real distinction.*

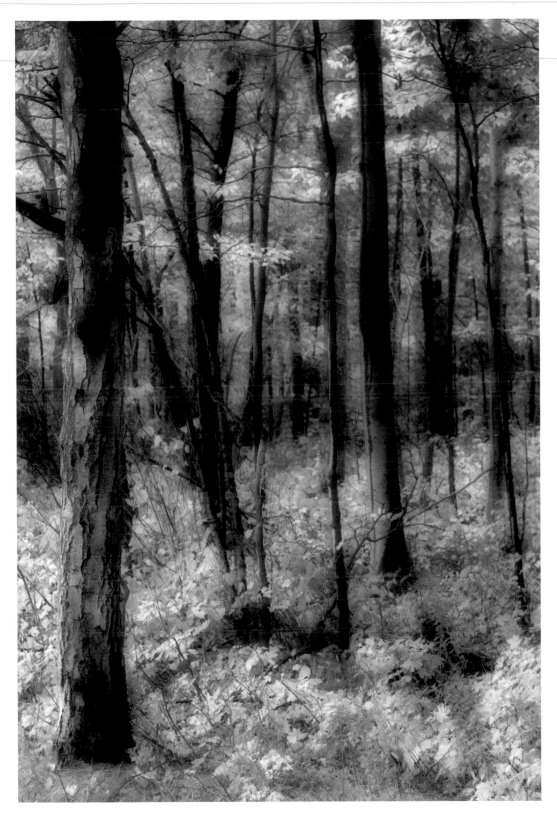

Above: *The soft-focus effect in this final image has obscured the original's lack of pin-sharp focus and given it a dream-like fairytale atmosphere.*

SOFT FOCUS

SELECTIVE SOFT FOCUS

2 Since Photoshop CS3 it has been possible to convert an image layer into a special type of layer called a Smart Object. This allows you to apply a filter to the layer and re-run it later with different settings. Choose *Filter > Convert for Smart Filters*, and then apply Gaussian blur or any other filters. To adjust the results, just double-click the filter's icon in the Layers palette.

1 Before Photoshop CS3, it was always best to work on a copy of the image layer. You could then add soft focus with *Filter > Blur > Gaussian Blur*, and fine-tune the effect by changing the layer's opacity percentage or removing the layer completely.

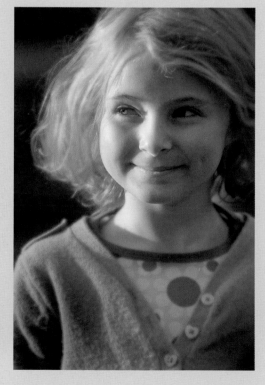

Right: *Only the girl's face has been left sharp. This was done by painting on the Smart Filter's mask.*

While a completely blurred image may sometimes be the intention, it's more common to let some of the original detail appear more distinctly. One way is to paint on the Smart Object's mask, removing blur from a subject's eyes, or you can reduce the blur layer's overall effect by reducing its opacity percentage in the Layers palette.

Multiply ▼	Opacity: 100% ▶
Normal	
Dissolve	Fill: 100% ▶
Darken	
Multiply	
Color Burn	
Linear Burn	
Darker Color	
Lighten	
Screen	
Color Dodge	
Linear Dodge (Add)	
Lighter Color	
Overlay	
Soft Light	
Hard Light	
Vivid Light	
Linear Light	
Pin Light	
Hard Mix	
Difference	
Exclusion	
Hue	
Saturation	
Color	
Luminosity	

3 Less obvious is what you can achieve by changing the layer's blending mode. Try Screen with high key pictures. This lightens the resulting image, though blacks are preserved, and you may want to add more Curves or Levels adjustment layers to balance the tones. The results tend to be more gentler and more dreamy.

Below: Changing the blur layer's blending mode to Multiply makes the picture look more low key and gives it a mysterious feel.

Above: *Soft focus works best when it applies to selected image areas. Here it has been restricted to the darker areas by using layer Blending Options.*

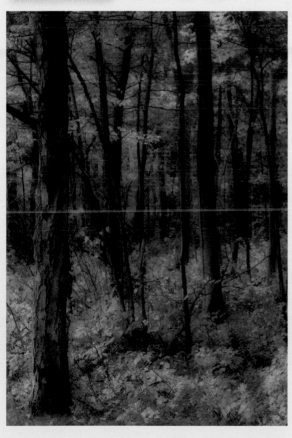

4 As well as changing the opacity percentage and adjustment layers, another option is to restrict the blur layer to certain tones by using the Blending Options (under Layer Styles). Here the blur layer's effect is only going to apply to tones between the Blend If slider's black and white triangles. Use Alt/⌥ to drag either triangle apart and smooth the transitions.

PRESENTATION
AND **OUTPUT**

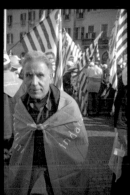

BORDERS

Particularly with a black-and-white print, the highlights can often be very close in tone to the paper and those around the picture's edge easily bleed out and merge with the surrounding white space. Examine the two images on the facing page—the bright clouds at the top left make the borderless image look very ragged. If the picture is framed and mounted, the matte can help hold the viewer's eye within its rectangular format, but not always. Moreover few of us frame every picture.

One obvious solution is to add a border and the example here shows how neatly a border can contain the picture's contents. As with most things in Photoshop, there are good and bad ways to do it.

Below: *Adding a border isn't the only solution, but it holds the viewer's eye without becoming a distraction.*

Opposite: *With no border, there is little difference between the highlights in the picture and the paper. This is especially damaging at the top left.*

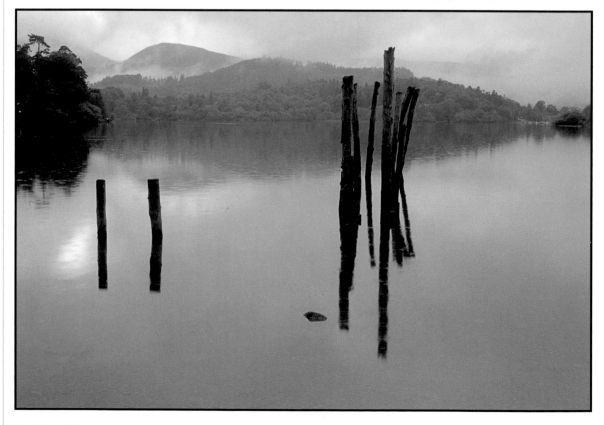

ADDING A BORDER

1 Avoid adding edges directly to image layers. Instead, add a new layer beneath the original and increase the overall image size using the *Image > Canvas Size* dialog.

Now reselect your image layer, which will have some surrounding transparent pixels, and, using the Blending Options (accessed via the "ƒx" button in the layers panel), choose Stroke. Choose a color for the border and set the position to Outside to avoid obscuring any pixels of the artwork.

2 You should usually add a border layer as one of the very last steps before the picture goes to the printer or the web, generally after running any sharpening actions or plug-ins which often work on a pixel layer created by merging the visible layers. Here, for example, the High Pass sharpening has also sharpened the border and produced a light rim. So either switch off the border layer's visibility before running such sharpening processes, or add the border afterward.

▼ Border 10 pixels
 ▼ Make layer
 Using: layer
 Name: "Edge"
 Mode: Multiply
 With Fill Neutral
 ▼ Set Layer Styles of current layer
 To: Layer styles
 Scale: 100%
 Stroke: stroke
 With Enabled
 Position: inside
 Fill Method: Color
 Mode: Normal
 Opacity: 100%
 Size: 10 pixels
 Color: RGB color
 Red: 0
 Green: 0
 Blue: 0

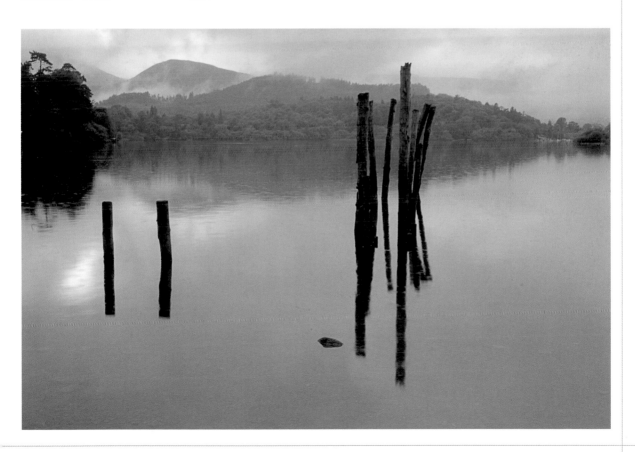

DECORATIVE BORDERS

Many photographers like simple borders, others none at all, while some prefer something fancier—if not all the time then at least for one-off specials. In the darkroom this often meant plenty of trial and error, and ruining perfectly good prints, but with Photoshop there is so much freedom that one regularly sees gruesome border effects proudly displayed. I won't altogether exempt those on these pages—after all, taste is individual—but what's more important is the underlying method and knowing how to use the style of decorative border that looks right with your images.

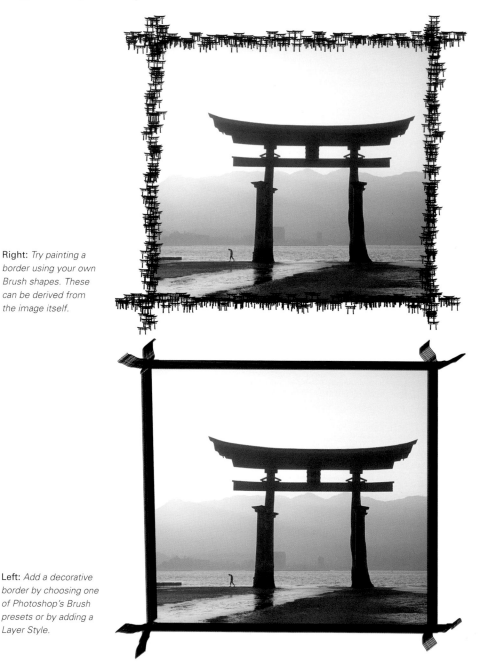

Right: *Try painting a border using your own Brush shapes. These can be derived from the image itself.*

Left: *Add a decorative border by choosing one of Photoshop's Brush presets or by adding a Layer Style.*

ADDING A DECORATIVE BORDER

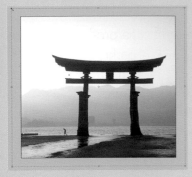

1 To make space for a decorative border, increase the canvas size. Zoom out a little, press D to reset Photoshop's colors, then activate the Crop tool (C) and select the whole image area. Holding down Shift and Alt/⌥, drag outward until you have made enough space. Hit the Return key or double-click inside the image to commit.

2 Always draw borders on a new layer. As usual, this is so you can reverse or fine-tune your work later. Activate the Brush tool (B) and expand the Brushes palette. You can choose one of the brushes shown, or expand your choice by loading a preset. Those in Dry Media and Faux Finish have particularly good textures. Here I chose a brush that reminded me of Japanese calligraphy.

3 While you can draw the border freehand, the results can be a little too inconsistent and simply not worthwhile. Instead, paint at one corner, hold down Shift, and then dab the next corner. Holding Shift makes Photoshop draw a straight line between two points. Here I tried to echo the gate's shape.

4 Another idea is to paint a border with your own Brush shape and use elements derived from the current image. Here, for example, I duplicated my main image and applied Levels adjustments until the gate's silhouette was all that remained. Selecting the whole image area, *Edit > Define Brush Preset* added my new brush shape to the Brushes palette.

5 You can paint with the brush straight away or experiment with some of the Brushes palette's other settings. The Scattering controls are great for making a repeating pattern.

FILM REBATES

For a period in the 1990s it seemed in vogue to print images with the negative's rebate showing. Rather like Madonna's famous bra, what had previously been hidden was now displayed, and the film stock and sprocket holes were used as the border of the final print. One method was to contact-print from large-format negatives, or you could file down or customize the enlarger's negative carrier. The rougher the better.

At first this technique seemed a striking demonstration that the photographer had so little need of digital trickery that the image could be presented raw and uncropped. While interesting at first, printing with visible rebate seemed to become a more tiresome reaction to the unstoppable rise of digital, so perhaps there's a certain irony in seeking to imitate it in Photoshop.

Left: *The final image, with "rebate" added digitally. Once you have scanned a strip of film, clean it up and save it as a template. This can then be applied to any image.*

Below: *The original image reveals its digital origins when compared to the final. Here it is seen without its square crop.*

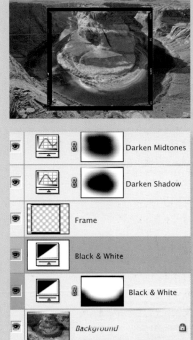

1 If you've never shot on film, and don't have any available, a few templates are available on the internet as JPEG or Photoshop files, or in theory you could create your own with Photoshop's drawing tools. If you do have access to some old film, it's far easier to do with a scanner.

My flatbed scanner has a transparency adapter, so I placed a strip of medium-format film onto the glass platen and scanned it directly into Photoshop at 1600dpi. Such a high resolution wasn't for optical quality but so the acquired scan would be similar in size to the digital captures. In this case my 2¼ inch (6cm) square negative would become a 3-4,000 pixel scan.

2 The scan usually needs some straightening and cropping and the removal of obvious defects, but the biggest task is to remove the negative's existing image. Double-click the background layer to make it into a regular layer, and then delete the central area using Photoshop's selection and masking tools. Take time over this, and you'll be left with a template with a transparent central area and which you can apply to as many images as you like.

3 With both the film template and your main image open in Photoshop, drag the film template layer from the Layers palette. If you need to resize the film frame, use Ctrl/⌘+T and hold down the Shift key so the frame's proportions are maintained.

EDGE BURNING

Edge burning is a gentle darkening around a picture's edge that is almost imperceptible yet is still sufficient to contain and hold the image together. Its function is closer to a border line than it is to the typically compositional or interpretative role of dodging and burning, though the methods are similar. Employed on its own, edge burning may be all that is needed, but marginally darker edge areas and a simple border can be an ideal combination.

How much to darken the edge areas is a subjective decision. Ansel Adams reckoned 5–10% and also described a couple of alternative methods. They were burning in all four sides at once, or burning in each side individually so that the corner received double helpings. As well as the strength of burning, consider how wide the border area should be.

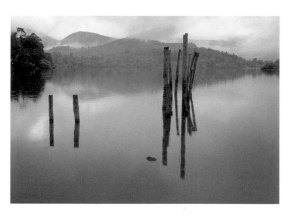

Above: After dodging the poles and burning in the surroundings, this picture still feels uncontained, with bright clouds at the top left.

Below: The final image includes the edge burning effect and a fine border for much stronger definition.

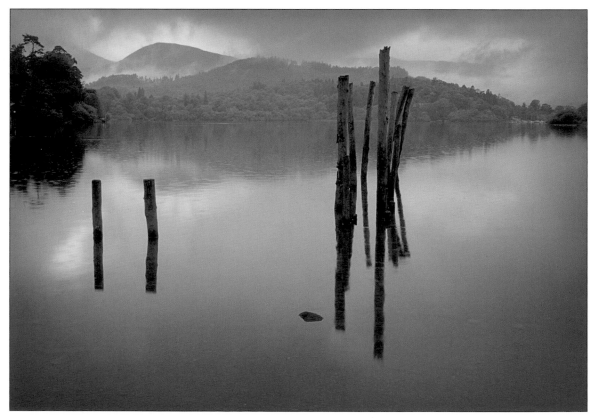

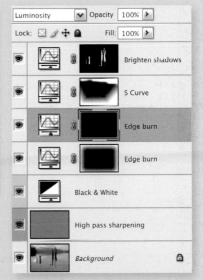

1 Start by using the Marquee tool to make a rectangular selection. The selection can be closer to those edges which are already dark. Then invert the selection (Ctrl/Cmd+I) so it only covers the border areas.

I like to feather the selection by entering Quick Mask mode and applying some blur. Press Q, which covers most of the image with a mask (which is red by default) and leaves the border areas clear. Apply some Gaussian blur, using the red mask to judge the softness of the selection's edges, and exit Quick Mask mode by pressing Q again.

2 Add a Curves adjustment layer and pull the curve down to darken the edges.

Each picture should be judged individually. Here I dragged down the curve's top-right corner, making all tonal ranges darker and rendering pure whites as pale grays. This was because this picture contained distracting bright clouds near the top-left edge. I then shaped the curve so that shadows and midtones weren't significantly darkened and wouldn't create ugly dark areas around the edges.

3 If the transition is too obvious, apply more blur to the mask, change the adjustment layer's opacity, or use other adjustments and filters. *Edit > Transform > Warp* can also be useful for reshaping the mask and changing the darkened border area.

This image benefited from a second edge-burning area, initially applied as an experiment. The Layers palette also shows how I've kept edge burning separate from the dodging and burning layers—one S curve adjustment layer adds contrast to "shape" the scene, and a second curve lifts the shadow detail in the poles.

FLIPPING THE IMAGE

Mounting the film in the negative carrier gives darkroom workers an opportunity to see, if only for a moment, how the image would look if it were reversed. It seems no big deal to flip the negative and print the picture in the darkroom. But on computer exactly the same action often seems to be only the first step on the road to devious digital trickery. But in the list of digital misdemeanours, this is a very minor infringement indeed. You should never be afraid to flip an image.

FLIP HORIZONTALLY

Clearly you might not want to flip a well-known landscape, pictures with lettering, or anything which would undermine the image's credibility. Portraits, still-lifes, and abstracts, however, can often benefit. In Photoshop, choose *Image > Rotate Canvas > Flip Horizontally*. If the result doesn't look right, choose Undo.

A lot depends on the exact composition, and also on our way of looking at a picture. In the example here, the man's eyes are positioned centrally, so perhaps the image works well in either direction, but the picture certainly seemed much more "closed" when it was oriented correctly. I immediately saw the eyes, and then stopped looking. This may well be due to being accustomed to reading from left to right—the correctly orientated picture forced me to jump leftward twice, first from the nearer eye and then from the other. Reversing the image made me read the left eye, then the right, and then continue into the space. It made "reading" this picture feel more natural and the resulting composition seemed more open.

Below: *The black-and-white composition looks more "closed" than the original.*

Opposite: *Flipping this image makes the picture read from left to right.*

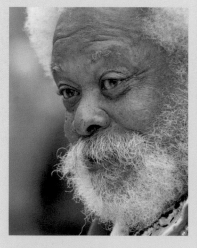

Above: *The eyes in the original image are centrally positioned so this picture can work either left-to-right or reversed.*

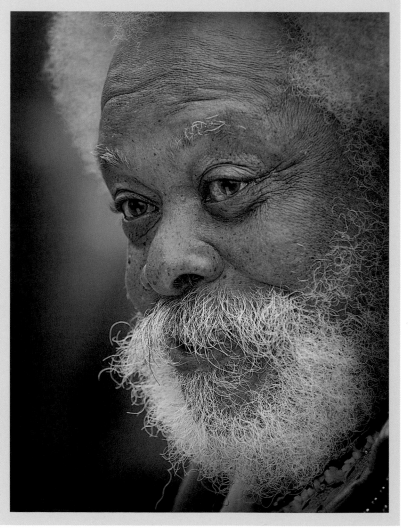

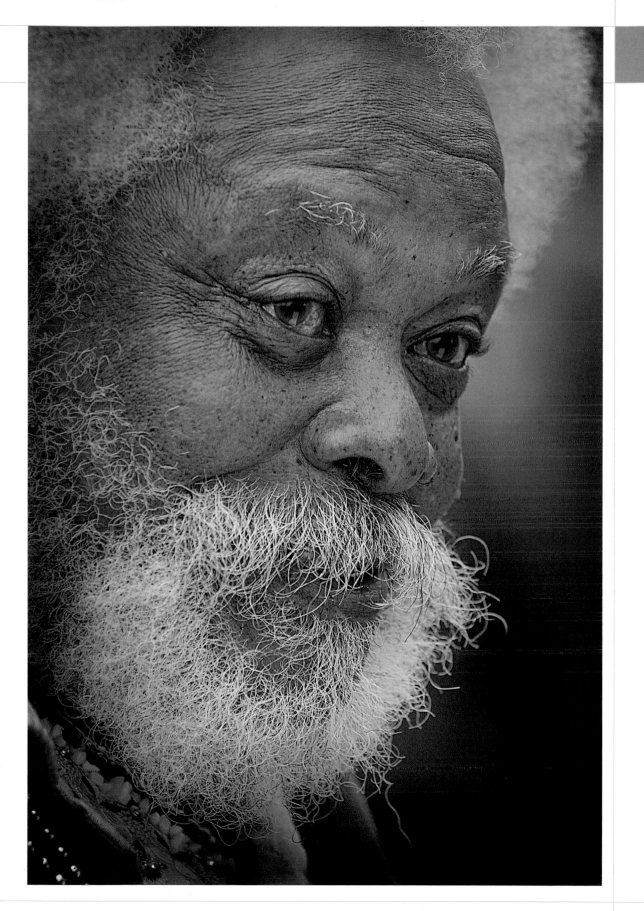

PRINT OR OUTPUT SHARPENING

From the moment light signals are registered by the sensor, right through to when the picture goes to the printer, the image loses sharpness and definition each time it is transferred from one medium to another. The printed picture will not match the sharpness of the image on your monitor, and further sharpening is necessary purely for the printing process. This is what Bruce Fraser called "output sharpening."

Output or print sharpening needs to be done at the very end of the editing process, after the picture has been scaled to its final print size. This is important because sharpening is like a rim or halo around the edges within the picture, and remains effective yet imperceptible if it is around 1/100 of an inch (0.25 mm) on the final output. If you correctly sharpened a picture and printed it at Letter or A4 size on a 300 dpi inkjet printer, that sharpening rim would be too small to be effective if you then decided to resize the picture and make a smaller print.

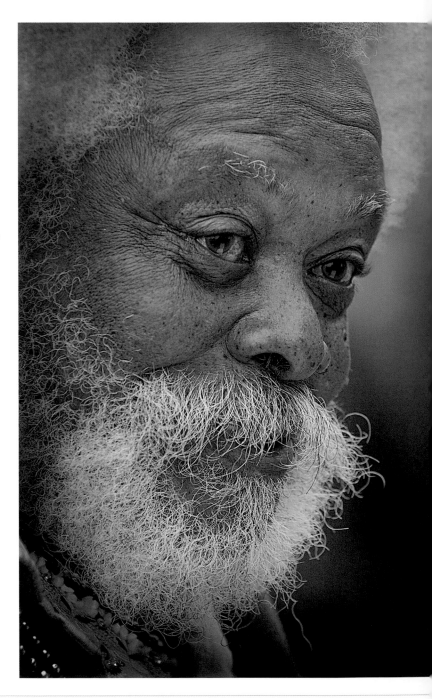

Right: *Computer screens and printers have very different output resolutions. You should always evaluate sharpening by examining the final print.*

Above: *Always keep sharpening on its own layer.*

Above: *Correct print sharpening looks unacceptably coarse on your monitor at 100%.*

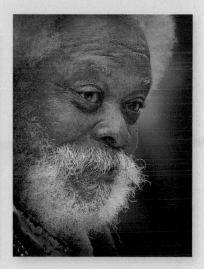

Above: *A radius of 3 produces a print sharpening rim that is effective but not too obvious.*

Above: *Zoom out to 25–50% to examine sharpening's impact on the image.*

If you do need to resize your image, it can be best to create a temporary duplicate of your master file, resizing the image and sharpening it. This prevents you accidentally saving your changes, particularly resizing, to the master file. After you make your print, you can discard the duplicate file if you don't anticipate making further prints of that size in the future.

In general, it is best to work on a copy layer—again, the principle of working non-destructively applies. Hide any border or even text layers so that they don't get sharpened too, and then hold down the Alt/⌥ key as you select Merge Visible from the Layers palette. On this new sharpening layer, apply your preferred sharpening technique. A radius of 3 is generally good for 300 dpi printing since it equates to 1/100 of an inch, and an amount of 150–200% is a good starting point.

You need to evaluate print sharpening by examining the print and not from the sharpening's on screen appearance. Your monitor has a lower output resolution than a printer and acceptable print sharpening usually looks brutal on a screen at 100%. It can help to zoom out to 25–50%, but even then you are still comparing apples with oranges—judge your sharpening by examining the final print itself.

PRINTERS

The inkjet is by far the most common type of photographic printer and offers a great balance between quality and affordability. Manufacturers are continually updating their product ranges and it is difficult to keep up with the latest developments. Before buying, check reviews in photographic magazines and take advantage of the vast number of resources now available over the internet. Someone, somewhere will have already used the printer you are interested in, and will have posted an online review.

Left: *With the right paper, with proper black and white ink, the quality of today's printers enables you to digital prints that can rival the beauty of a fine darkroom print.*

PRINTERS: INKJET

Almost any inkjet printer can print a photograph, but for decent quality you need to look at the models that manufacturers produce specifically for photographic printing. These are more expensive, but their output quality is much higher—as in so many things, you get what you pay for. Photographic inkjet printers have more colors, usually 6 or 8 and in separate cartridges, while standard inkjets often only have cyan, magenta, yellow, and black, all in a single cartridge which has to be replaced as soon as one color runs dry. With extra colors, the more expensive photo-quality printers offer better color rendition. Most manufacturers now include extra grayscale cartridges such as light black for better mono reproduction.

Right: *Modern printers such as the Epson 2400 have additional ink cartridges for grayscale output and increasingly sophisticated drivers.*

PRINTERS: CONTINUOUS FLOW

Some printers can accept continuous flow systems. These are often from third-party suppliers, sometimes from the printer manufacturer, and usually consist of self-standing ink bottles with tubes connecting them to the inkjet cartridges. After an initial cost, running costs are much cheaper and even relatively modest printing volume can justify the outlay. One big advantage is that you can use specialized black-and-white inks which the printer manufacturer may not produce.

TIP

Archival longevity should also be a major consideration. The better photographic printers tend to have inks based on pigments which tend to be much less susceptible to fading than dye-based inks. This is a fast-moving area, so it pays to review the specifications carefully when deciding to buy a new printer.

Above: *Many printers can accept continuous flow systems. These can reduce ink costs considerably, but involve initial setup costs.*

NEUTRAL BLACK AND WHITE

There's a certain irony in color being one of the biggest problems of black-and-white digital printing, and it's important to maintain a healthy scepticism when reading about new printers' black-and-white capabilities. The fresh print may look fine when it is viewed in daylight or with a daylight-balanced light, but it's a different story once you see the print under regular tungsten house lighting. What had previously seemed pure black and white suddenly exhibits a magenta color cast, or is occasionally greenish. The unwanted tone is different when the light source is fluorescent, and it also varies greatly depending on which paper you use. You can change your printer, and a lot of other things too, but a lot of photographers make the best of a bad job and discover a new enthusiasm for split toning.

SPLIT TONING

There's an underlying technical obstacle here. For a color inkjet printer, printing a toned or split-toned black-and-white image is little different from color printing as it can blend the tone from half a dozen color cartridges, and then add black from one or more grayscale inks. But printing a neutral black and white presents a problem, even for a top-of-the-range printer. One or two grayscale inks are not enough to produce a smooth tone. To balance this the colored inks are also used, and the printer driver tries to combine them in a balance that results in a neutralized (gray) color. The output may look right in daylight, but it's inevitably a compromise.

Things are getting better. Printer manufacturers are introducing third and fourth grayscale inks so less use has to be made of colored inks cartridges. Drivers are also improving, though those from printer manufacturers tend to cover only their own brand papers. Even then, manufacturers' claims need to be put to the test. Check the print under normal house lighting and a faint color cast is often visible.

Some photographers are happy with the mono output from third-party RIPs such as ImagePrint, QuadTone Rip, and QImage. These are replacements for the original printer drivers and have a range of specialist features like reducing ink usage, supporting a wider range of paper types, and print queuing. They also have black-and-white settings.

But opinions differ. I've only ever been really satisfied by using dedicated black-and-white ink sets. These are available from companies such as Piezography, Lyson, and Permajet and are replacement cartridges or continuous flow systems. At their simplest, one swaps the black and white cartridges in and out as needed, taping over their nozzles when not in use. Because there is no need to compromise and use color inks, the results are much more neutral—simply black and white.

Opposite: Specialized inks produce the most neutral black-and-white results.

Above and Below: Specialized black and white inks are often based on carbon pigment and have carbon's warm undertone. They usually come in sets which let you add tonal variation.

| Warm neutral | Cool neutral | Neutral | Cool sepia |

CMYK OUTPUT

Commercial repro printing is a specialized and highly skilled field. For many photographers, the whole topic of CMYK, the four-color printing process used by most commercial presses, has the mysterious status of a black art. CMYK needs the picture to be separated into cyan, magenta, yellow, and black components, from which four printing plates are made and attached to the press's rollers. Each then applies the appropriate ink color as paper passes through the press. While the computer can do the RGB-to-CMYK calculation, the screen's RGB image contains a wider range, or gamut, of colors than the press can accurately reproduce. These out-of-gamut colors will be clipped. Alternatively, the RGB colors need to be adjusted before the CMYK separation.

That adjustment is usually made by the printer, not the photographer. Many pro photographers have never once been asked to submit CMYK-separated material, and that includes some acquaintances with 40 years' experience. They hand over their pictures in RGB form, and their publisher or printer handles all the CMYK issues. For the photographer to perform those tasks would involve a major transfer of commercial risk and responsibility. From the perspective of those running the presses, generally the last thing they would want would be non-experts submitting erroneous attempts at CMYK color separations.

While it is uncommon for the black-and-white photographer to handle CMYK separation and printing, Photoshop gives you a fair chance of doing a good job. It has a group of soft proofing tools that preview the gamut problems, so you can then decide exactly how the image's color range is compressed to remain within the range of colors that the printer can output. Any such work is usually best left to the very end of the editing process since some familiar Photoshop features behave slightly differently in CMYK mode. So complete your regular editing work as normal, resizing the picture to its output dimensions and sharpening it, and save a master file in RGB format. Then prepare the CMYK version using a duplicate file.

When you are taking responsibility for something so critical, it is important to communicate with the printer and keep proper documentation. Plan to submit both the RGB and the CMYK files, accompanied by an inkjet print for reference.

Opposite: *The final output stays sharp with manually adjusted CMYK channels for better definition of colors that were out of gamut after RGB conversion.*

Below: *CMYK separates the picture into cyan, magenta, yellow, and black components and is used in most commercial printing presses.*

Above: *Conversion issues particularly affect toned images. This picture's strong cyanotype-style color is too bright to reproduce properly on a CMYK press.*

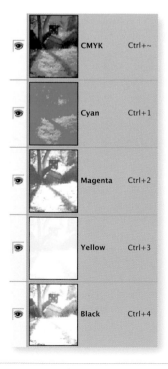

CMYK	Ctrl+~	
Cyan	Ctrl+1	
Magenta	Ctrl+2	
Yellow	Ctrl+3	
Black	Ctrl+4	

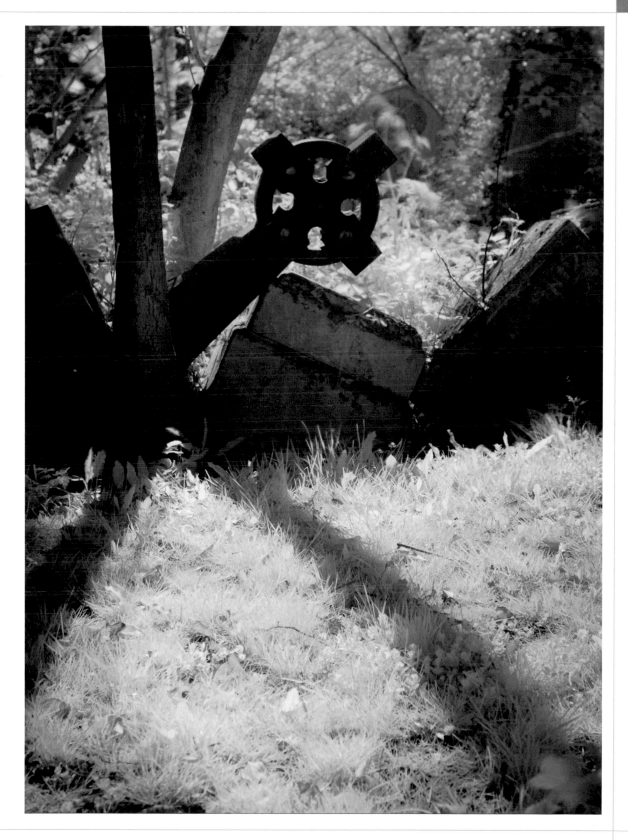

COLOR MANAGED CONVERSIONS

1 As with all advanced work, it is important to make sure your monitor is calibrated and profiled, and to set Photoshop's color settings so they are correct for the printing press. In the USA that would generally mean choosing North America Prepress 2, but this varies by country and it is best to seek written confirmation from the printers.

2 To see if your RGB image contains any colors that are out of gamut, set up Photoshop's soft proofing for the specific type of press which will be used. While you can pick *View > Proof Setup* and then choose Working CMYK, a more sophisticated choice is Custom which lets you fine-tune the settings.

The Device to Simulate signifies the press type. SWOP or Standard Web Offset Press is one US standard, but you should place the responsibility on the printer to supply the correct profile for their equipment, especially if the printer uses sheet-fed presses. For Rendering Intent, choose Relative Colorimetric, which will clip any colors but preserve brightness values. Then make sure you save your settings.

3 Switch on soft proofing by selecting *View > Proof Colors*, and switch on *View > Gamut Warning*. This enables a preview mode that shows what will happen to your RGB colors after you make the image CMYK. A gray overlay marks out-of-gamut areas.

Above: *Photoshop's Gamut Warning makes it very obvious when RGB colors are out of the CMYK press's gamut or printable range.*

4 With Photoshop's Gamut Warning active, you can add a Hue/Saturation adjustment layer and reduce the saturation while watching its effect on the RGB image's colors. Here I have begun to drag the overall or Master saturation to the left and this has reduced the out-of-gamut areas. The Edit drop-down box also lets you adjust individual colors, which may be useful if you are working with a split-toned picture. Alternatively, use a Selective Color adjustment layer.

5 You can also target specific image areas with the color adjustments. Before adding the adjustment layer, go to *Select > Color Range* and pick Out Of Gamut. When you add an adjustment layer, it is automatically masked.

6 The adjusted colors will not usually be as sparkling as in the original AdobeRGB or ProPhotoRGB image, but you should be able to adjust a toned black and white so that the colors are acceptable and can be reproduced on the CMYK press. Once you are satisfied with the soft proof, *Image > Mode > CMYK* is the quick way to make the CMYK version and applies Photoshop's current settings to the picture.

7 For more control, choose *Edit > Convert to Profile*. This also lets you review the settings that will be applied. Generally one chooses Adobe (ACE) as the Engine and Relative Colorimetric as the Intent. Black Point Compensation should also be ticked so Photoshop matches the output black to the image's black. Allow Photoshop to flatten the image, make sure your copyright and content details are in the file, and save it as a standard TIFF.

BLACK AND WHITE IN BULK

Most of this book has focused on making the best individual black-and-white image. "Best" is judged in terms of quality, and in terms of using the mono conversion creatively, so the final work has made the most of the captured image data and presents the best subjective interpretation of the subject. It is an approach suited to one-off jobs, and is perhaps indicative of a fine-art mentality.

ACTIONS

But more and more photographers also want black and whites not just of the day's best few shots, but of every frame worth keeping that day. Given how quickly some cameras can fill flash cards, the one-off, fine-art approach could amount to an awful lot of Photoshop time. Essentially there are five possible solutions:

- Shoot black-and-white RAW+JPEG
- Process color RAW files with a Photoshop Action
- Process color RAW files through a RAW converter
- Use a cataloging program to output in black and white
- Use new-generation combined cataloging and RAW processing programs such as Lightroom and Aperture.

For sheer efficiency, choose the RAW+JPEG shooting setting if your camera has one, and set it to black-and-white mode, too. Once the pictures are on your computer, all you then need to do is get all the pictures into one Finder or Explorer folder and sort them by file type. Of course, you will have to make this decision before you press the shutter release.

A Photoshop Action is a way of recording editing steps so they can later be replayed and applied to other images. To set up a black-and-white conversion Action, open an image and start a new Action in the Actions palette. Add a Black and White adjustment layer, a sharpening layer, and maybe a border, then save the file and close it. Click the Stop playing/recording

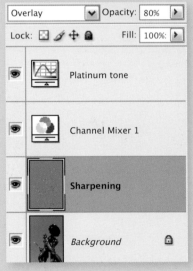

Above: *A Photoshop action can add adjustment layers and be an efficient way to process lots of pictures consistently.*

button in the Actions palette, and the Action is ready. You can now open the next color picture, run the Action, and proceed through all the images.

You could also introduce user input into the Action. For instance, tick the column to the left of the Black and White adjustment layer step, and the Action will pause each time it is run, enabling you to adjust the sliders to

Below: *Actions let you replay your editing steps and can be paused for user input.*

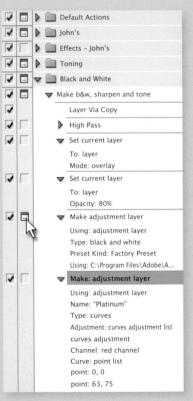

suit each image. Alternatively, if you simply want to leave the computer processing multiple images, you can select them in Bridge and set off the Action using the command *Tools > Photoshop > Image Processor*.

Photoshop Actions work well once you have set them up and tested them, and when your editing work involves little variation. Little things, like dealing

Above: *Camera Raw's Stack Mode can work on many images at once.*

Above: *iView Media Pro is a multimedia cataloging tool with photographic tools.*

differently with portrait and landscape format images, can prove awkward, even for photographers adept at automating their workflow. Others struggle and find Actions, let alone Photoshop scripting, a concept and discipline they never quite grasp.

Another approach is to use the RAW processor. This could be done equally well using Bibble, Nikon Capture, Capture One, or another standalone RAW converter, but it is quite easy in Bridge. Select the RAW files, then right-click and choose Open in Camera Raw. As we saw in the section on black-and-white conversion techniques, Adobe Camera Raw version 4 has a specific grayscale output option and accompanying sliders. You can select all the images and apply identical settings, or fine-tune each picture. Do not click Open, but choose Save, and you will be prompted for a folder and format for the output. When Items Remaining has counted down to 0, click Cancel so that your black-and-white conversion settings do not overwrite any existing color RAW conversion settings.

Cataloging and photo-organizing programs can often output black-and-white from color images. In this category are consumer-oriented packages like iPhoto on the Mac and Picasa on the PC, and more pro level DAM (digital asset management) tools such as iView/Expression Media. These programs include basic controls for black-and-white output and special effects like sepia toning and vignetting. They may be geared more toward convenience than professional quality, but they're great if you are using them to manage and find your pictures and need a lot of black and whites in a hurry.

BLACK AND WHITE IN BULK

RAW LIBRARY SOFTWARE

Left: *Adobe Lightroom, like Apple Aperture, saves alternative versions of your files. They are "virtual copies" that exist only in the database until you print or output them.*

Below: *Library's Quick Develop panel is a fast way to apply preset black-and-white conversion recipes.*

Left: *Lightroom's Develop module offers fine control of how colors are rendered in grayscale tone.*

Another option emerged at the turn of 2005/2006 when Apple and Adobe each released ambitious new programs combining top-quality RAW image processing with pro-level DAM features. Apple's Mac-only Aperture and Adobe's Lightroom, which runs on both PC and Mac, aim to meet photographers' need to organize, adjust, and output large number of pictures. While it is too early to say how far these "workflow" programs will reduce photographers' use of Photoshop, both contain adjustment tools that can accomplish many of the main tasks, and they are designed particularly for working with many pictures at once. Each can produce excellent black and whites.

At the time of writing, Lightroom offers the more sophisticated control over black and white. In its Library you can select any number of images—hundreds, if you want—then right-click one and select Create Virtual Copies. This makes Lightroom add duplicate thumbnails to its database, which you can use for the black-and-white versions, leaving the color versions untouched. You can also press Ctrl/⌘+N and put the virtual copies into a new Collection with the name of your choice, so they are easy to find later.

To make these thumbnails black and white, the quickest way is to click the Quick Develop panel (F8) on the screen's right, and choose Grayscale from the Preset drop-down. Lightroom updates all the selected thumbnails with default black-and-white treatments.

But much finer control is available in the Develop module. Keeping the thumbnails selected, press the D key to switch to Develop, and then activate the Grayscale panel at the right of the screen (F8). This panel's controls work in a similar way to the Black and White adjustment layer in Photoshop CS3. You drag individual sliders to change a color's grayscale rendition, or use a Targeted Adjustment Tool so you change slider values by dragging the cursor directly across image areas.

Above: *In Lightroom, switch to Auto Sync mode to apply your adjustment to all the selected images.*

Develop's sliders usually adjust only the picture that is currently shown on screen. To apply those adjustments to all selected images at once, press the Sync button. Lightroom lets you decide which adjustments to apply—for instance, you may not wish to apply the same crop or dust correction to all the pictures.

But there is an even more efficient way to work in Develop—hold down the Ctrl/⌘ key and click the Sync button. This switches Develop into Auto Sync mode, which means your slider adjustments now apply to all selected images. I always work in this mode, selecting a sequence of similar images in the Filmstrip (F6), adjusting the sliders, then selecting the next group of pictures, and so on.

As well as fine-tuning black-and-white output, in Lightroom you can change contrast, sharpen, or apply split toning to multiple images. You can then send them all to the printer, burn them to a disc, or output them to the web.

Right: *Lightroom's black-and-white conversions are applied to the entire picture. Individual shots must be sent to Photoshop if they need more than one conversion adjustment, or require dodging and burning.*

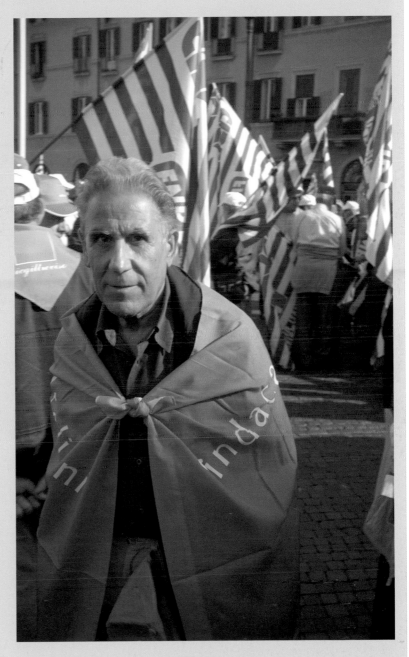

BLACK AND WHITE IN BULK

APERTURE

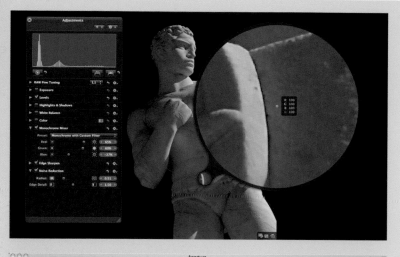

Left: *Apple's Aperture has a Monochrome Mixer that works like Photoshop's Channel Mixer.*

Left: *After fine-tuning one image, you can "lift and stamp" your adjustments to the others.*

Apple's Aperture is also designed for adjusting the overall appearance of multiple pictures, not working Photoshop-style on one image at a time or manipulating images at pixel level.

Like Adobe Lightroom, the Aperture workflow involves making virtual versions of your pictures. In the Browser view, select the thumbnails and choose *Image > Duplicate Version*. While Aperture automatically adds a version name, which will make it easier to find these new versions at a later date, it still makes sense to change the version name to something more useful, such as the master filename and a suffix. You can do this in *Metadata > Batch Change*.

Then display the Adjustments palette (^A) or go into full-screen mode (F) and bring up the Adjustments heads up display (H). From the palette or HUD menu, choose Monochrome Mixer and you have access to a set of sliders which work like Photoshop's Channel Mixer. You can apply negative values to one or more channel, but ideally the three sliders should add up to 100%. There is also a Color Monochrome adjustment so you can apply a single tone to the image, though there is no split-toning adjustment.

Once you have converted one image to black and white, you can apply those adjustments to multiple images using a Lift and Stamp tool, which works just like

regular copying and pasting. This needs to be done sensibly—the same mono conversion isn't right for every image—but it is very efficient for adjusting batches of pictures.

At the time of writing, Aperture's range of black-and-white controls is some distance behind Lightroom. But these programs are in direct competition and their features will develop quickly. Either application is already a viable option for bulk black-and-white work.

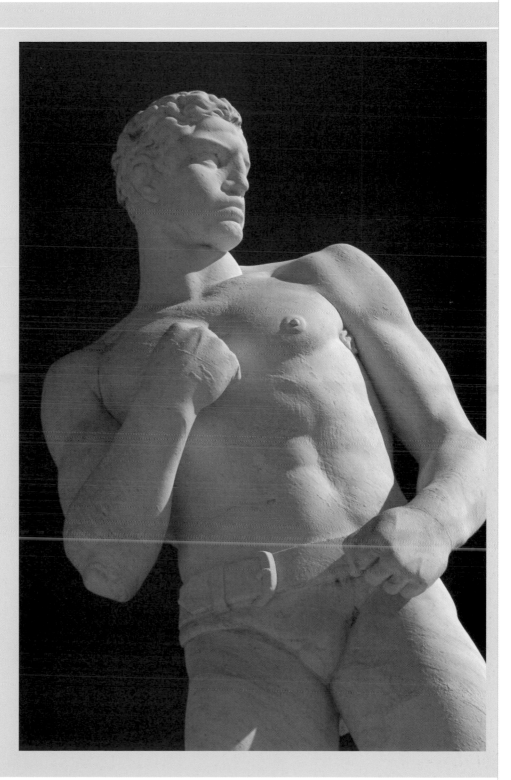

Right: *Aperture is ideal for producing high-quality black-and-white output and working with large numbers of pictures.*

OUTPUT FOR THE WEB

The web is an increasingly popular means of displaying your work and there is a corresponding increase in the number of ways to do so. You can upload pictures to various photosharing and stock services, maintain your own site, or send pictures to a web designer. But regardless of which method you choose, you need to ensure your images look their best online, and make it as difficult as possible for people to steal your work.

Preparing images for the web should be done after completing all other work on a picture. So you don't overwrite the master file and lose all your adjustment layers, it can make a lot of sense to use a temporary duplicate for your web preparation work. Then resize the images, apply an appropriate level of sharpening, set a correct Color Profile, add a copyright logo, and last of all, check the pictures have the right metadata.

Right: *Include your name in your copyright watermark. It will take a copyright thief so much time to remove this notice that it will act as a deterrent. But be careful not to offend legitimate visitors.*

SWITCH TO sRGB

When you're checking the pictures you've uploaded to your web site, you may notice that the colors look washed out in comparison to their original appearance in Photoshop. While this is not such a big issue for black and whites, it can still affect toned mono work. The reason for this is that web

Below: *Convert your images' color profile to sRGB before putting them online. Most web browsers are not color-managed and your visitors will see tones that are much less saturated.*

browsers are not color-managed (at the time of writing, the Mac-only Safari is the sole exception) so there is little point saving your ICC profile with the file and hoping that Safari is the only browser used to view your pictures. You need to allow for the lowest common denominator online, so choose *Edit > Convert to Profile* and switch your picture's color profile so sRGB. You may then need to adjust the color saturation, but this will ensure your site's visitors see your pictures at their best.

ProPhoto (in non-Safari browser)

sRGB (in non-Safari browser)

ProPhoto (in Safari)

sRGB (in Safari)

HOW MANY PIXELS?

Until recently, the "right" size for the web made the best use of limited bandwidth and online storage space, but today the bigger considerations are the screen sizes which you expect your visitors will use to view your work, and the security of your pictures. You cannot assume that your visitors will only use 30 inch screens, or have the same-sized monitor as you. You need to target a much lower screen size and make web output no larger than 1000 pixels. Also remember that screens are wider than they are tall, and visitors to your web site should not need to scroll the browser to see the bottom of a picture in portrait format.

While you clearly want your work to impress, security is the other main reason for limiting the dimensions of web output. It is a common fallacy that Flash-based web sites protect your work better than HTML-based sites. A visitor can always take a screen grab (sometimes for legitimate reasons like shortlisting your pictures in a proposal). So, other than not putting work online, ultimately you cannot stop the determined thief. Instead, you need to increase his cost in terms of time and manual effort, and reduce the potential gains. So the smaller the image, the less useful it is to steal. At 600 pixels wide, someone could only make a decent 2 inch (5 cm) print at 300 dpi, but the temptation obviously increases once you put larger images online.

SHARPEN THE IMAGE

After resizing the image and adding a border if required—but before you add any copyright notice—the next step is to sharpen the picture for web output. Unlike print sharpening, where the printer's different output resolution means sharpening often looks gruesome on screen, the output medium for web images is your visitor's monitor. So, broadly speaking, your own screen is fine for judging how much sharpening to apply for web use—just make sure you apply sharpening with Photoshop zoomed in to 100% or actual pixels. Set the Radius to below 1 pixel.

0.7 is good and at a typical 72 dpi monitor resolution roughly equates to 1/100 inch (0.25 mm) or the same-sized rim as for print sharpening. Also, if use the Unsharp Mask, make sure you immediately follow it with *Edit > Fade Unsharp Mask* and select Luminosity as the blending mode. This prevents any colored artifacts.

Left: *Unlike sharpening for print, your monitor is a good guide for the final result online.*

Left: *Too much sharpening creates an unsightly halo around image edges.*

ADD COPYRIGHT NOTICES

As well as limiting the size of your images, you should also add a visible copyright notice that includes your name. Its size is obviously a judgement call—you don't want to deface your work too much or treat all visitors as dishonest. But it needs to be obvious enough to stop legitimate users making mistakes and also deter casual copying.

Most of all, the larger the copyright notice, the more time the thief would need to spend Photoshopping it away. Again, it's a case of deterrence rather than complete protection.

Above: *You can use one of Photoshop's built-in shapes for a copyright symbol.*

Left and Above: *Use layer styles and reduce the Fill opacity to 0% for a neat transparent effect.*

ADD INVISIBLE METADATA

As well adding a visible copyright notice to the image, you can take invisible measures to deter theft and prove your ownership of an image. Photoshop's *File > File Info* command lets you check that your images contain your copyright and contact metadata before you upload them. Ideally, such information would have been added when you transferred the pictures from your camera to your computer, using Bridge or a cataloging program, but in practice the information can easily get stripped away—by Photoshop's own Save for Web command, for instance. Instead, Photoshop's Save As command preserves metadata, but be aware that this includes camera-generated EXIF information such as the camera model, shutter speed, and other information that you may not wish to include.

It is best to do a final check using Photoshop's *File > File Info* command, and it is a good idea to set up a metadata template that contains your copyright and contact information. The determined thief can always remove these details, but at least you are tipping the cost/benefit balance in your favor.

Below: *Photoshop's File Info panel lets you add invisible information about the picture. A determined copyright thief could remove this, but legitimate users of your work would not normally do so.*

GLOSSARY

ACTION Photoshop keystrokes recorded to automate routine activity.

ADJUSTMENT LAYER A layer in a Photoshop image that adjusts the appearance of layers beneath it, and keeps editing adjustments separate from image data.

ALIASING Jagged edges in a digital image, caused by the square shape of its constituent pixels.

ALPHA CHANNEL A grayscale version of the image that can be used with the color channels for saving a mask or selection.

ANTI-ALIASING Smoothing jagged edges by introducing additional pixels of intermediate tone.

APPLE APERTURE Image editor introduced in 2005 by Apple Computer and combining DAM features from cataloging programs and RAW image processing.

ARTIFACT Foreign shapes degrading a digital image as a result of its capture, manipulation, or output.

BITMAP An image consisting of a grid of tiny pixels, each with color and brightness values.

BLENDING MODE The calculation that controls how one Photoshop layer is composited with other layers.

BLOWN OUT Containing no detail, usually referring to overexposed parts of an image.

BRIGHTNESS Subjective impression of luminosity.

BROWSER A program that examines folders in real time, displays image files' thumbnails and large previews, and allows metadata entry. Searches are performed by examining the file system. Examples include Bridge, Photomechanic, Breezebrowser. Also used as shorthand for Web Browser.

BURN A photographic darkroom and Photoshop technique to darken part of the image.

BURNT OUT Containing no detail, usually referring to overexposed parts of an image.

CATALOG A program that records the contents of folders, displays image files' thumbnails and large previews, and allows metadata entry. While folders may be shown, their contents are not updated in real time but only when instructed, and searches are performed upon the database. Examples include Extensis Portfolio, iView MediaPro, iMatch, and ACDSee.

CAMERA RAW In Photoshop, the module responsible for converting RAW images from any digital camera.

CHANNELS The three colors whose brightness values are used to record the color of a pixel.

CLIPPING An absence of detail in image areas because the brightness values record either complete black or pure white.

CMYK Cyan Magenta Yellow Black—the subtractive model of defining color.

COMPRESSION Reduction of image size by use of algorithms to discard superfluous data.

CONTINUOUS FLOW SYSTEM A system of bottles and tubes that supplies ink to the printer.

CONTRAST Difference in brightness between neighboring areas.

CURVES In Photoshop, a method of mapping pixels' brightness values to the value at which they are output.

DEPTH OF FIELD The area in acceptable focus, in front of and behind the point at which the lens is focused, and varied by opening and closing the aperture.

DERIVATIVE An image file produced from an original, for instance the JPEG or PSD file saved after a RAW or DNG original has been edited in Photoshop.

DESTRUCTIVE Permanent change of pixels' brightness values or positions.

DIGITAL ASSET MANAGEMENT The practice of downloading, backing up, evaluating, describing, categorizing, selecting and archiving digital image files.

DODGE A photographic darkroom and Photoshop technique to lighten part of the image.

DPI Dots per inch, the standard measure of resolution.

DYE A type of ink that soaks into the paper.

EXIF Commonly refers to exposure information stored with digital image files; strictly refers to the file format.

F-STOP The ratio of the focal length to the aperture diameter, expressed as $f2.8$, $f4$ etc.

FEATHERING In Photoshop, making the edges of a selection softer.

FILTER (PHOTO) Transparent material which changes the light passing through it.

FILTER (SOFTWARE) A Photoshop adjustment to the brightness values of image pixels.

FOCAL LENGTH The distance between the center of the lens and the focal point.

FOCAL POINT The point at which light rays passing through a lens converge.

FOCUS Where light rays converge on the sensor and form a sharp image.

GRADIENT Smooth blending of one color to another.

GRAYSCALE An image containing pixels with brightness values only on a black-and-white scale and with no color data.

HIGHLIGHT The brightest tones in an image.

HISTOGRAM A chart showing how the distribution of pixels by brightness value.

ICC PROFILE A measure of a digital imaging device's color characteristics, used for accurate communication of color between devices. As set by the International Color Consortium.

IMAGE MODE Method of recording color and brightness in a digital image file.

INTERPOLATION The addition or deletion of pixels when Photoshop resizes an image.

ISO Measure of sensitivity to light ("speed") as set by the International Standards Organisation.

JPEG A digital image file format which compresses file size by the removal of unused color data.

LASSO A Photoshop tool to select image areas.

LAYER In Photoshop, a level of the image file to which changes can be independently applied.

LCD Liquid crystal diode, used to refer to the screen on the back of digital cameras.

LIGHTROOM Image editor introduced in 2006 by Adobe combining DAM features from cataloging programs and RAW image processing.

LOSSY A file format which discards image information to create a smaller output file. Opposite of lossless.

LUMINOSITY The quantity of light reflected by or emitted from a surface.

MACRO A type of lens capable of closeup photography at more than 1:1 magnification.

MARQUEE A Photoshop tool used to select image areas.

MASKING Blocking parts of an image from light, or in Photoshop excluding parts of layers from the composite image.

MIDTONE The average luminosity parts of a digital image.

NEUTRAL DENSITY Uniform density across the visible wavelength and of no color.

NOISE Random pixels on a digital image.

PIGMENT A type of ink consisting of particles that lie on top of the paper.

PIXEL Picture element, the smallest unit of a digital image.

RAW FILE The image data recorded by a digital camera's sensor in the camera maker's proprietary file format and containing the unchanged image data and one or more embedded JPEG thumbnails and previews.

RESOLUTION The level of detail in an image, measured in pixels or dots per inch.

RGB The primary colors of the additive model of recording color, used for recording image colors on monitors and in image editing.

SATURATION The purity of color, with high saturation being most intense.

SELECTION Part of a Photoshop layer selected by the user and marked by the "marching ants" dotted lines.

SHADOWS The darkest tones of an image.

SHUTTER Camera mechanism that controls the time that the sensor or film is exposed to light.

SLR A camera that shows the same image directly through the viewfinder as on the sensor or film.

SMART FILTER From Photoshop CS3, a filter applied to a Smart Object layer and altering its appearance. Unlike earlier uses of filters, its effect can be reversed or adjusted at any time.

SMART OBJECT A protected layer in Photoshop (CS2 onward) whose appearance may be adjusted or distorted without changing or losing the underlying image data.

SOLARIZATION Usually the same as Sabattier effect but strictly an effect caused by greatly overexposing film emulsion.

SPLIT TONE The addition of one or more tones to a monochrome image.

STOP See *f* stop, also used as the action of closing the aperture, as in "to stop down."

TIFF Tagged Image File Format, a file format for high-resolution graphics, widely compatible with other operating systems.

UNSHARP MASK A process which increases the apparent detail of an image by computer manipulation.

WHITE BALANCE Automatic compensation for the color temperature of artificial light.

FURTHER READING

Ansel Adams *The Negative*

Ansel Adams *The Print*

Don McCullin *Sleeping with Ghosts*

Don McCullin *Unreasonable Behavior*

Patricia Morrisroe Mapplethorpe *A Biography*

Eddie Ephraums *Creative Elements*

John Paul Caponigro *Adobe Photoshop Masterclass*

Martin Evening *The Adobe Photoshop Book for Digital Photographers*

John Beardsworth *Lightroom Essentials*

ONLINE RESOURCES

Adobe
http://www.adobe.com

Russell Brown
http://www.russellbrown.com/

Aperture
http://www.apple.com/aperture/

Permajet
http://www.permajet.com/

Lyson
http://www.lyson.com/

Piezography
http://www.piezography.com/

QuadTone RIP
http://www.quadtonerip.com/

Heidelberg Druckmaschinen
http://www.heidelberg.com/

INDEX

INDEX

ACKNOWLEDGMENTS

I dedicate this book to my mother who is still in my thoughts every single day, and my friends and family, particularly those who have carried my bags and tripods over the years. Particular mentions go to Denise, Phil, and Catherine Quenby; Sarah and Stephen Vey; to Manuela who survived and finally escaped; and to Agnieszka and her camera. And to Tom Waits and Cristiano Ronaldo.